{WINE ACROSS AMERICA}

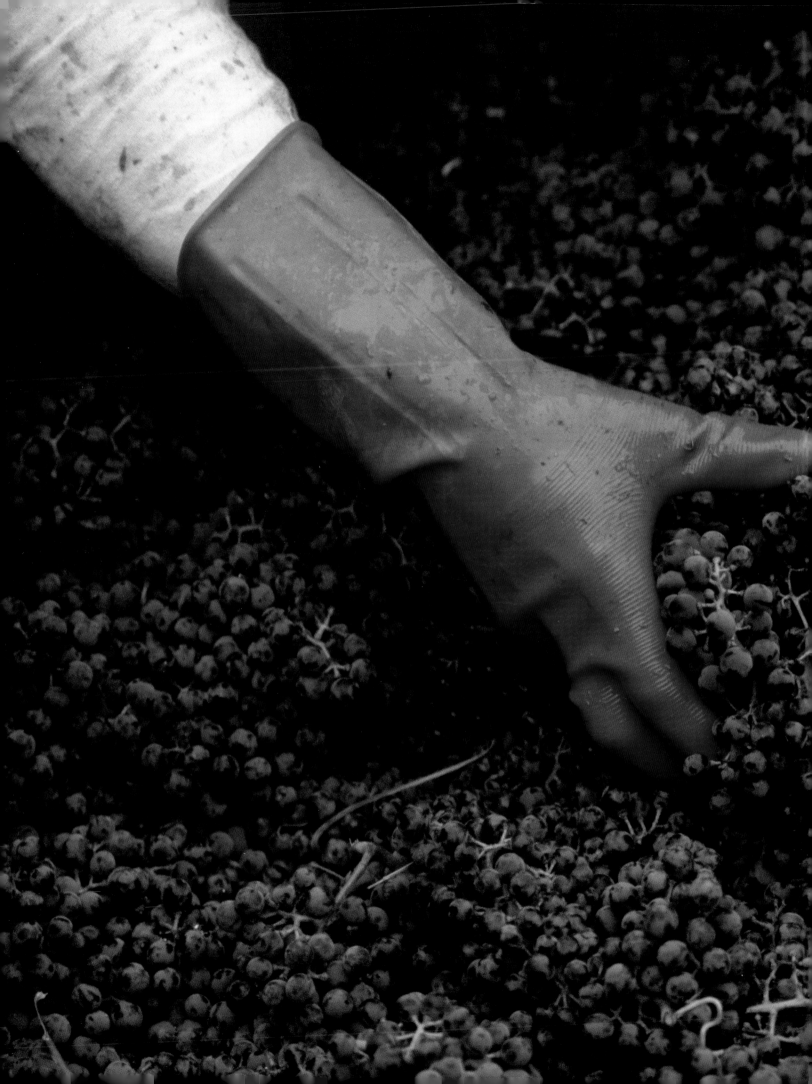

WINE ACROSS AMERICA

A Photographic Road Trip

Photographs by

CHARLES O'REAR

Text by

DAPHNE LARKIN

WINEVIEWS PUBLISHING, ST. HELENA

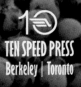

TEN SPEED PRESS
Berkeley | Toronto

This edition published in 2007 by
Wineviews Publishing LLC, Box 193
St. Helena, California 94574
Tel: 707-963-2663

1⊜

Ten Speed Press
Box 7123, Berkeley, California 94707
www.tenspeed.com

Distributed in Australia by Simon & Schuster Australia, in Canada by Ten Speed Press Canada, in New Zealand by Southern Publishers Group, in South Africa by Real Books, in Southeast Asia by Berkeley Books and in the United Kingdom and Europe by Publishers Group UK.

ISBN-13: 978-0-962-5227-6-5
ISBN-10: 0-962-5227-6-7
Library of Congress information on file with publisher
Printed in China

10 9 8 7 6 5 4 3 2 1

Design: Jennifer Barry Design, Fairfax, California
Editing: Susan McWilliams
Layout production: Kristen Hall
Production assistant: Lindsay Garvey
Cartography: Ben Pease

View additional wine photography at: www.wineviews.com

Photo Credits: Page 60: Satellite Imagery Provided by GlobeXplorer.com; page 61: Carlos Ortiz, Rochester Democrat and Chronicle; page 112-113: M. J. Wickham; page 135: Keith Cotton; pages 25 and 89: Courtesy of San Antonio Winery; page 143: Courtesy of Mt. Bethel Winery; page 19, map © 2007 Charles O'Rear

GEORGIA: A row of Norton grapes for Tiger Mountain Vineyards frames a traditional hip-roofed barn near the town of Tiger in the state's northeast corner. The Norton grape is one of the oldest native North American varieties in commercial cultivation today. Its resistance to fungal diseases makes it popular in the humid southern states, where some call it the "Cabernet of the Ozarks." (Preceding page 1)

WASHINGTON: A worker sorts through grapes before they are crushed in a ritual that dates back to ancient times. The history of wine is entwined with that of humankind, with records of vineyards planted in Egypt as early as 3000 B.C. and tales of wine consumption in China dating to the same period. It is believed that the Greeks were the first Europeans to make wine, and that the ancient Romans exported the culture of the vine with them into what is now Europe. (Preceding pages 2–3)

CALIFORNIA: Near San Luis Obispo, Baileyana Winery's Cellar Manager Mike Wheeler examines a barrel sample of Pinot Noir in the afternoon light. Baileyana's winemaker, Christian Roguenant, designed the winery's cellar with huge windows to allow sunlight into what is traditionally a dark and damp environment. (Following page 6)

It is well to remember that there are

five reasons for drinking wine: the arrival of a friend;

one's present or future thirst; the excellence of the wine;

or any other reason. —LATIN PROVERB

{ CONTENTS }

INTRODUCTION
A Road Trip Through America's Wine Country

17

MAP OF AMERICAN WINERIES BY STATE 19

PLACES
Landscapes, Vineyards, Wineries

25

THE NORTHEAST 54 • THE PACIFIC NORTHWEST 76

PEOPLE
America's New Pioneers

89

CALIFORNIA 114 • THE MIDWEST 126

PASSION
A Love Affair with Wine

143

THE WEST 162 • THE SOUTH 196 • WINE BOTTLES U.S.A. 218 • WINE FACTS U.S.A. 220

INDEX

222

SAKONNET RHODE ISLAND RED

2003

A bottle of good wine, like a good

RHODE ISLAND: Brilliant red colors identify this wine label for producer Sakonnet Vineyards in Little Compton. The label, which won a competition at the Rhode Island School of Design, catches the eye, where hundreds of labels compete for the consumer's attention. (Left)

NEW YORK: A brilliant sun backlights this scene at Lenz Winery in Peconic on the North Fork of Long Island where winemaker Eric Fry draws a sample using a traditional wine "thief" or siphon. This area of eastern Long Island benefits from well-drained soil, a long frost-free growing season, an even rainfall, more sunshine than anywhere else in the state and—important for selling wine—many visitors from nearby New York City. The climate in the area is often compared to that of the Bordeaux region of France. (Below)

act, shines ever in retrospect. —ROBERT LOUIS STEVENSON

WASHINGTON

ILLINOIS

HAWAII

OREGON

CALIFORNIA

NEW MEXICO

TEXAS

CONNECTICUT

MARYLAND

NEW YORK

MISSOURI

ARIZONA

TEXAS

COLORADO

Wine makes life easier, less hurried, with

10

MASSACHUSETTS: Brothers Rob and Bill Russell exchange laughs at their Westport Rivers Winery in Westport. Their family winery is the state's largest and their vineyards are the most extensive in New England. Wineries in Massachusetts, as in many states, face challenging state laws for distributing and selling wine. (Below)

Even so, the passion for wine is reflected in everyone involved in the business across the United States, whether owner, winemaker, field or cellar worker, vineyard manager, college instructor, or chef. (Left; see page 224)

fewer tensions and more tolerance —BENJAMIN FRANKLIN

OREGON: A sign welcomes visitors to a winery tasting room in Carlton. Wineries are becoming destinations for visitors wanting to sample wines in beautiful places. (Below)

PENNSYLVANIA: Ripe Concord grapes lure Tucker and Hunter Rodland and Cutter Hall to their family vineyard in Harborcreek east of Erie. (Facing page)

Wine is art. It's culture. It's the essence

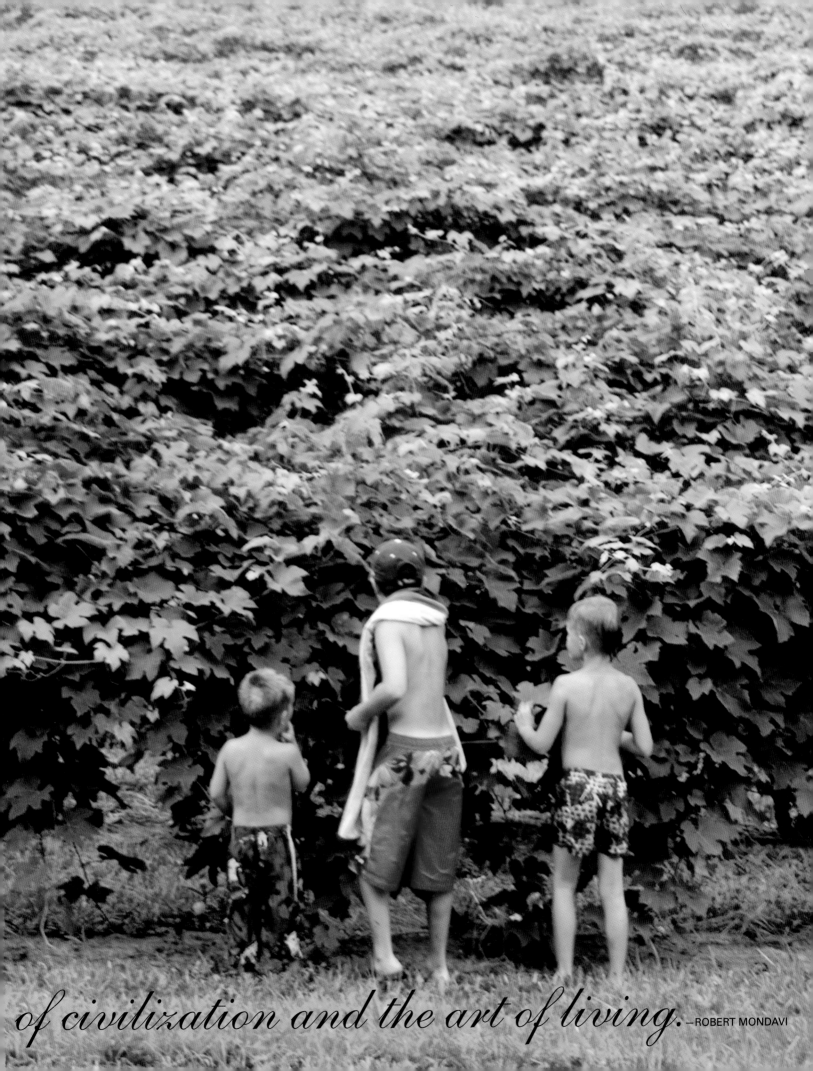

of civilization and the art of living. —ROBERT MONDAVI

CALIFORNIA: Century-old casks line the Cask Room at Merryvale Vineyards in St. Helena where a wedding party enjoys a memorable Napa Valley evening.

One of life's greatest pleasures is to share a glass of

wine with friends at the end of the day. —MICHAEL CREEDMAN

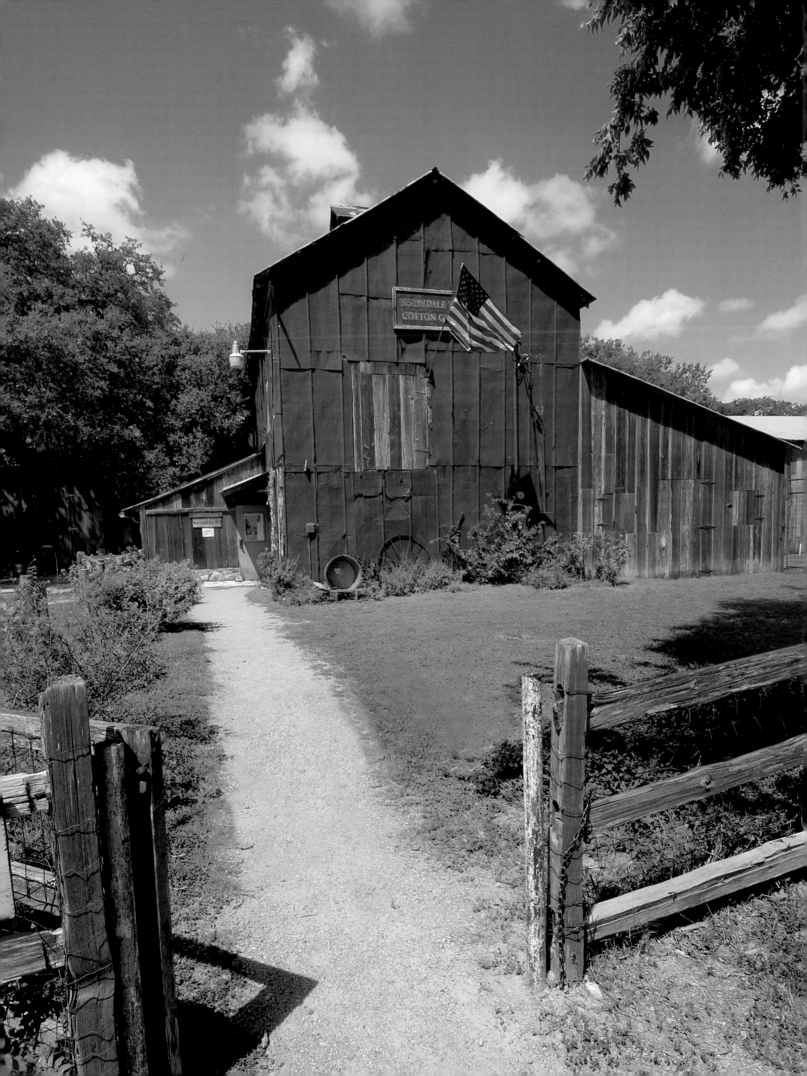

INTRODUCTION

In the spring of 2005, we were sitting on our porch in Napa Valley overlooking a sea of vineyards on the verge of "bud break." It was late afternoon, the sun was about to sink behind Spring Mountain, and the bottle of wine friends had brought us from another state was being thoroughly enjoyed. The wine got us to talking about the amazing fact that wine was being made in every state of the country—from Alaska to Hawaii, Montana to Georgia and all the states in between. There was a wine revolution going on out there in our country and few people seemed to know about it.

Soon we'd packed up our Ford Explorer and were on the road for what would be the ultimate road trip and the first of many travels over the next two years across America. It wasn't the first time we had worked while traveling. Most of Chuck's life has been spent looking through the viewfinder of a camera, capturing images that appeared in *National Geographic* magazine as well as in seven books celebrating wine and wine regions around the world and Daphne had been around the world twice over as a member of the United Nations press office. Now, we were on the road again, Chuck in full throttle on his eighth photography book on wine and Daphne by his side reporting the story.

Our journey would take us more than 80,000 miles by air and car as we traveled the back roads of the United States, weaving our way through American wine country in such varied and unexpected places as the hollows of Tennessee, the Blue Ridge mountains of North Carolina, the Missouri River Valley, Texas Hill Country, Hawaii's volcanic slopes, a suburban shopping center in Alaska, New York's Finger Lakes, the Florida beaches, and a Montana Indian reservation.

The industry once associated mostly with California has taken root across the country, with Americans planting vineyards and opening tasting rooms in far-flung locations, housing wineries in backyards, mansions, and mobile trailers, in former cotton gins, mills, waterworks stations, churches,

TEXAS: A restored 1885 cotton gin in the Texas Hill Country serves as home to Sister Creek Vineyards. (Left) As more wineries spring up across the country, existing buildings are transformed for winemaking and wine tasting. Today, wineries appear in former schools, churches, tobacco, dairy and potato barns, fire stations, textile and grain mills, and even a bordello.

CALIFORNIA: The entrance to Viansa Winery south of Sonoma suggests a courtyard in Tuscany. The tile-roofed winery sits on a hilltop surrounded by olive trees and vineyards. (Above)

Summerside
VINEYARDS

2005 Route 66 Red
Craig County, Oklahoma

schools, stables, fire stations, convents, and converted potato, dairy and tobacco barns. There were no rules for America's new pioneers!

We visited many of the almost 5,000 American wineries and found that they came in all sizes. There were basement wineries that produced enough for the winemaker and his friends, small family operations that made up to 3,000 cases, and corporate wineries that produced millions of cases annually. This new breed of vintners was making wine not only from wine grapes, but from blueberries, rhubarb, plums, apple, apricots, oranges, strawberries, honey, garlic, pineapple and more.

Today, winegrowers and winemakers of America are as varied as the wines they make. They include teachers, firemen, doctors, pilots, judges, artists, lawyers and third generation farmers who've transformed their soybean, corn and cotton fields and cattle ranches into vineyards. What they all share is the desire to work their land to create something that is far more than a product, a liquid as old as the Bible, imbued with magic and mystique.

We found these Americans to be an adventuresome, fun-loving and hearty breed who are passionate about what they do and who generally are not in it for the financial gain—though wine grapes probably represent the fastest growth segment in agriculture today due to the prices they fetch.

In reality, those who grow wine grapes must love what they do, for it's not an easy life watching over their vineyards 24/7, protecting them from insects, pests and the vicissitudes of weather. Still, it's a life many Americans are embracing with gusto as they take up the charge of their ancestors and return to working the land and putting down roots—literally.

OKLAHOMA: Summerside Vineyards and Winery sells its wine from a former truck garage on Route 66 at the Oklahoma turnpike entrance in Venita. The wine label is named after the famous highway which passes through the town. (Above)

TEXAS: A tree-lined entrance welcomes visitors to Fall Creek Vineyards in the Texas Hill Country west of Austin. Owners Susan and Ed Auler discovered in the 1970s that sandy loam soil, warm days, and cool breezes off nearby Lake Buchanan provided the perfect microclimate for growing premium wine grapes. (Top right)

WINERIES U.S.A.: The map illustrates the number of wineries in every state. The figures on the map can be misleading because, in many cases, individuals or companies are granted licenses to produce and sell wine, but don't own wineries open to the public. (Bottom right)

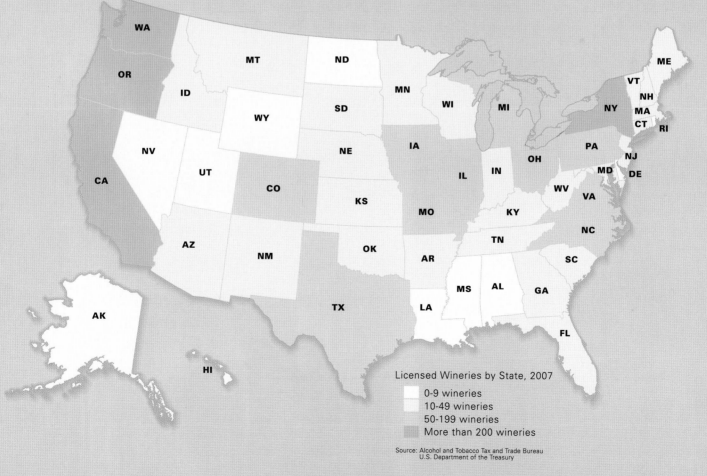

Licensed Wineries by State, 2007

0-9 wineries
10-49 wineries
50-199 wineries
More than 200 wineries

Source: Alcohol and Tobacco Tax and Trade Bureau
U.S. Department of the Treasury

19

While America's first wine grapes may have been planted in Florida in 1524 and Native Americans made wine from local grapes such as the Norton, Catawba and Muscadine varieties still used today, the recent resurgence of winemaking in America began in the 1960s. Perhaps the best known vintner of that era is Napa Valley's Robert Mondavi, who built the first winery in our country since Prohibition. Others soon followed, contributing to today's wine revolution, which has created a cultural sea change in America's lifestyle, boosted local economies, spurred leisure travel, and expanded the scope of America's palate.

In recent years, improvements in regional winemaking, increased media coverage, consumer-friendly court decisions on interstate shipping and higher quality wine at lower prices have all encouraged new wine appreciation. Universities have taken note of the growing interest in wine, offering courses in winemaking and grape growing, placing more professionals in the field.

Everywhere we went, winegrowers and winemakers graciously opened their winery doors to us, shared their wines, their lives, and their passion about the work they've chosen. They showed great regional pride and local knowledge of their craft, which is as much an art as it is a science.

We hope our visual journey into America's wine country inspires you to venture out and experience first-hand the winemaking and wine growing that exists in your own backyards. Explore, make new discoveries, drink in the romance of our country's growing love affair with wine that's revolutionizing the lifestyle in every state in the nation. America is making wine like crazy and Americans are loving every drop of it!

—Charles O'Rear and Daphne Larkin

VIRGINIA: Photographer Charles O'Rear and writer Daphne Larkin pause during a visit to the site of Thomas Jefferson's original vineyard east of Charlottesville.

WINE LABELS U.S.A.: American winemakers are creating colorful and unusual wine labels that range from eloquent to evocative to witty, such as those on the next few pages. A wine label communicates many things, including the grape variety, the region where the grapes were grown, the vintage year, and marketing messages. Sometimes serving suggestions are provided for the wine such as pairing it with beef, chicken and fish or, as one Arizona winemaker recommends, with scorpion, tarantula and rattlesnake meat.

"Where the grapes can suffer"

ALEXIS BAILLY VINEYARD

2003
MINNESOTA
SEYVAL BLANC

White Table Wine

Produced & bottled by Alexis Bailly Vineyard Inc. Hastings, MN 651.437.1413
www.abvwines.com Alcohol 11.5% by volume.

Winterport Winery

BLUEBERRY WINE

Table Wine

LIVE OAK WINE

IRVIN-HOUSE VINEYARDS

LIVE OAK RESERVE
RED MUSCADINE WINE
CHARLESTON COUNTY, SOUTH CAROLINA

ALCOHOL 12% BY VOLUME SERVE CHILLED

SNOW FARM
WINERY

Snow White
White Table Wine

*A playful blend
of white grapes to
sweeten your heart.*

Tess Lebowitz!

Produced and bottled by Snow Farm Winery, LLC, South Hero, VT
Table Wine, Contains sulfites, 750 milliliters

GOVERNMENT WARNING: (1) ACCORDING TO THE SURGEON GENERAL, WOMEN SHOULD NOT DRINK ALCOHOLIC BEVERAGES DURING PREGNANCY BECAUSE OF THE RISK OF BIRTH DEFECTS. (2) CONSUMPTION OF ALCOHOLIC BEVERAGES IMPAIRS YOUR ABILITY TO DRIVE A CAR OR OPERATE MACHINERY, AND MAY CAUSE HEALTH PROBLEMS.

Hálfsætt Traditional Mead
Piscassic Pond

Honey Wine

PRODUCED AND BOTTLED BY PISCASSIC POND WINERY L.L.C. NEWFIELDS, NH

Jefferson
V I N E Y A R D S™

2003

MONTICELLO

MERLOT

ALC. 12.5% BY VOL.

Bryant
vineyard

DIXIE GOLD
MUSCADINE
ALABAMA
SWEET TABLE WINE
GROWN, PRODUCED AND BOTTLED BY
BRYANT VINEYARD, TALLADEGA, ALABAMA
BW-AL-4 CONTAINS SULFITES

Wm. Zimmerman

OLIVER
Vineyards & Winery

BLACKBERRY
WINE

WOLLERSHEIM WINERY

NapA VALLEY RED
RUTHERFORD GROVE TWO THOUSAND FOUR

BILTMORE ESTATE®
AMERICAN
WHITE ZINFANDEL
A LEGACY OF TASTE AND STYLE
SINCE 1895

Geo. W. Vanderbilt

**Strikers'
Premium Winery**

Cynthiana
Tennessee
Table Wine Alc 12.4% by Vol 750 ml

Established
1996

Domaine Reserve
Lake Wisconsin Viticultural Area
Dry Red Wine
2005

alcohol 13.5% by volume

GROWN, PRODUCED & BOTTLED BY
WOLLERSHEIM WINERY, INC.
PRAIRIE DU SAC, WISCONSIN

South Dakota wines since 1876.

**RedAss
RHUBARB**
95% RHUBARB &
5% RASPBERRY WINE

Prairie Berry

Uncle Erik's Midgard

Honey Mead

www.nhmead.com

PRODUCED AND BOTTLED BY PISCASSIC POND WINERY NEWFIELDS NH HONEY TABLE WINE

*Maple River
Winery*

Apple Jalapeno Pepper Wine

Alc. 10% by vol. 750 ml

▶GUY
DREW
VINEYARDS

2005
VIOGNIER
MONTEZUMA COUNTY
COLORADO
ALC. 13.5% BY VOL.

MOTOR 2006

KENTUCKY DERBY

2006 Derby Artist

CABERNET SAUVIGNON
AMERICAN
750 ML
ALC. 13.9% BY VOL.

EQUUS RUN VINEYARDS

Four Sisters Winery

Seyval Blanc 2005
American • Dry White Table Wine
Produced & Bottled by Four Sisters Winery • Belvidere, N.J.
B.W. #272 • Alcohol 11% by Volume

21

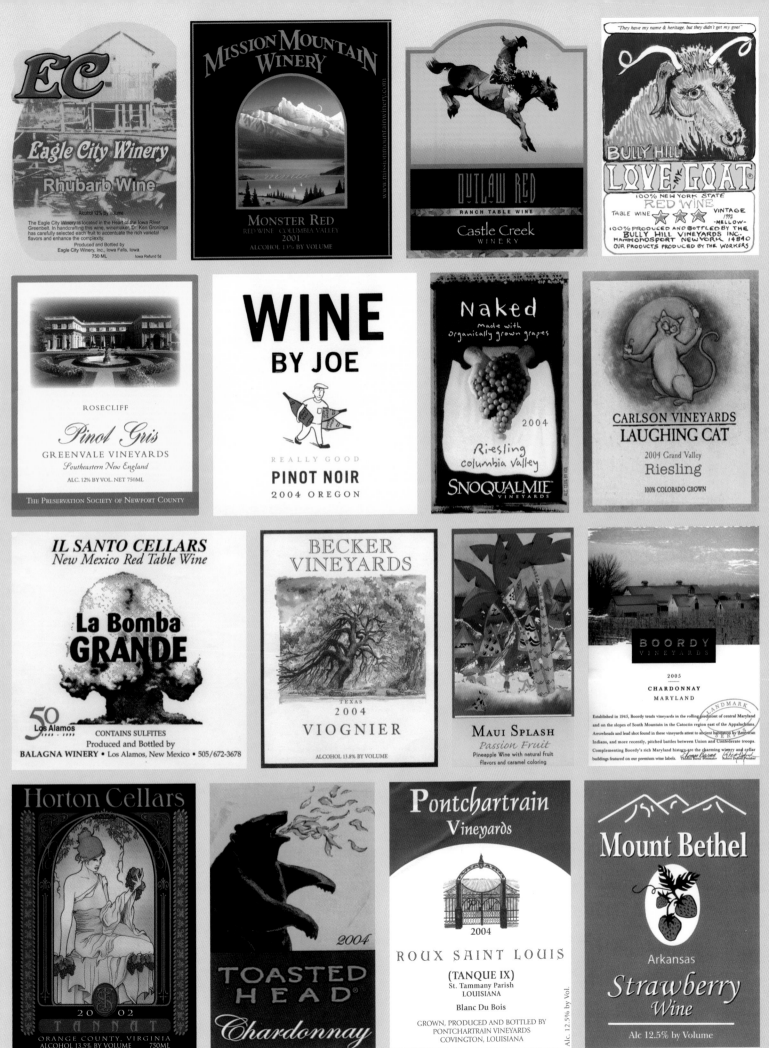

23

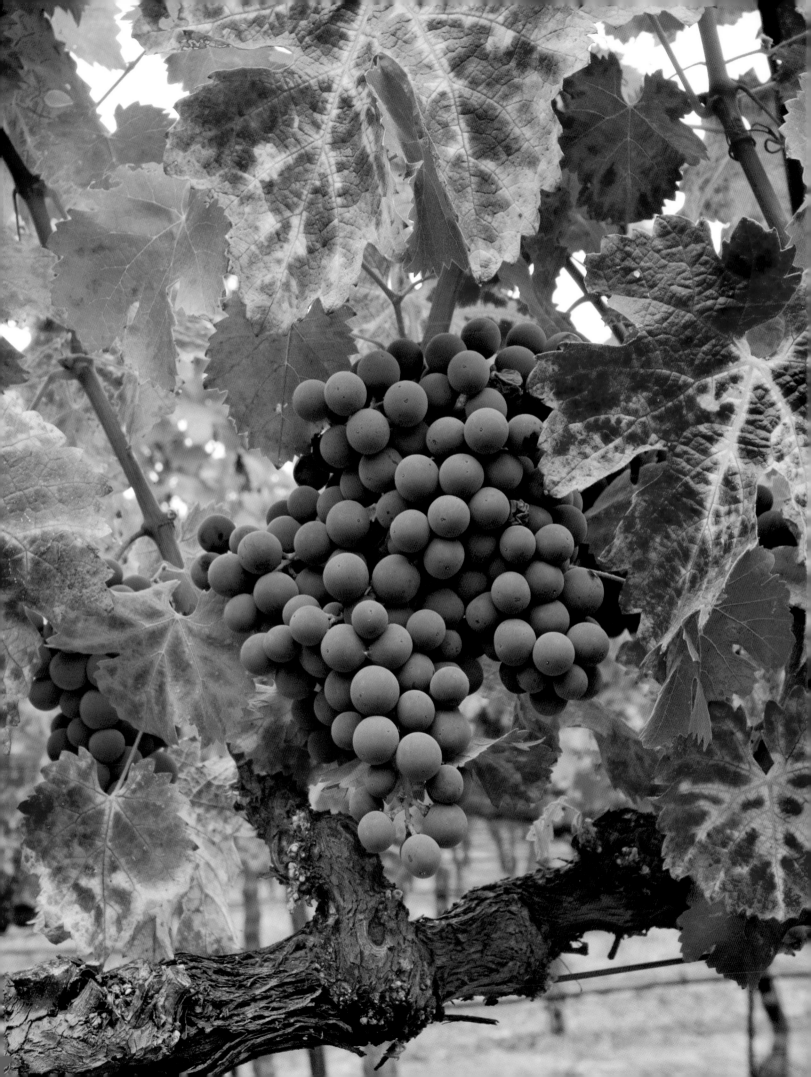

{ PLACES }

Landscapes, Vineyards, Wineries

Wine can of their wits the wise beguile, make

CALIFORNIA: Cabernet Sauvignon grapes in a Napa Valley vineyard in Oakville reach ripeness in autumn as harvest approaches. (Preceding page 24)

Mountains above Los Angeles rise behind these pickers in a scene from the 1930s. At one time more than 100 wineries existed in the Los Angeles area. Today, only two exist. (Preceding page 25)

FLORIDA: A sign to nowhere stands along a country road approaching Florida Estates Winery, which operates from a converted country home. Opened in 2001 north of Land O' Lakes, the winery is located on a 3,600-acre working plantation. (Above)

CALIFORNIA: An icon on a weathervane tells visitors they have reached Wolff Vineyards south of San Luis Obispo in the state's central coast area. The region became popular for winemaking over the last 30 years as temperatures and soils proved conducive for growing wine grapes. (Facing page)

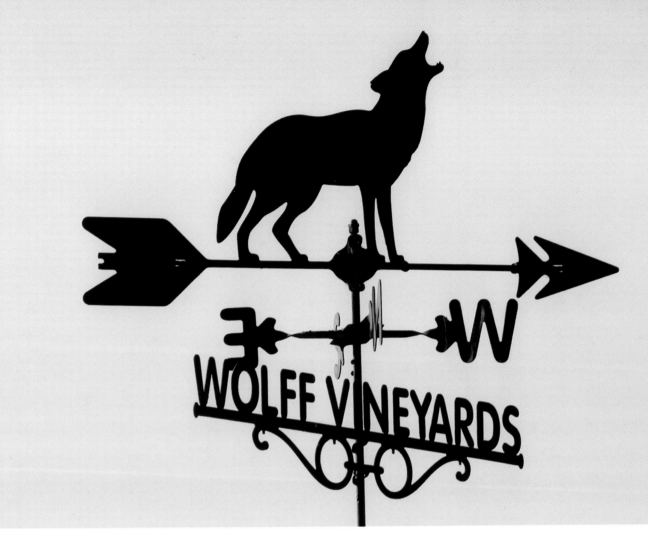

the sage frolic and the serious smile! —HOMER

{ The Muscadine grape is used in Florida to make more than 1½ million bottles of wine annually. }

OHIO: Signs point visitors to many wineries found in the Lake Erie region in the state's northeast corner. Ohio winemaking goes back 200 years and by 1860 the state led the nation in the production of wine. Today, this area close to the Grand River boasts the state's most wineries.

BUCCIA

BISCOTT

4.

5.

LAKEHOUSE 21

OLD FIREHOUSE 21

LAURELLO 22

OLD MILL 22

HARPERSFIELD 23

FERRANTE 24

SOUTH RIVER 25

DeBONNE 29

VIRANT 30

CLAIRE'S 30

MAPLE RIDGE 35

St. JOSEPH 40

DeLUCA 47

CALIFORNIA: The symmetry found in vineyards across America creates beautiful scenery for those on the ground or in the air. Ballooning in Napa Valley has been a favorite pastime for wine lovers for over 30 years. Today the valley is the most traveled balloon corridor in the country.

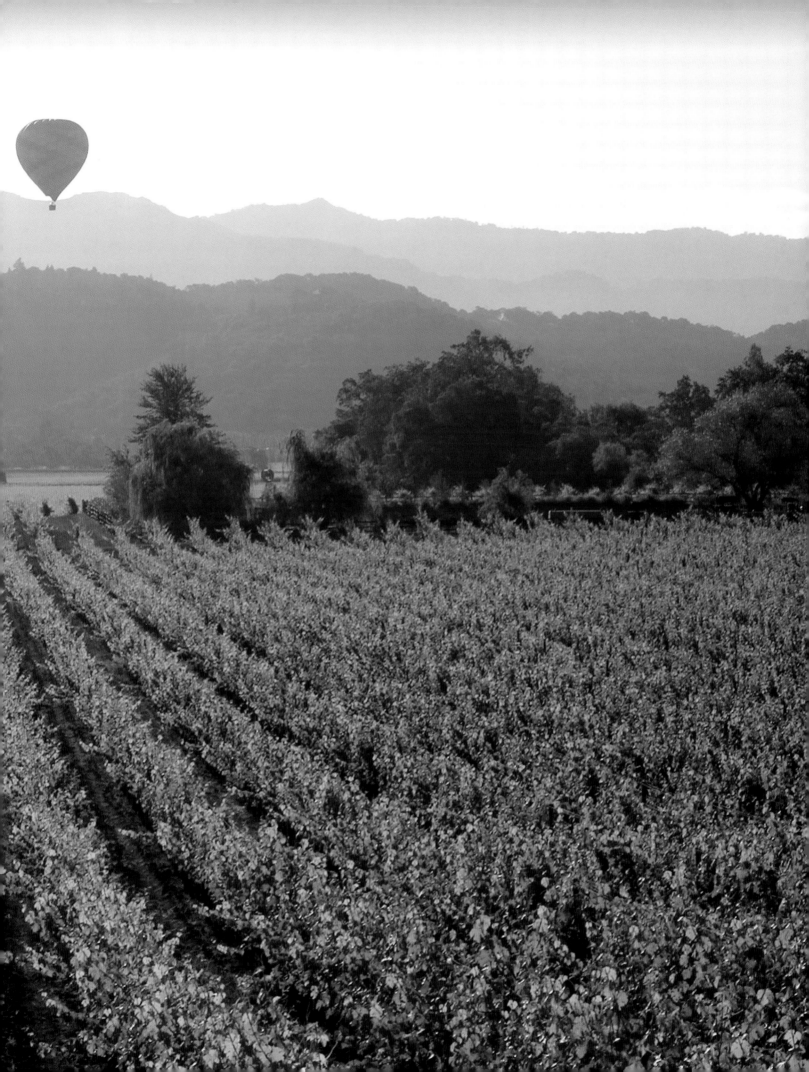

NEW JERSEY: Modern stainless steel fermenting tanks stand behind Alba Vineyard's winery near Milford. (Below) The tanks present a contrast to the 200-year-old former dairy barn which serves as the winery and tasting room.

NEW MEXICO: Summer storm clouds gather over the entrance to Balagna Winery near Los Alamos. Owner John Balagna opened his winery after a long career as a nuclear chemist at the Los Alamos National Laboratory famed for its atomic research. One of his wine labels, La Bomba Grande, features the mushroom cloud visible after an atomic explosion. (Facing page)

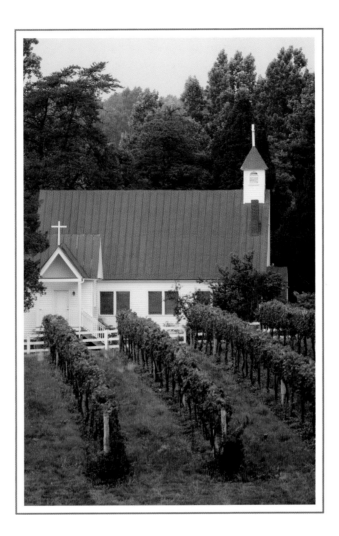

Thomas Jefferson, who no doubt penned the Declaration of Independence with a glass of fine wine at hand, can justifiably be called America's first wine connoisseur. —APPELLATIONAMERICA.COM

NEW MEXICO: A maze of colors, shapes and wines cover a table at the Toast of Taos wine judging at the Taos Country Club. Wines from five southwestern states are tasted at the charity event sponsored by Holy Cross Hospital Foundation. Regional pride, need for recognition, and publicity prompt wineries to enroll in competitions. (Left)

VIRGINIA: The land on which Thomas Jefferson grew his first grapes in 1774 is part of nearby Jefferson Vineyards, which considers the area to be the "birthplace of American wine." Merlot grapes grow in the shadow of 120-year-old St. Luke's Episcopal Church outside of Charlottesville. (Above)

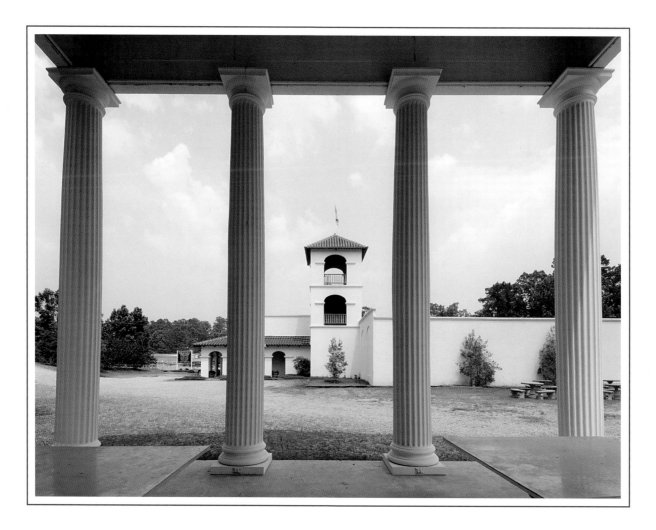

More than 20 million people visit American wineries annually. After France and Italy, America is the third largest wine-consuming nation in the world.

LOUISIANA: Greek columns support a pavilion used for private events, framing the Spanish style architecture of Feliciana Cellars in Jackson. Most wines made here are produced from the native Southern Muscadine, a hearty grape that thrives in the heat and humidity of the South. The winery opened in 1994, soon after laws allowed wineries to operate in the state. (Above)

MICHIGAN: Amish craftsmen built Round Barn Winery near Baroda as a banquet and wedding facility. Emphasizing the country theme, wagon wheels from early years decorate the lawn. The winery attracts visitors from the Chicago area an hour away. (Right)

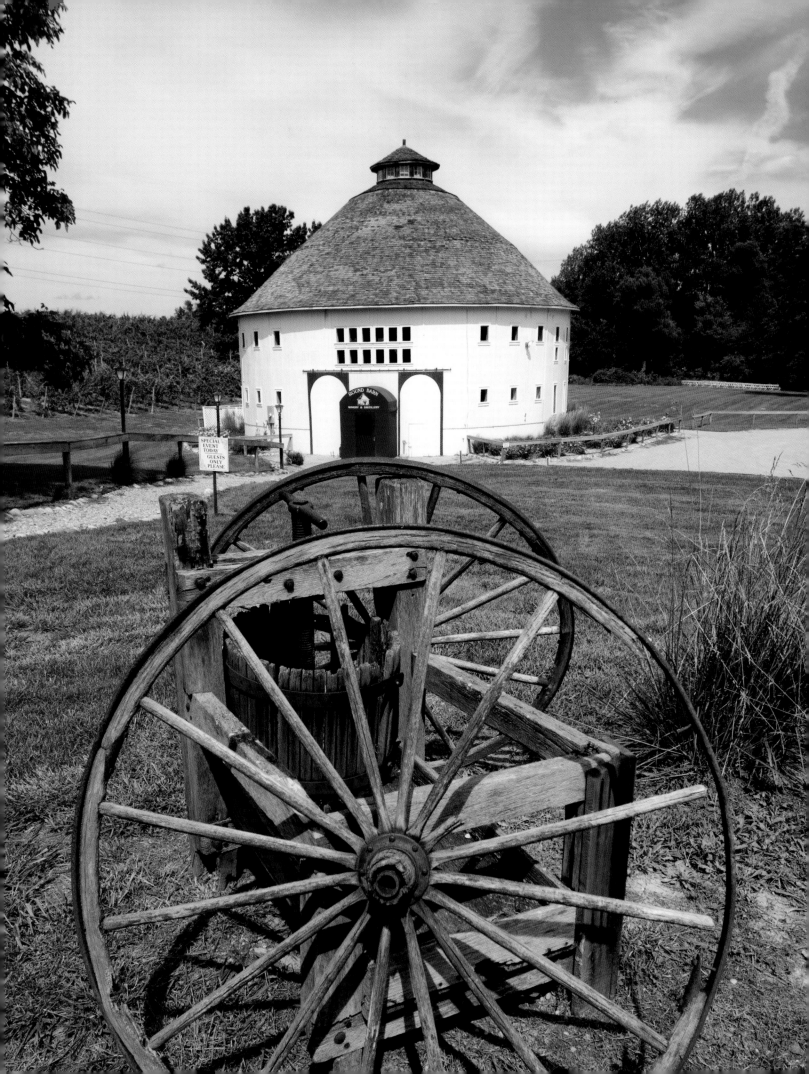

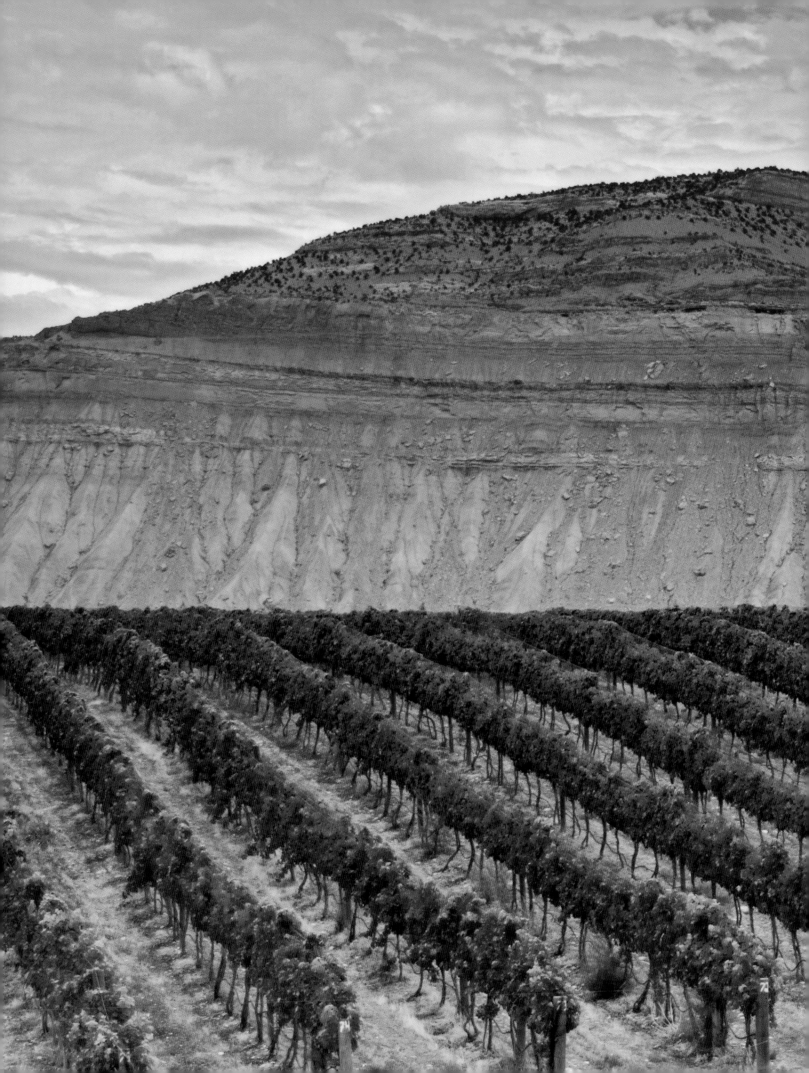

COLORADO: The Rocky Mountains of Colorado provide America with majestic scenery and a place where water begins its flow toward different oceans. The western slopes of the Rockies in the Grand Junction area are home to one of the country's most verdant agricultural regions. Peaches were planted here a century ago while more recently wine grapes have found a home. Mount Lincoln provides the dramatic backdrop for Grand River Vineyards.

*Winery architecture across America often expresses a sense of place
while also making a statement about the wine.*

CALIFORNIA: The architecture of Sterling Vineyards
in Napa Valley is reminiscent of a Greek monastery.
Built in 1969, it was one of the valley's first wineries
designed after Prohibition and since America's
renewed interest in wine began. (Left)

WASHINGTON: A corner of newly constructed
Desert Wind Vineyard in Prosser suggests the
Southwestern architecture of this winery in the
Columbia Valley growing region of eastern
Washington. (Above)

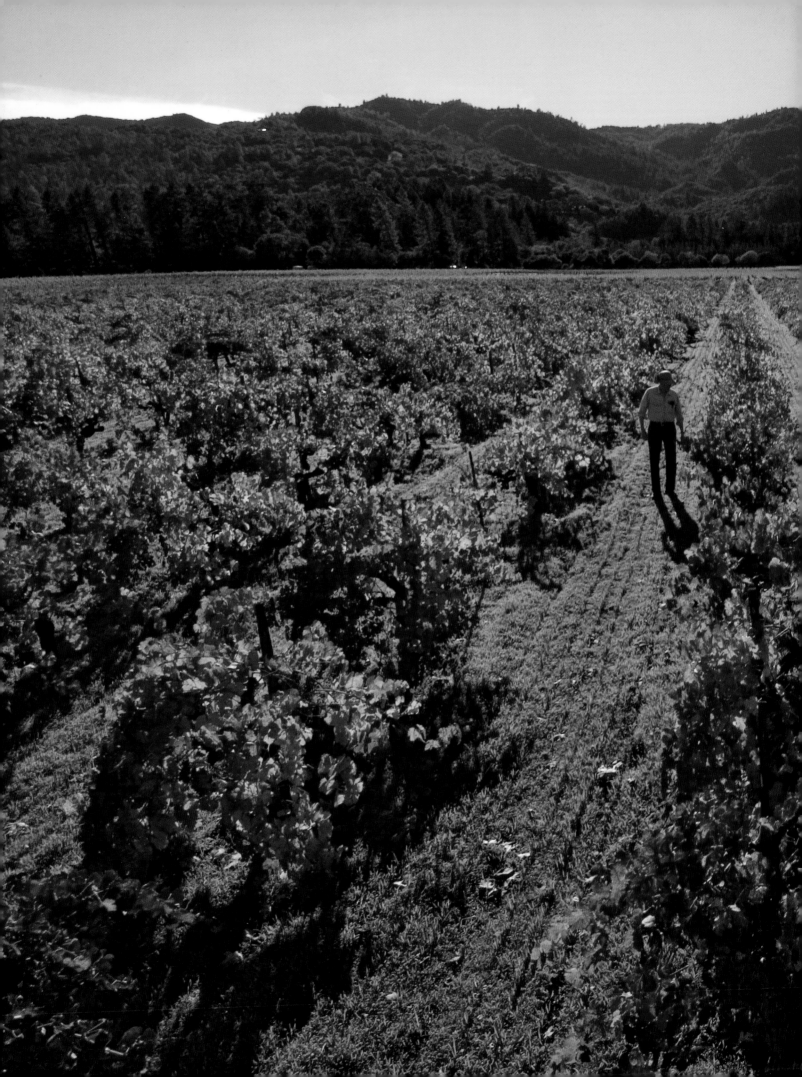

CALIFORNIA: Grape grower Alston "Otty" Hayne walks his autumn vineyard in Napa Valley. This style of "head pruned" vines is being replaced by newer growing techniques in the region to improve farming efficiency. Otty grows four varieties of grapes, including these 55-year-old Petite Sirah vines.

The color of red wine is a clue to the grape from which it came. It can range from the light red of Pinot Noir to the deep purple of Petite Sirah.

KENTUCKY: Cynthia Bohn hops aboard her favorite tractor at Equus Run Vineyards west of Lexington. She has taken a former tobacco and cattle farm and transformed it into vineyards, a winery, and a location for musical concerts. The tasting room is in a former garage on the property. (Top right)

MONTANA: There's no mistaking what is made in this barn near Dayton on the shores of Flathead Lake. Mission Mountain Winery owner Tom Campbell built the winery in 1984 on the Flathead Indian Reservation and now produces 16 different wines. (Bottom right)

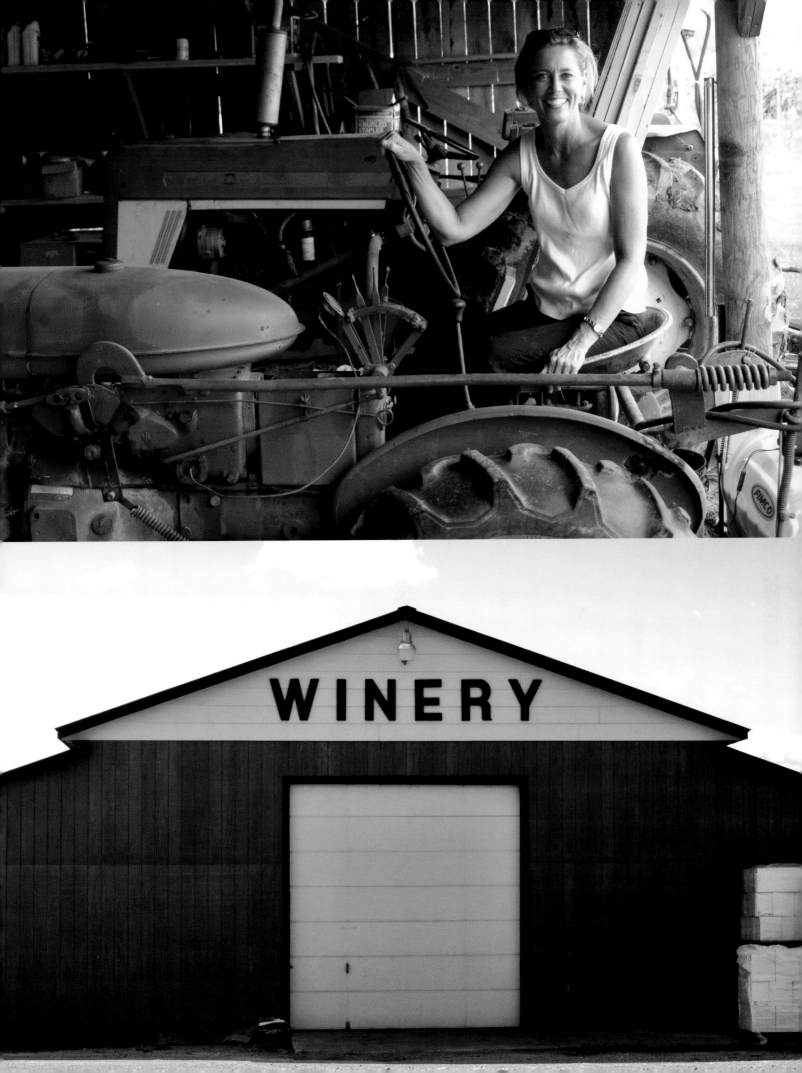

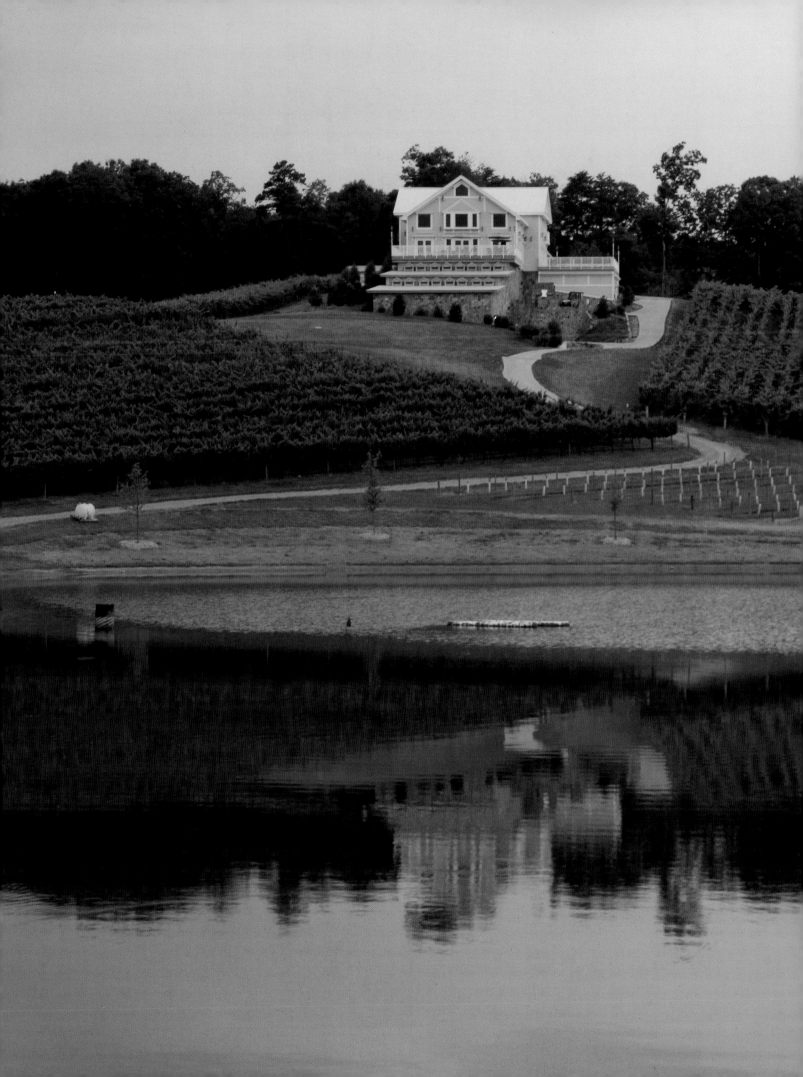

GEORGIA: The winery and vineyard of Frogtown Cellars lie on the Dahlonega Plateau in the foothills of the oldest mountain chain in the world—the Appalachian Mountains. North Georgia's red clay offers benefits for grape growers here.

W eather extremes, hot or cold, challenge grape growers from Hawaii to Minnesota.

HAWAII: Tedeschi Vineyards on the island of Maui displays a sign identifying Chardonnay, a grape that struggles to grow in the constant warmth and humidity of Hawaii's tropical climate. Tedeschi's most popular wines are made from local pineapple juice. An estimated 250,000 visitors a year make the drive to the cooler elevation on the slopes of Haleakala Mountain, probably making the winery the second most visited in America. (Top right)

MINNESOTA: Alexis Bailly Vineyard, the state's largest, buries its French hybrid Leon Millot vines under a layer of straw to protect them from winter's sub-zero temperatures. Perhaps this is why the winery's slogan is "Where the Grapes Can Suffer." Owner Nan Bailly walks a January vineyard. (Bottom right)

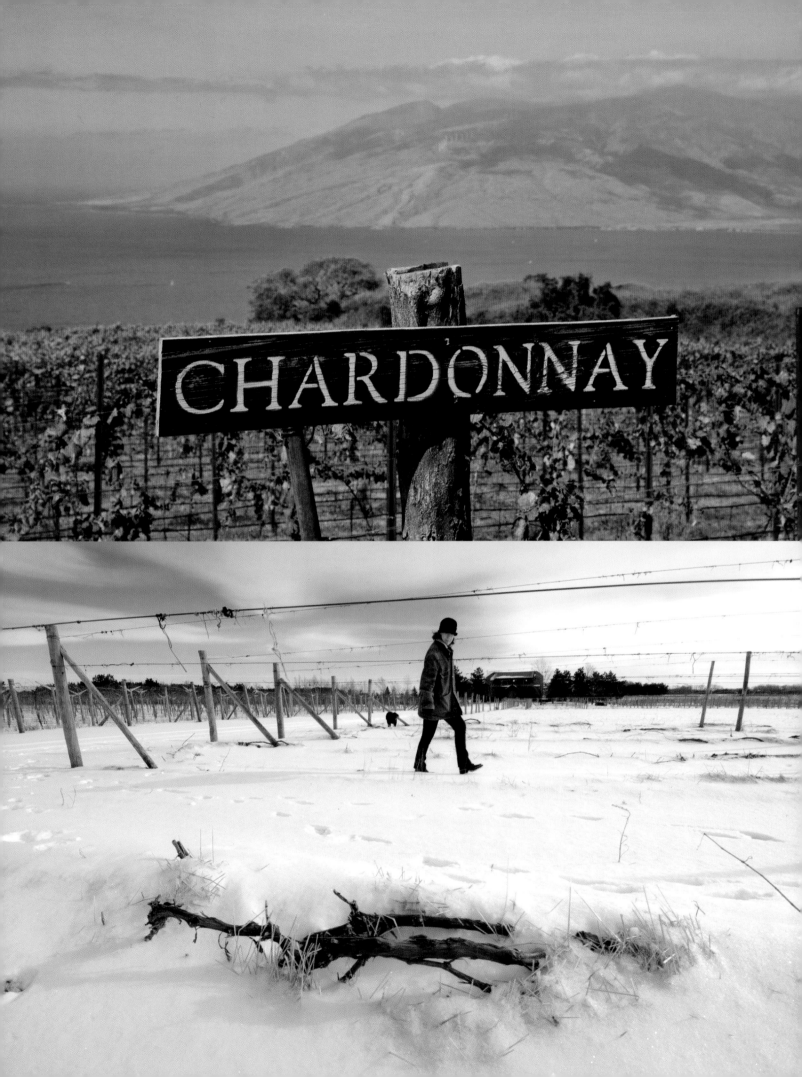

CALIFORNIA: The 2,000-foot elevation of Spring Mountain in the Napa Valley region experiences occasional snow in winter when grape vines are dormant. These vines have been left unpruned until the new growing season begins in April.

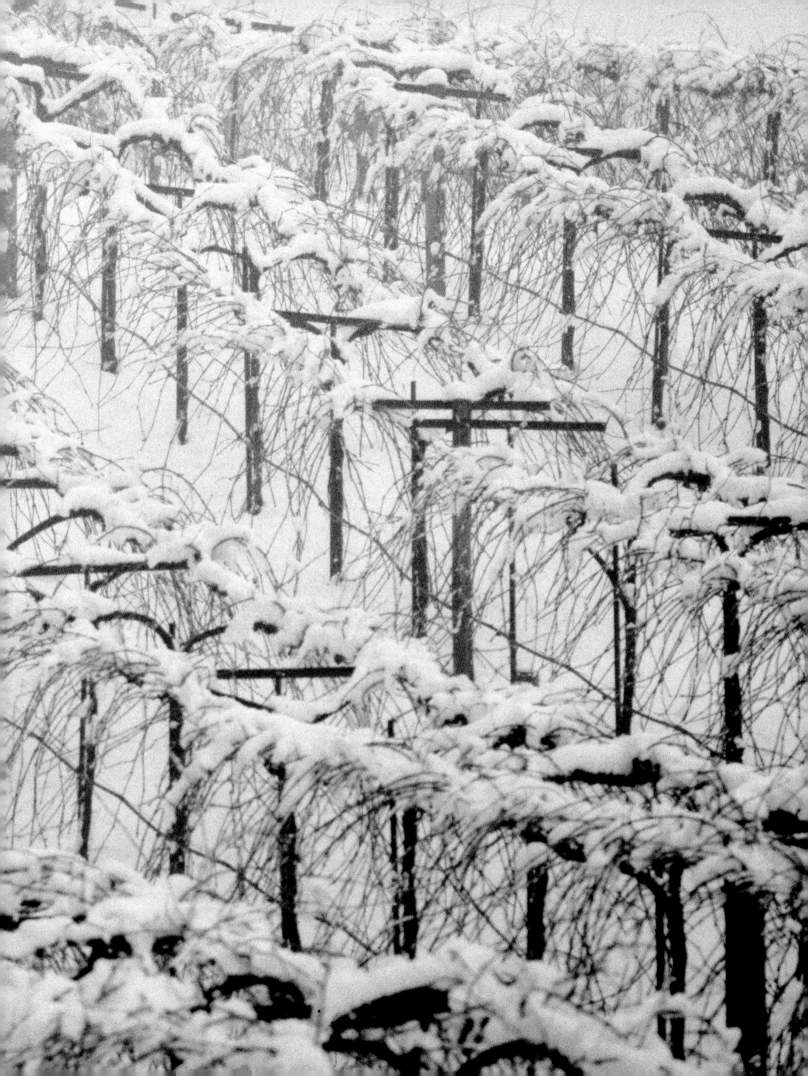

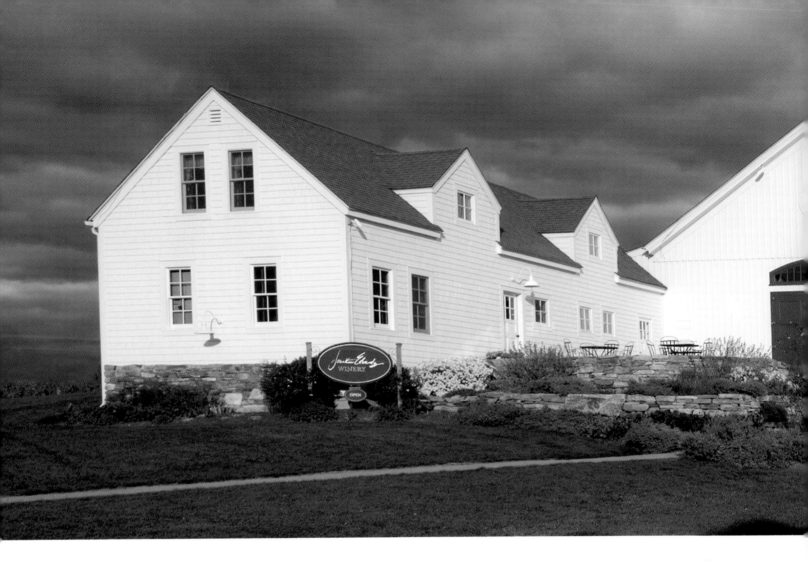

CONNECTICUT: A fall glow reflects on a former dairy barn, which is now Jonathan Edwards Winery of North Stonington. The winery produces wine from five European varieties grown on the property, as well as from grapes grown in Napa Valley. (Above)

MASSACHUSETTS: A signpost describes one of the six grape varieties grown at Cape Cod Winery in East Falmouth. Many wineries in cold climates choose vineyard locations near large bodies of water, especially the ocean, so as to benefit from milder temperatures. (Right)

Stretching from Pennsylvania to Maine, this region is as diverse as any in the country. Known for its concentration of people and large urban areas, the Northeast also lays claim to some of the country's most successful wine growing areas and world renowned wines. Here, grapes are being grown alongside New York's deep glacial Finger Lakes, in former potato farmlands on Long Island Sound, on Martha's Vineyard and Cape Cod, and in New England's vast rolling hills. Lake Erie's south shore has bragging rights to one of the largest grape growing belts in the United States and Pennsylvania was home of the first, but now defunct, commercial winegrowing business in the country—The Pennsylvania Wine Co. begun in 1793.

New York is the second largest wine-producing state in the nation, with vineyards in nearly half of its counties. Many of the grapes grown in the northeast are native or have been bred to withstand the cold climate, and states like Maine, New Hampshire and Vermont are making wines from blueberries, cranberries, apples and even maple syrup.

In spite of the extreme weather in this part of the country, its many lakes and the Atlantic Ocean help maintain near perfect vineyard temperatures during hot summers and harsh winters. Much of the architecture of the wineries has been influenced by early American settlers whose legacy for hard work is reflected in the men and women making wine in the region today.

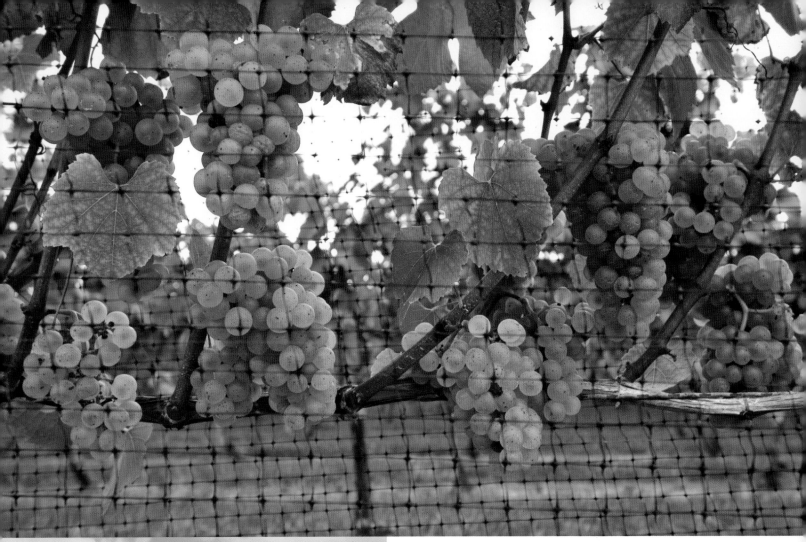

NEW YORK: Ripe Gewürztraminer grapes and yellow picking boxes make a colorful combination on Long Island's North Fork as harvest reaches its peak in October (above and right). At Lenz Winery (left and below), freshly picked Chardonnay grapes arrive from an independent grower, while deep under the winery's tasting room a bottle of sparkling wine is held up for inspection.

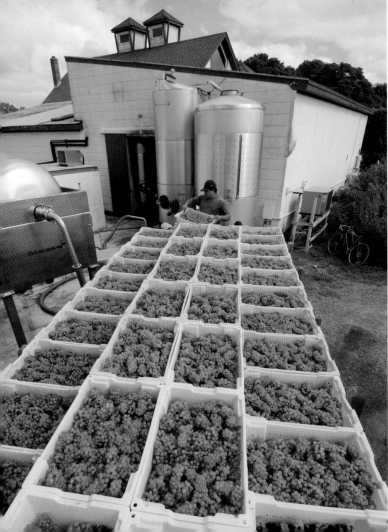

NEW YORK: Rows of tended vines on rolling hills provide a perfect backdrop for celebrations and weddings as wineries across the country become inviting destinations. The vineyards of Pellegrini Winery are home to some of the oldest vines on Long Island's North Fork.

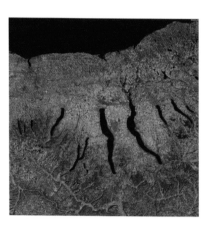

The deep glacial lakes of the Finger Lakes region provide a warming effect for grape growing, which counteracts the harsh winters. Riesling grapes thrive in this unique "terroir."

NEW YORK: From this satellite view of the Finger Lakes region it's easy to understand how the area got its name. The waters of Lake Ontario are seen at the top of the photograph. (Above)

Fall in the state's Finger Lakes district provides a memorable view of Keuka Lake (top right), while winter brings snow and ice, much to the delight of wineries wanting grapes for a sweet "late harvest" wine. By allowing grapes to ripen long enough to achieve high sugar content and to freeze before picking, winemakers create "ice wine." Tourism in the area has reached an all-time high as more than 100 wineries have been built, many of them offering tastings and providing weekend destinations for more than two million annual visitors. (Right)

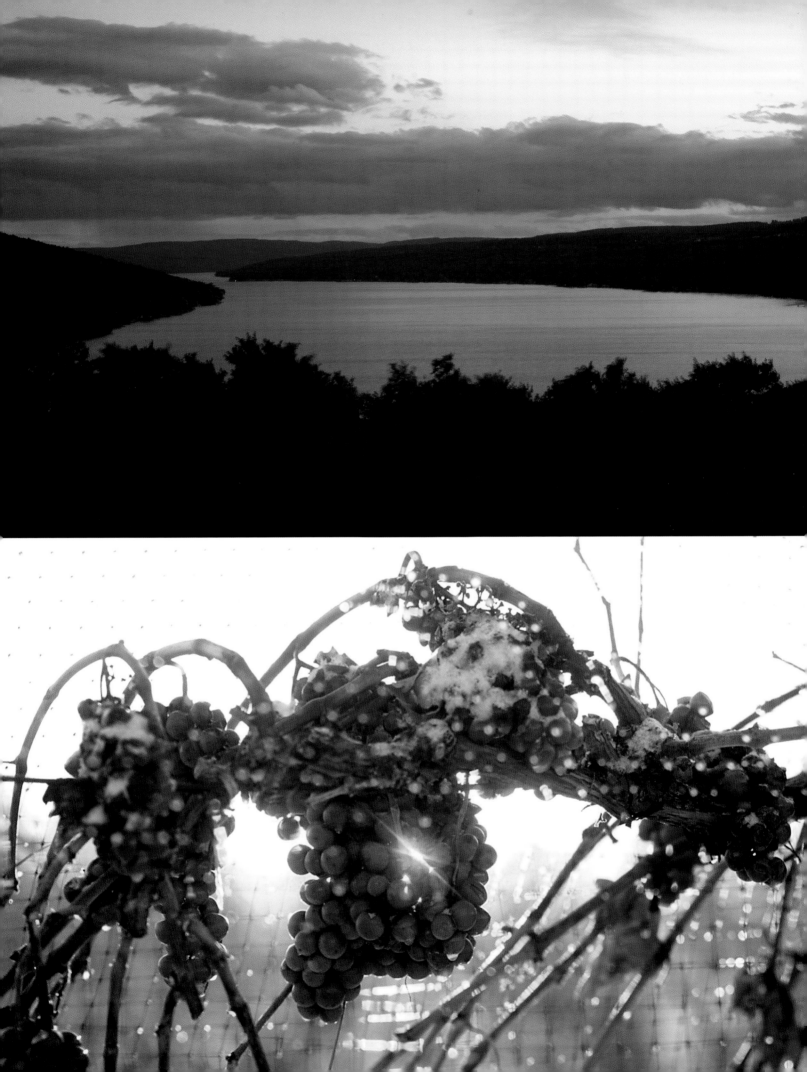

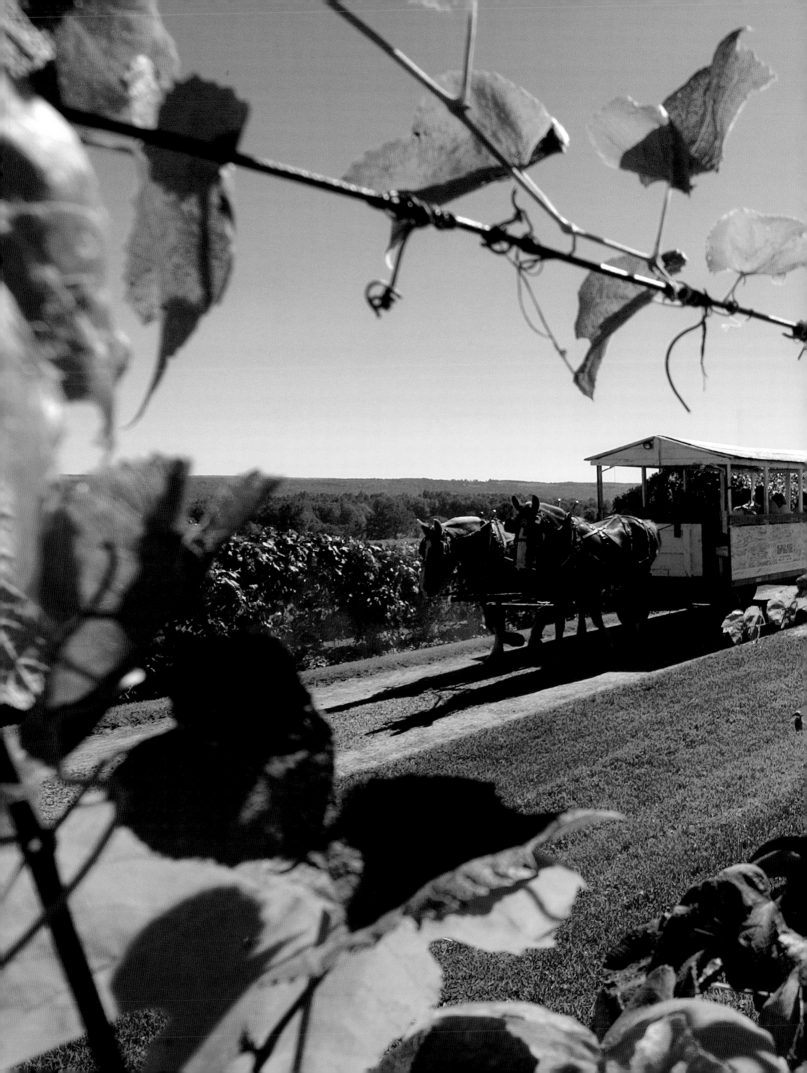

NEW ENGLAND: Traditional architecture marks wineries throughout America's Northeast. The building style, with its perfectly pitched roof and shingle exterior, reflects a 17th century tradition and protects against New England's notoriously stormy weather. A cupola stands above the tasting room of Gouveia Vineyards (top left), near Wallingford, Connecticut, while Cape Cod Winery in East Falmouth, Massachusetts sports red trim on its doors (bottom left). Chicama Vineyards (right), the first commercial winery in Massachusetts, sells wine from its tasting room on Martha's Vineyard.

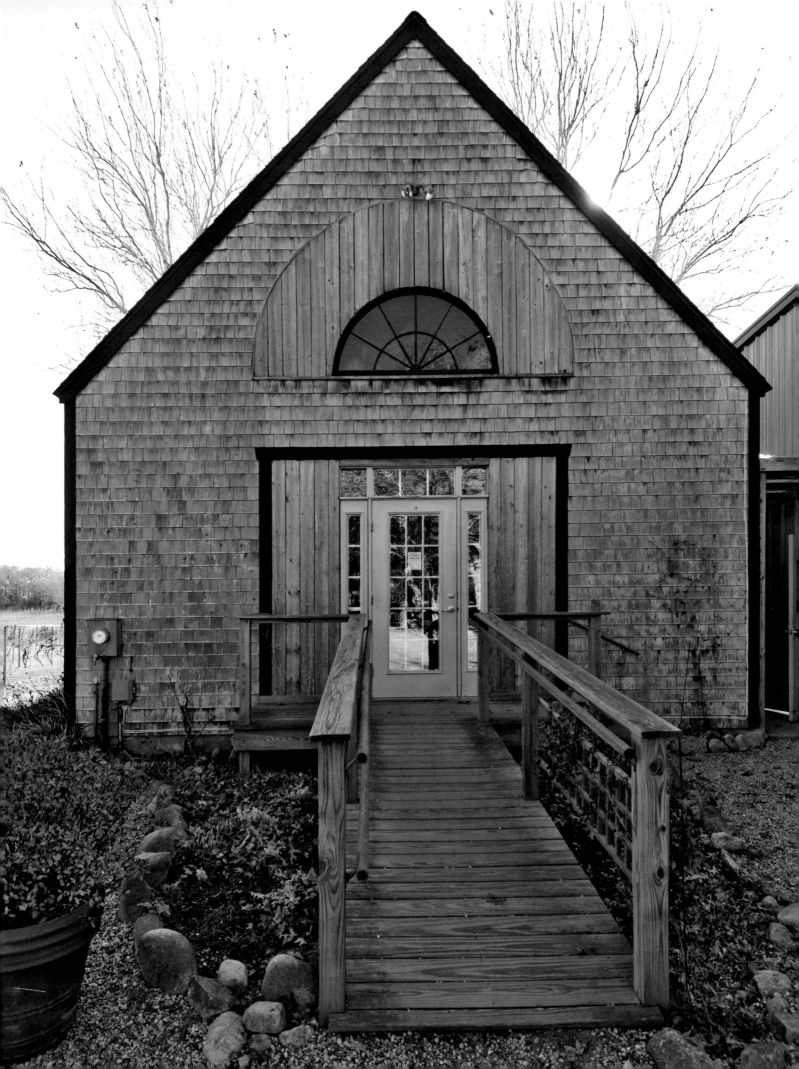

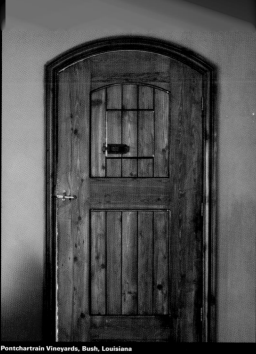

Pontchartrain Vineyards, Bush, Louisiana

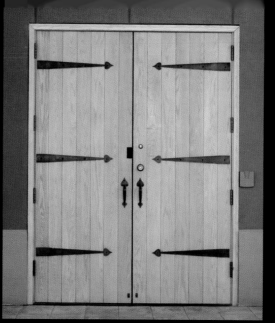

Snoqualmie Winery, Prosser, Washington

Castle Creek Winery, Moab, Utah

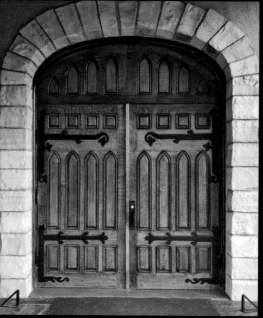

Blue Sky Vineyard, Carbondale, Illinois

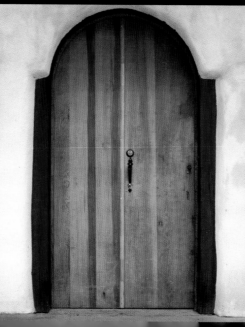

Blue Sky Vineyard, Carbondale, Illinois

WINERY DOORS U.S.A.:

A door is a gateway to mysteries inside. Wineries use their doors to welcome visitors and sometimes to make statements about

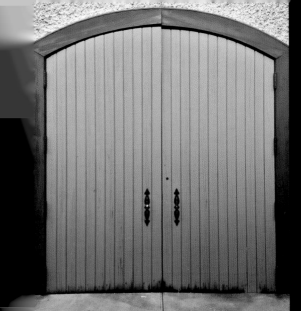

Biltmore Estate, Ashville, North Carolina

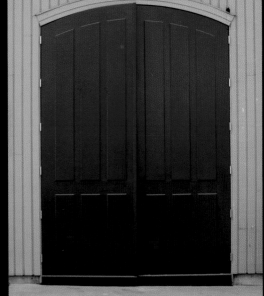

Domaine Drouhin, Dundee, Oregon

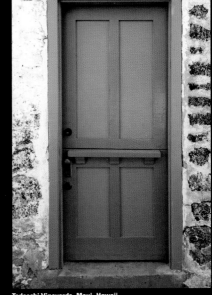

Tedeschi Vineyards, Maui, Hawaii

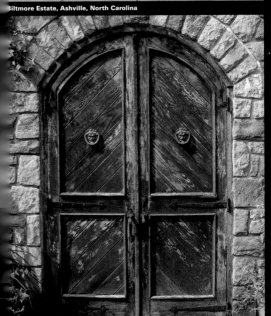

Alba Vineyard, Milford, New Jersey

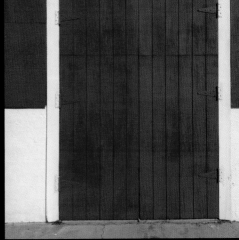

Hunt Country Vineyards, Branchport, New York

Wills Creek Winery, Duck Springs, Alabama

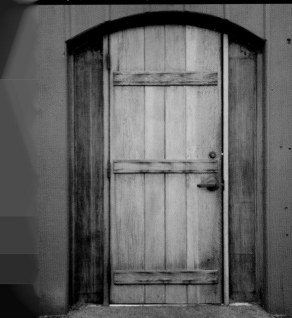

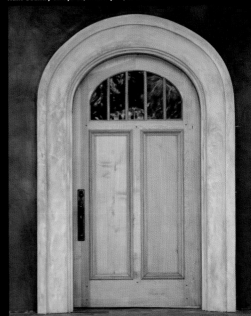

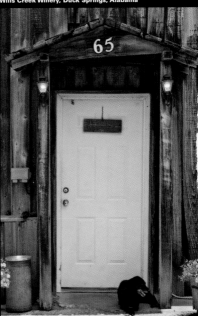

lage of Elgin Winery, Elgin, Arizona

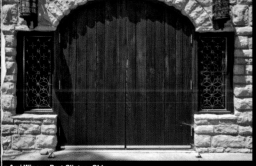

n Ami Winery, Port Clinton, Ohio

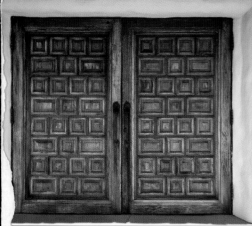

t Mondavi Winery, Oakville, California

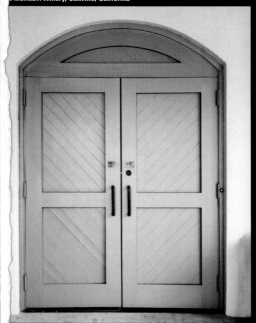

au St. Jean, Kenwood, California

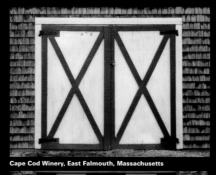

Cape Cod Winery, East Falmouth, Massachusetts

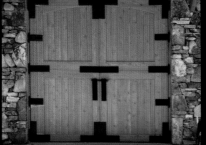

Blackstock Vineyards, Dahlonega, Georgia

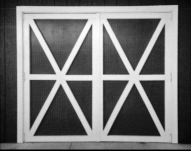

Oakencroft Winery, Charlottesville, Virginia

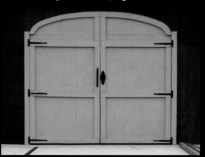

Equus Run Vineyards, Midway, Kentucky

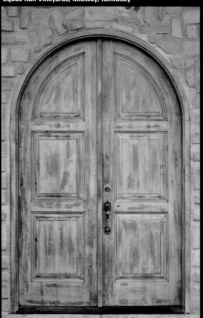

Two Rivers Winery, Grand Junction, Colorado

Trefethen Vineyards, Napa, California

Becker Vineyards, Stonewall, Texas

Jonathan Edwards Winery, North Stonington, Connecticut

Rubicon Estates, Rutherford, California

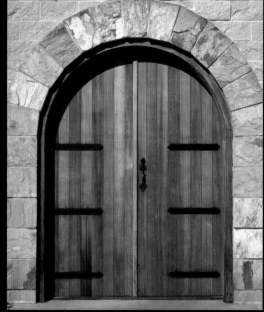

Silver Oak Cellars, Oakville, California

Boordy Vineyards, Hydes, Maryland

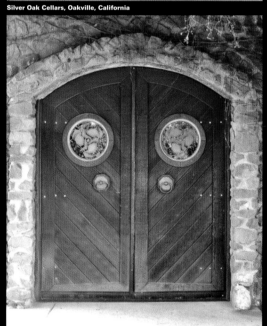

Ravenswood Winery, Sonoma, California

Wollersheim Winery, Prairie du Sac, Wisconsin

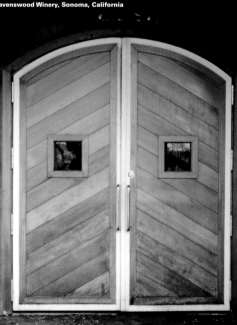

Kunde Estate Winery, Kenwood, California

Beaulieu Vineyards, Rutherford, California

winery, the owner has many design options to consider for its door: should it have windows, should it be carved, should it be arched like a church door, or should it just be functional?

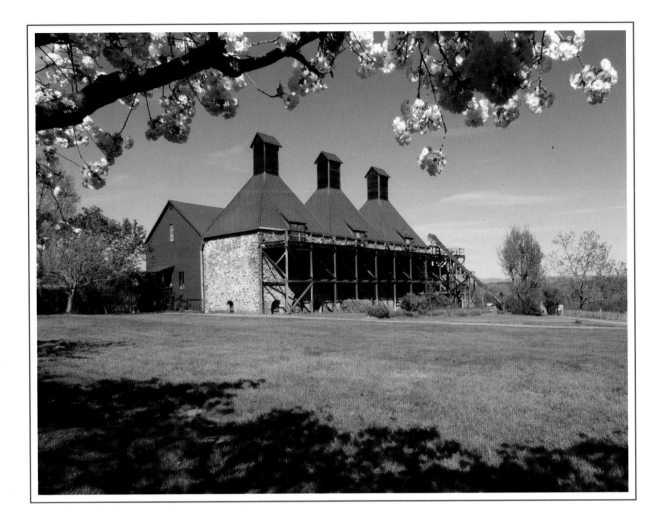

Northern California's wineries present many design styles, including mission, Victorian, farm style, European, and contemporary.

CALIFORNIA: Spring blossoms surround historic Hop Kiln Winery near Healdsburg in Sonoma County. The building was used to process hops before it became a winery in the 1950s, among the first of many opened in the area over the past 30 years. (Above)

Dusk arrives at Franciscan Oakville Estate in Napa Valley. This new tasting room resembles a mission church and was built in 2001. (Right)

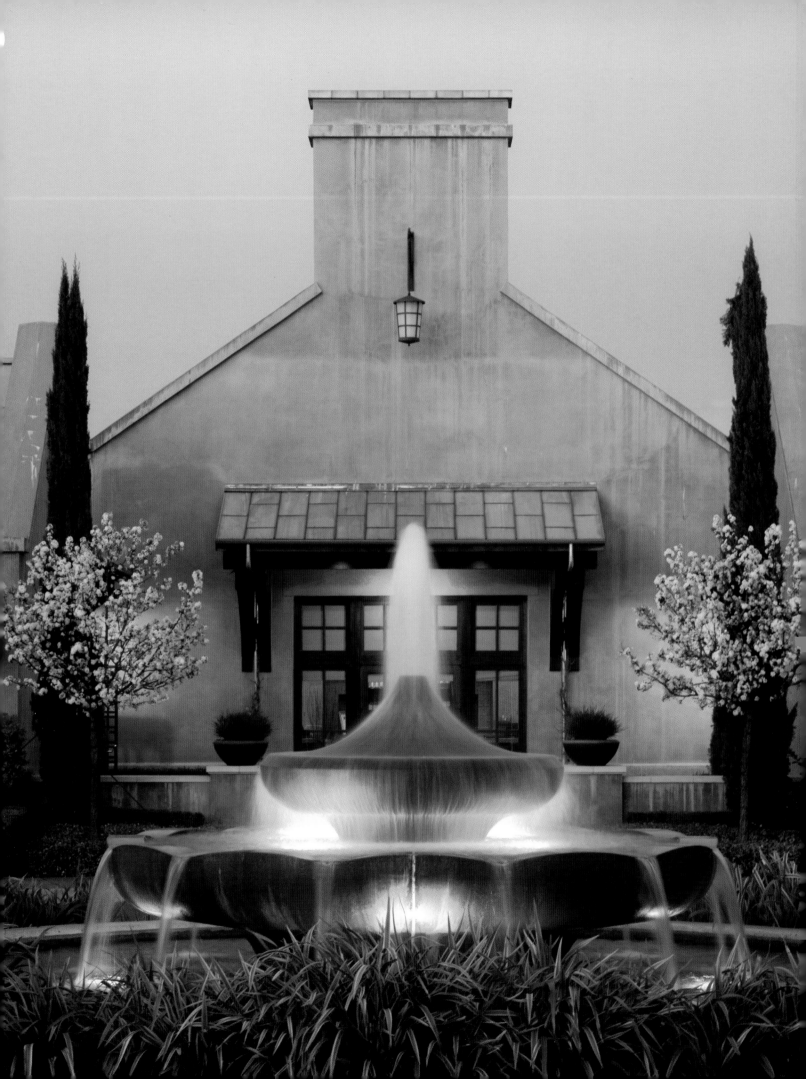

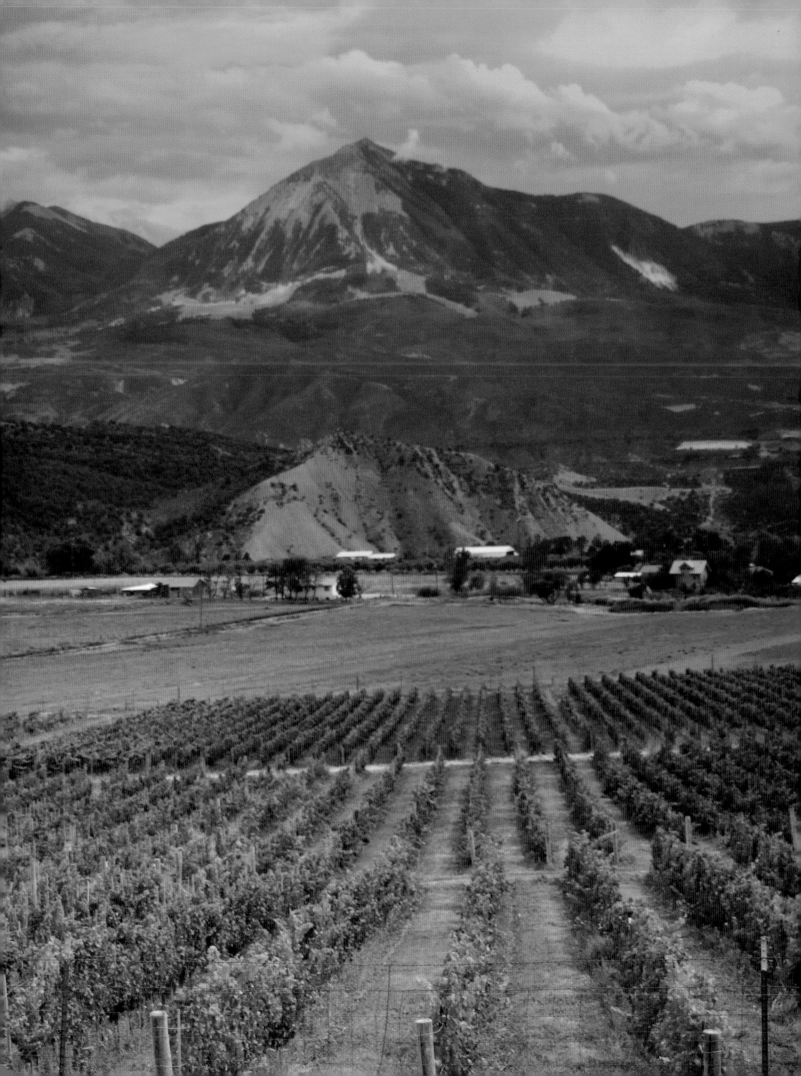

> *"Leaves are the pages in the book of a vine's autobiography revealing its heritage, health and life experience."*
>
> —LUCIE MORTON, VITICULTURIST AND AMPELOGRAPHER

COLORADO: Perhaps America's highest elevation vineyard, Terror Creek in Paonia grows Riesling and Pinot Noir grapes at 6,400 feet. The area's southern exposure contributes to quick ripening, a plus for the short growing season. In contrast to the pests faced by most wine growing regions in America, bears are one of the biggest threats to grapes growing here. The winery looks across at 11,400-foot Mount Lamborn on the western slopes of the Rocky Mountains. (Left)

OREGON: Pinot Noir grapes burst with juice days before harvest at Brick House Vineyards in the Willamette Valley. South of Portland, the region has become best known for Pinot Noir and Chardonnay wines because of the favorable climate and soils. (Above)

Acres of softball-sized basalt stones in this vineyard across the state line from Walla Walla, Washington, provide a playground for winery owner Christophe Baron and friend. Christophe, who owns Cayuse Winery and Vineyards, discovered that this ancient riverbed provides the perfect "terroir" for the Viognier, Syrah and Grenache grape varieties he grows in his 50-acre, biodynamic vineyard. He named his winery after a Native American tribe which once lived here. (Right)

With high mountains ranges, an active volcano, alpine lakes, redwood forests, arid canyons, fast flowing rivers, deep gorges, and the wild Pacific Coast, grape growing in the Pacific Northwest can be an extreme sport! Yet, the region's great variety of climates, geography and soils come together to produce grapes of superb quality and exceptional character. This unique combination of factors, including the long summer daylight hours of northern latitudes and cool nights, more than makes up for the extremes found in the region's "terroir."

In Oregon's Willamette Valley, for example, sunlight and heat needed for grape ripening are sparse due to heavy rainfall—40 inches of rain a year is not uncommon. Washington has its own dramatic temperature fluctuations to cope with, often experiencing a drop of more than 50 degrees a day in the eastern part of the state where most of the vineyards are located.

Wines being produced in the region have earned national and international recognition. Perhaps the most renowned are the Willamette Valley's Pinot Noirs while Washington is a top producer of Merlot and Cabernet.

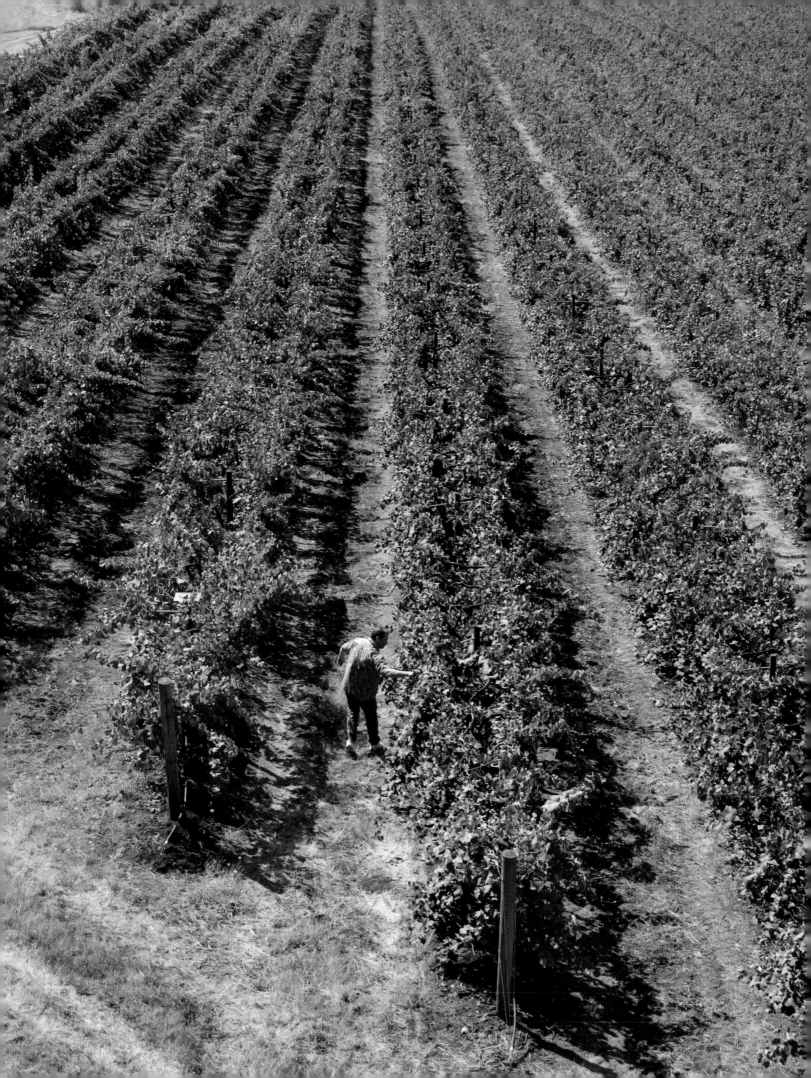

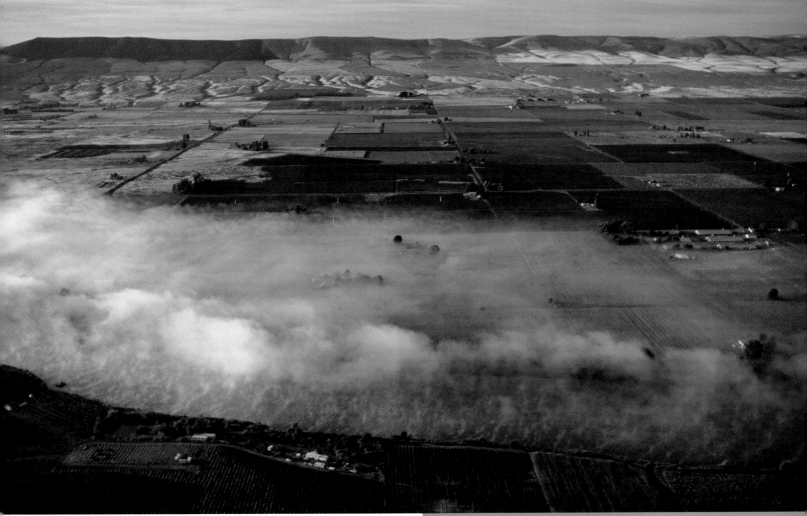

WASHINGTON: A morning fog hangs above the Yakima River near Prosser, dubbed by the city fathers as the "birthplace of the Washington wine industry." In the distance, Horse Heaven Hills forms a farming plateau which stretches 20 miles to the Columbia River and is also home to many vineyard operations. (Top) The entrance of Reininger Winery near Walla Walla beckons. (Right)

OREGON: Willamette Valley Vineyards winemaker, Forrest Klaffke, inspects his vineyard which was home to blackberry vines and plum trees when owner Jim Bernau bought the land in 1983. (Left)

Visitors in a chauffeured limousine depart the Tyrus Evan tasting room located in a converted train station in the town of Carlton southwest of Portland. (Below)

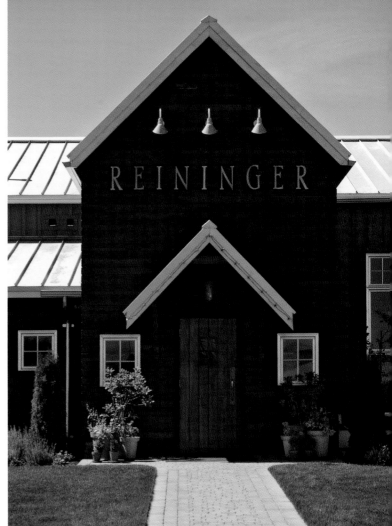

REININGER

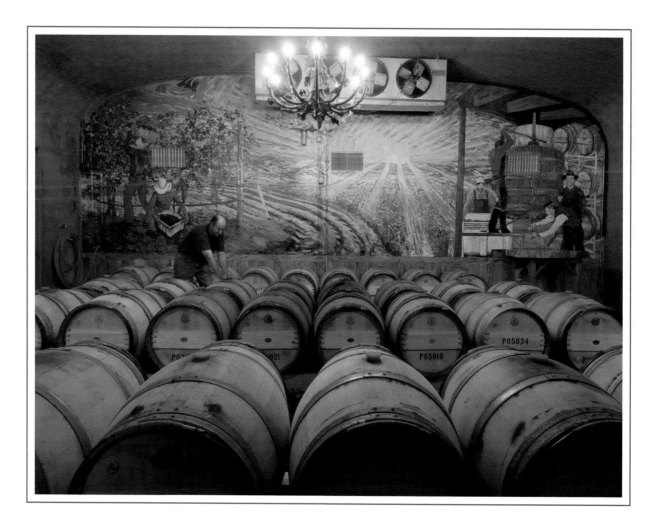

The artist's palate, whether made by man or nature,

is a wonder to behold.

WASHINGTON: With a background mural depicting vineyard and winery scenes, winemaker Jean-François Pellet inspects barrels at Pepper Bridge Winery south of Walla Walla. Wine growing has exploded in the region, with more than 60 wineries and 1,200 vineyard acres, up from six wineries and 100 acres in 1990. (Above)

OREGON: Undulating vineyards appear to swallow a farm home at Sokol Blosser winery in the Dundee Hills. The winery, which planted its first vines in 1971, was among the first to take advantage of the region's climate and soils for growing wine grapes. Today, the state has 300 wineries. (Right)

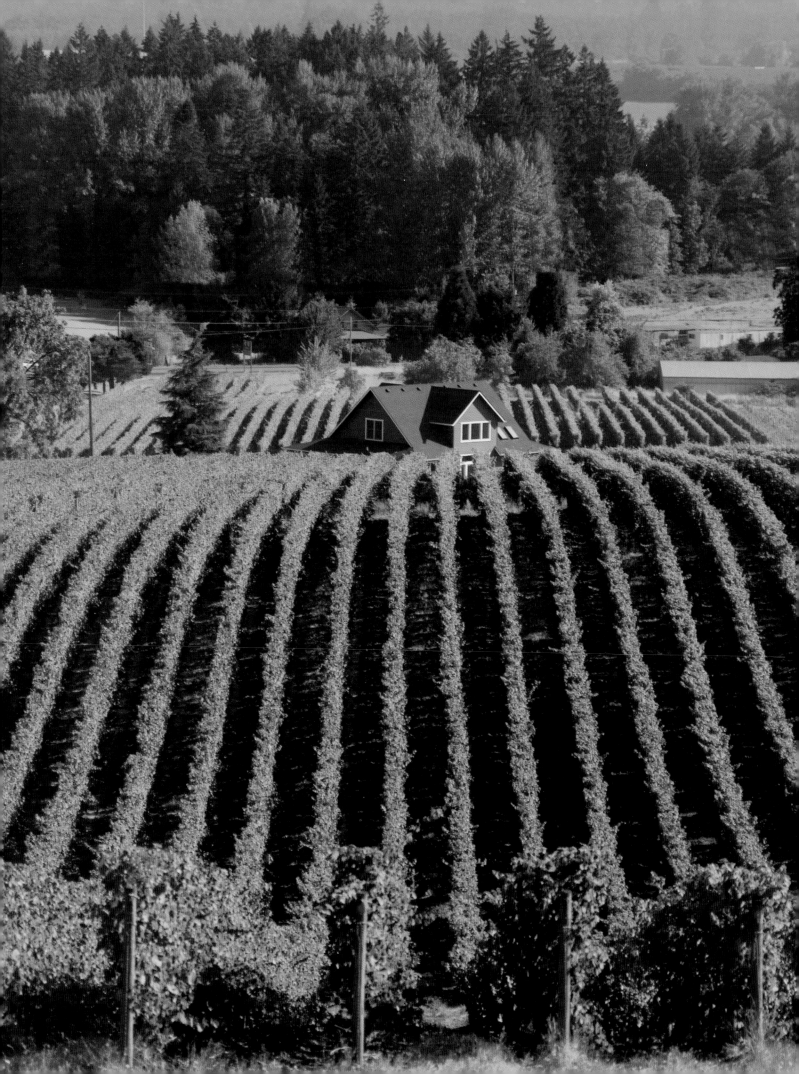

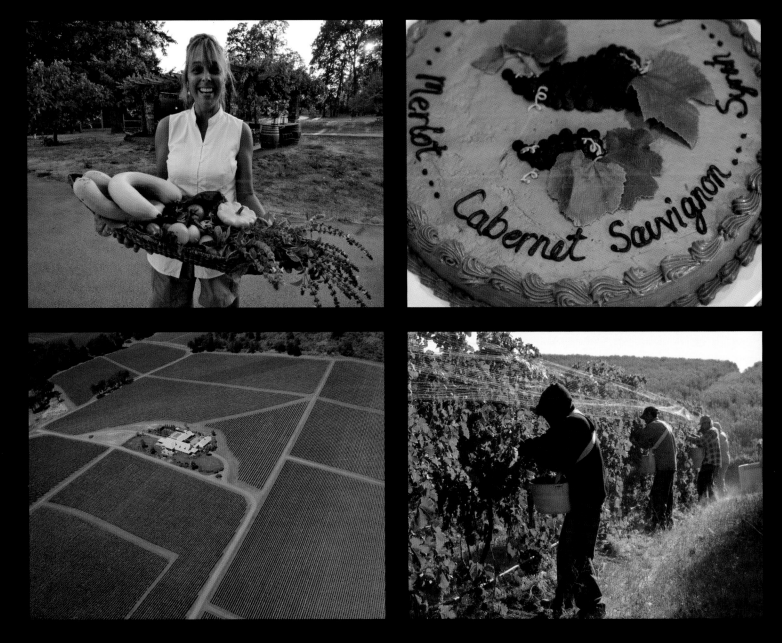

WASHINGTON & OREGON: (Top row, left to right) Melissa Mills holds the bounty from her garden at Brick House Vineyards. A cake celebrates a weekend festival at Chateau St. Michelle in Woodinville. Pinot Noir grapes grown biodynamically are held by Doug Tunnell at his vineyard in the Willamette Valley. A 1915 school serves as offices and tasting room for L'Ecole No 41 west of Walla Walla.

(Bottom row, left to right) An aerial view shows vineyards in the Dundee Hills southwest of Portland. Workers from Mexico pick Merlot grapes at Seven Hills Vineyard south of Walla Walla. Freshly picked Pinot Noir grapes wait for transport to Domaine Drouhin above Dundee. Bottles wait labeling at Argyle Winery in Dundee.

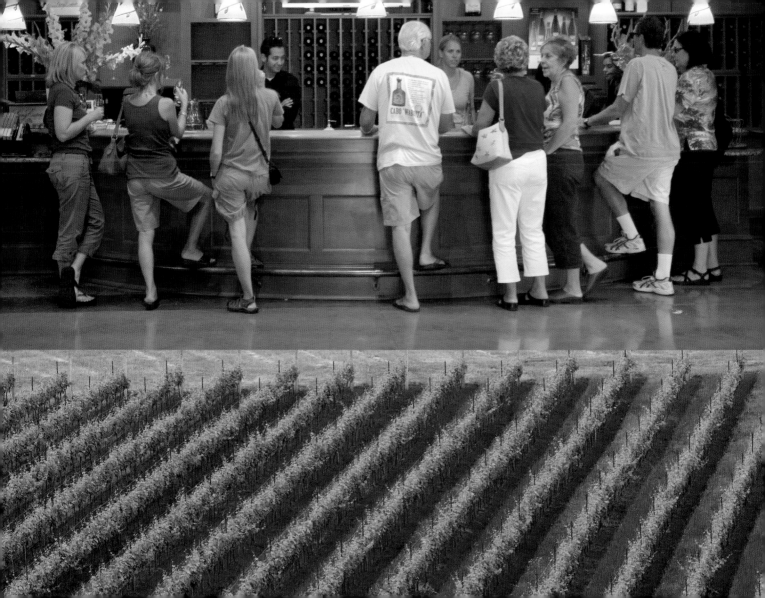

Harvested from the bark of the cork oak tree, cork has been used as a stopper for thousands of years. Dom Pérignon, a French monk, realized in the 1600s that cork was the perfect wine closure for champagne, paving the way for its modern-day use in wine bottles.

OREGON: At King Estates Winery in the Lorane Valley southwest of Eugene, visitors line the tasting room bar on a weekend afternoon. The winery grows grapes from more than 400 surrounding acres and has developed orchards, gardens and a nursery. (Top left)

Like patterns in a quilt, this early summer vineyard in the Dundee Hills shows off the soils of the region. The area is unique for its reddish silt, clay and loam soils. (Bottom left)

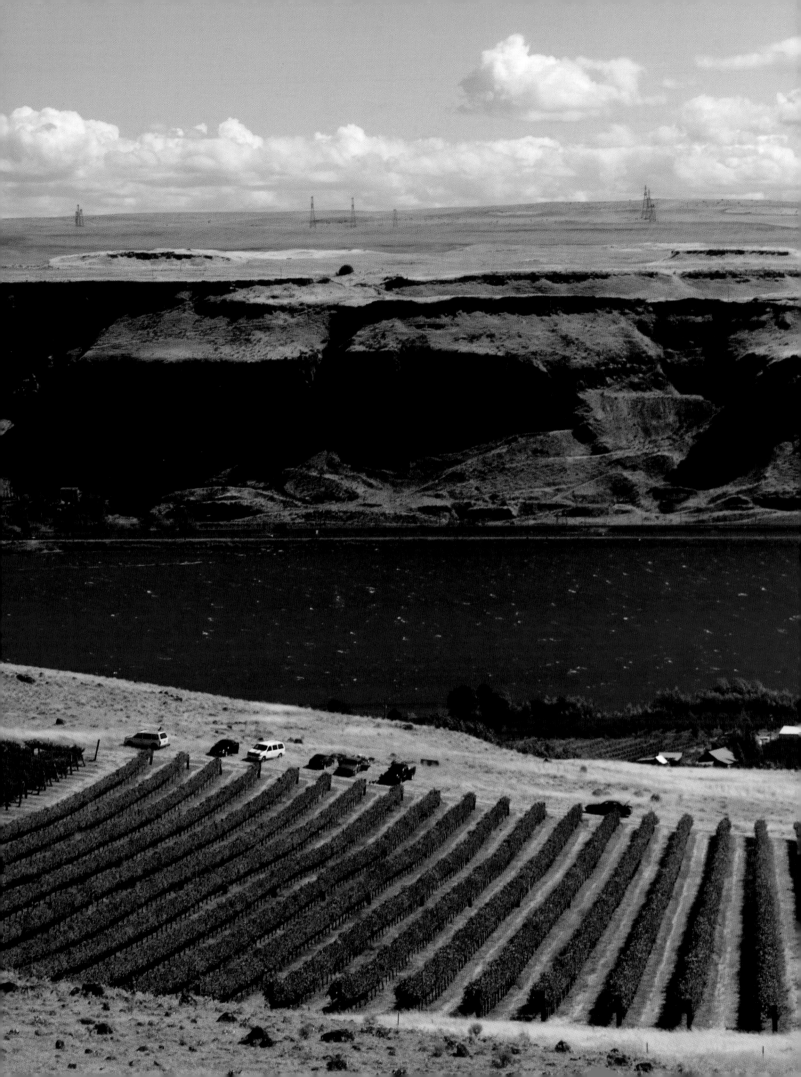

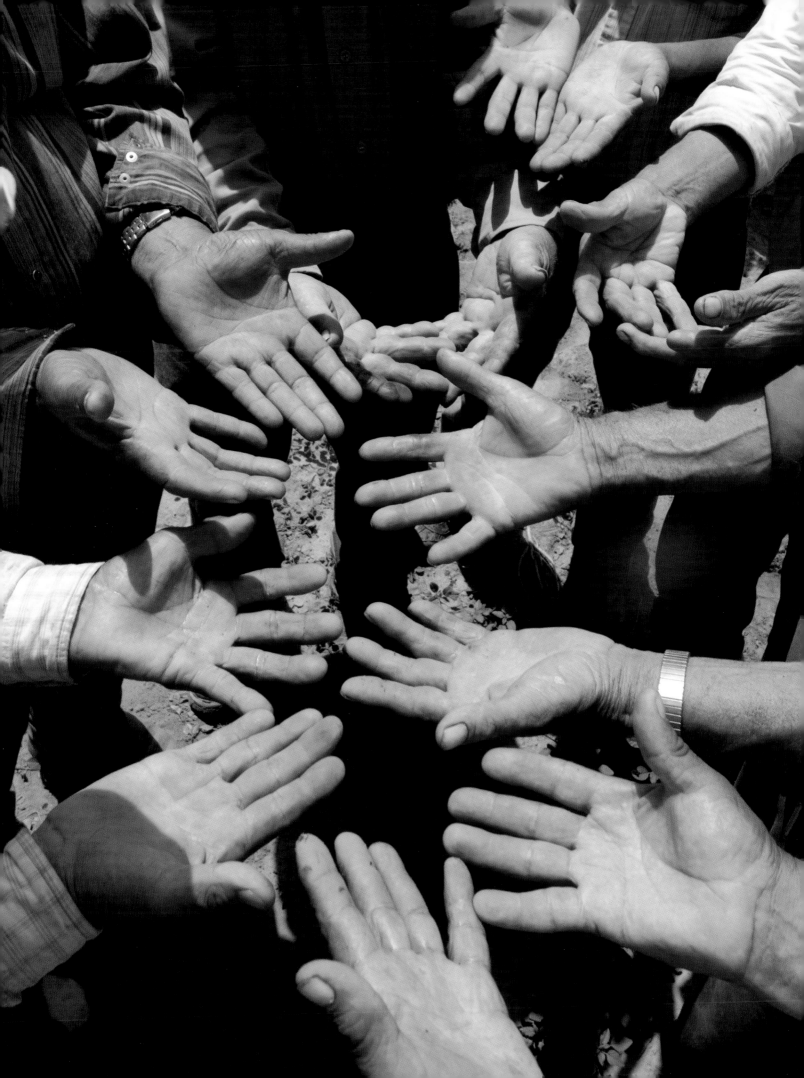

{ PEOPLE }

America's New Pioneers

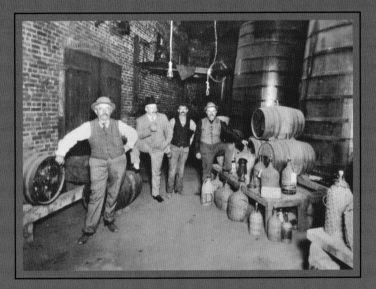

Wine cheers the sad, revives the old, inspires the

NEW MEXICO: Farm workers who commute daily from Mexico 25 miles to the south show their hands at harvest near Deming. Employees of New Mexico Vineyards, the workers tend 27 grape varieties on some 300 vineyard acres. The grapes are sold to southwestern wineries for around $1,200 a ton, one-fourth the price of premium California grapes. (Preceding page 88)

CALIFORNIA: In Los Angeles, workers pose in the 1920s at San Antonio Winery which today continues to operate as one of the last wineries in the area. (Preceding page 89)

KENTUCKY: Pediatrician Chris Nelson inspects his vines at Chrisman Mill Vineyards southeast of Nicholasville. Dr. Nelson brings to his winemaking a passion which he shares openly on his website. (Above)

VIRGINIA: Vineyard manager Rafael Sanchez walks the red clay soil of newly planted Chardonnay vines at Kluge Estate Winery near Charlottesville. Wine has been made in the state for four centuries and today there are more than 100 wineries. (Facing page)

young, and makes weariness forget his toil. —LORD BYRON

In Kentucky, the first commercial vineyard was established in 1798. Today vineyards are replacing tobacco farms in the state.

Unlike picking grapes, pruning vines is as much art as it is science

for it is in this work that the fruit yield is determined.

OREGON: Workers listen to instructions on the first day of harvest before picking Merlot grapes at Seven Hills Vineyard in the Walla Walla wine region that extends from Washington state into Oregon. The pickers' boxes are adapted from those used by nearby cherry orchard workers. Vineyard workers in America normally receive pay based on hourly work or on the amount they pick. (Right)

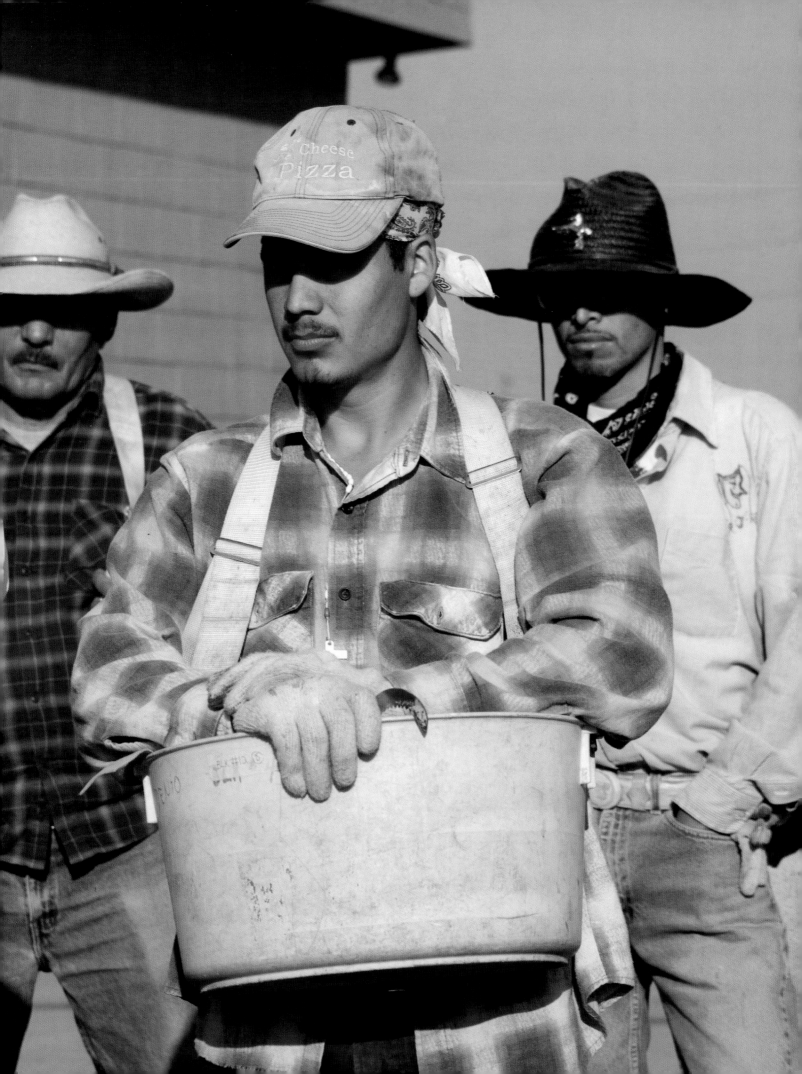

OREGON: Autumn sun lights harvest day at Domaine Drouhin, built above the town of Dundee in 1988. After picking, premium wine grapes in America are often placed in individual 50-pound boxes to reduce damage to the fruit.

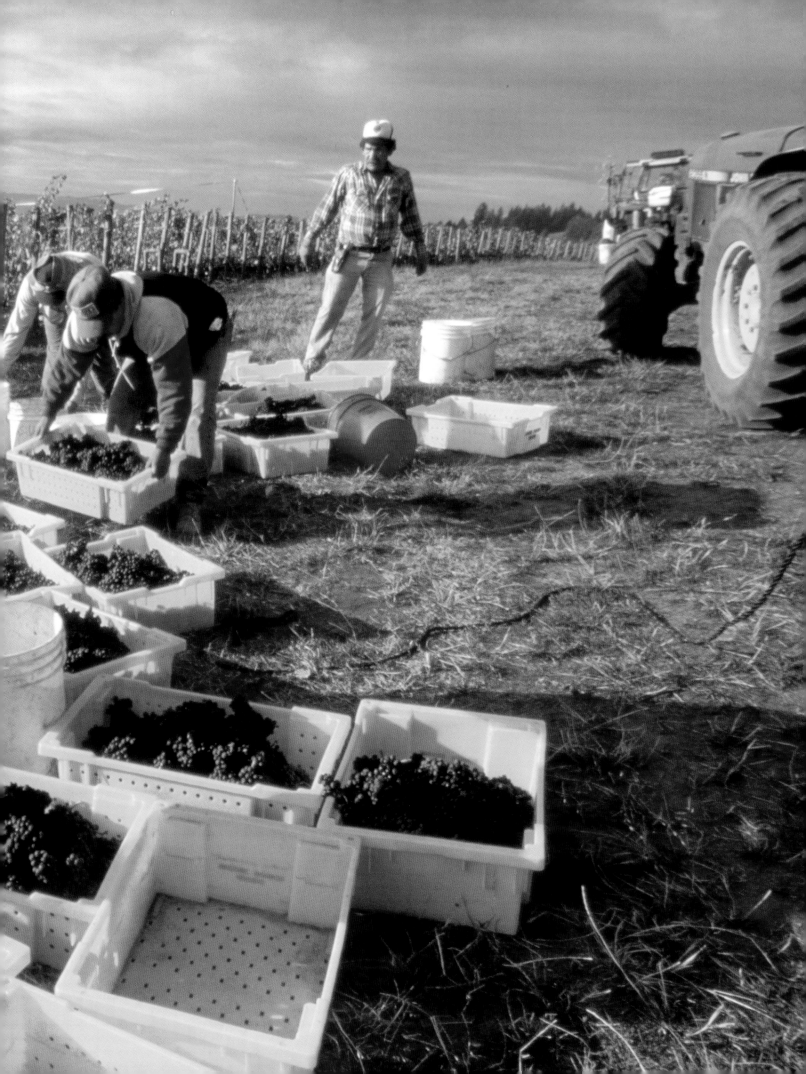

There are a few experts in the world who can go into a vineyard and quickly identify grape vines. Ampelographer Lucie Morton—who calls herself the "vine whisperer"—is one of them.

OREGON: The well-worn vineyard boots from a small family winery in the Willamette Valley reveal the toil needed to grow grapes. (Left)

VIRGINIA: Grapevine specialist and author, Lucie Morton of Broad Run, prepares to take off through a vineyard southwest of the country's capital on "Daphne," her all-terrain vehicle. Lucie analyzes vineyards across the country and beyond, helping vintners grow grapes that will create the best wine possible. (Right)

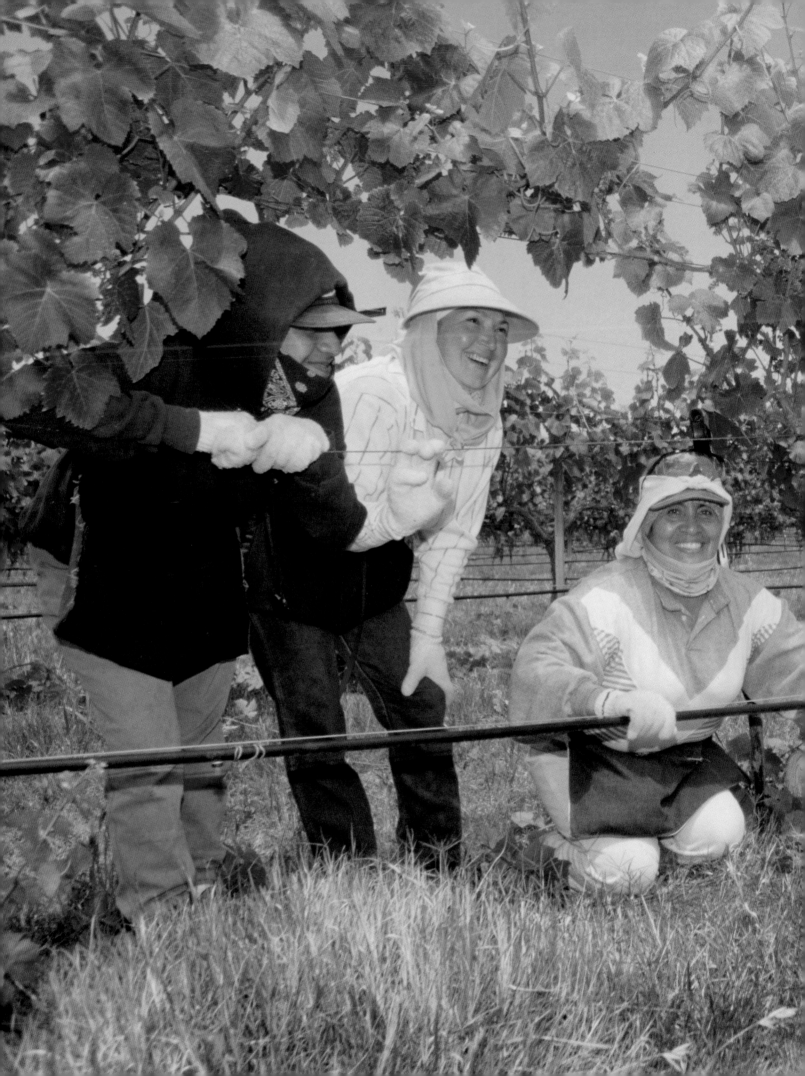

WASHINGTON: A crew of women vineyard workers smiles at the camera at Houge Cellars near Prosser. Field workers in most American vineyards come from Spanish-speaking regions such as Mexico and Central America.

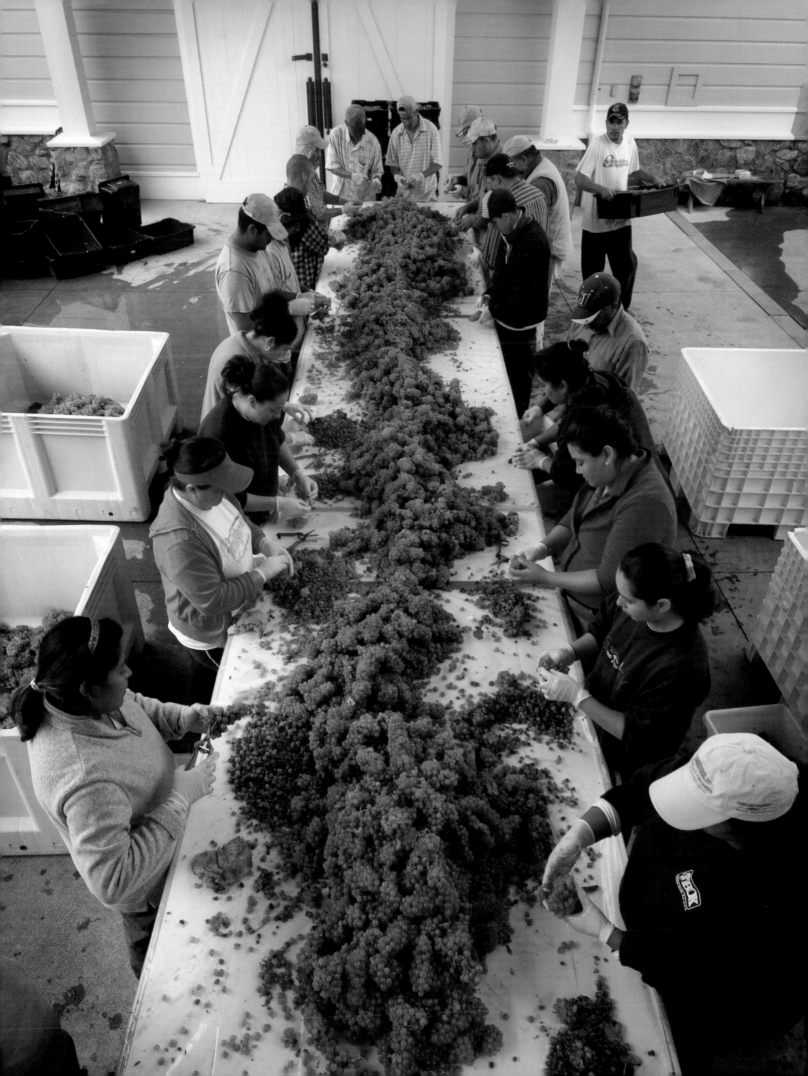

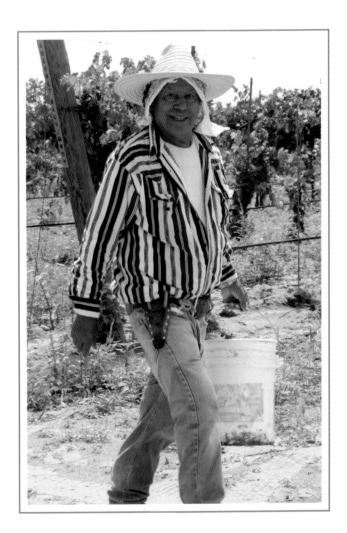

God made only water, but man made wine.

—VICTOR HUGO

CALIFORNIA: Fast hands sort and clean freshly picked Sauvignon Blanc grapes at Spottswoode Winery in St. Helena in the upper part of the Napa Valley. Many wineries take extreme care to remove MOG, or Material Other than Grapes, such as stems and leaves which affect flavors of the wine. (Left)

NEW MEXICO: A vineyard worker heads for his ride home across the Mexican border a few miles away. Long-time field workers in the Deming area along the Mexican border enter the U.S. with a work permit and return home daily. (Above)

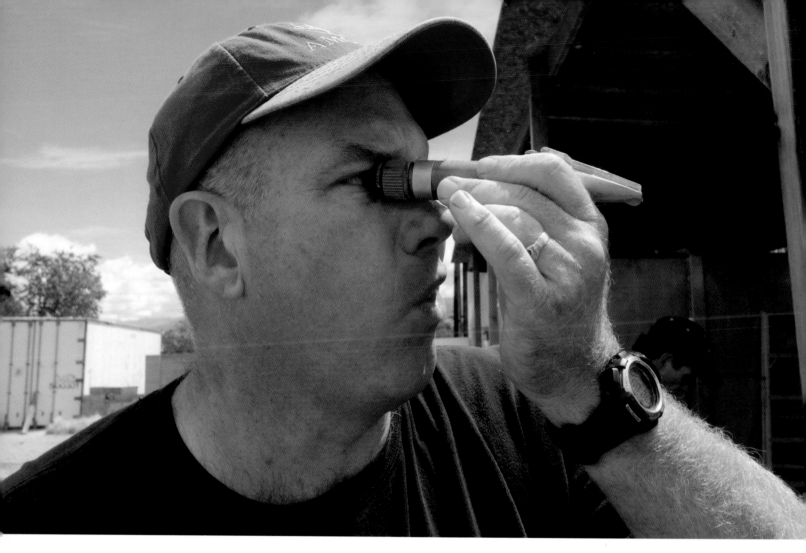

NEW MEXICO: Winemaker Mark Matheson of Santa Fe Vineyards peers into a refractometer to measure sugar content from the juice of freshly crushed grapes during harvest. Monitoring levels of sugars and acids is crucial to successful winemaking. (Above)

LOUISIANA: Wineries require clean tanks for winemaking. In the southern part of the state, an employee climbs into a stainless steel tank prior to washing it before the next harvest. Stainless steel tanks are often chosen over traditional wood tanks because they impart no flavors and are easier to clean. (Facing page)

The number of wineries across America has doubled in the past decade to almost 5,000 today.

Wine is produced in all 50 states, including

Alaska and Hawaii. In 2002, North Dakota became the

last state to officially make wine.

ALASKA: Tom Hall and Judy Beauchemin-Hall, owners of the state's largest winery in Anchorage, hold the essence of their business. Juice from wine grapes arrives in boxes from California, is combined with yeast in a six gallon "carboy," fermented for a couple of weeks, and bottled. A sign welcomes visitors to the winery where people can buy wine or make their own. (Above and right)

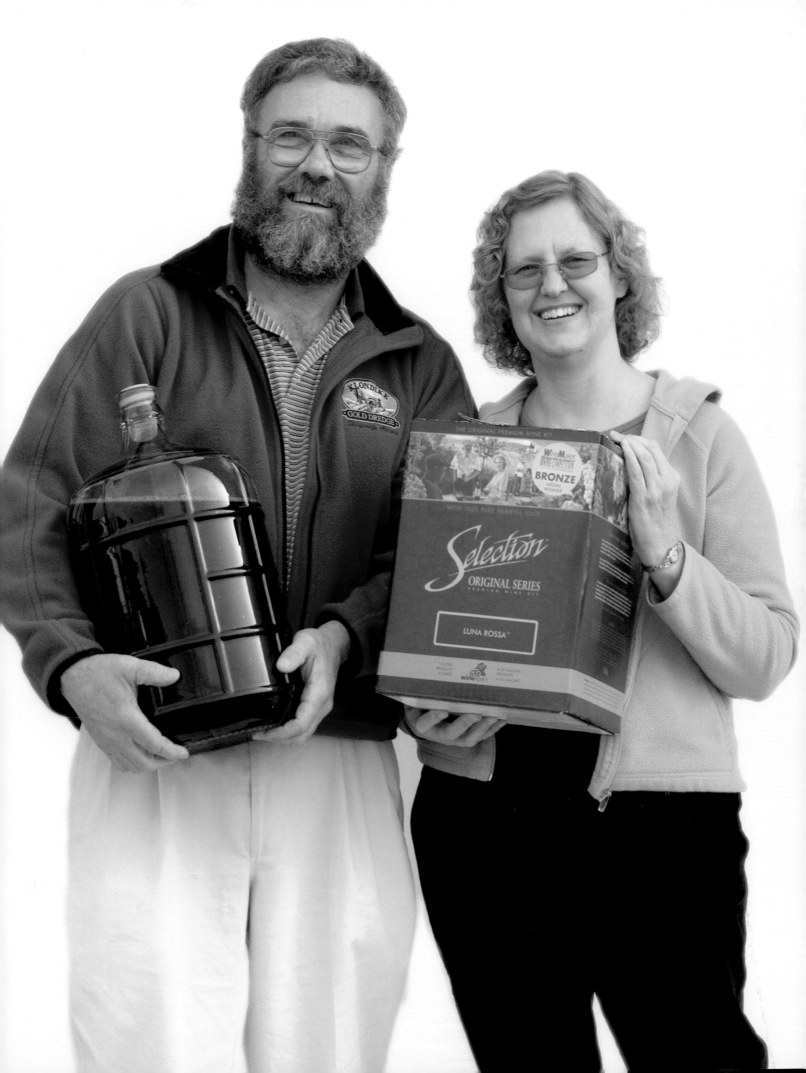

T exas is one of the largest wine-producing states in the nation with 95 wineries, which are located in four regions: the Hill Country in central Texas; North Texas around Dallas/Ft. Worth; the High Plains near Lubbock; and the Trans-Pecos in the far west.

TEXAS: A carving of a cowboy sells as a bottle stopper at a Fredericksburg winery. (Left)

Eighty-three-year-old Oma Switzer takes an active role working in the winery that her three sons built and operate in the heart of Texas Hill Country. (Right)

Americans drink more than 3½ billion bottles of wine a year and the average time between purchase and consumption is four hours.

TENNESSEE: At Strikers Premium Winery near Athens, Shannon Miller labels white Muscadine wine. The winery opened in 1996 and buys its grapes from individual grape growers in the area. For many small wineries, budgets do not allow for expensive machinery so wines must be bottled and labeled by hand. (Above)

MARYLAND: At Basignani Winery near Sparks, John Raver moves empty barrels to make room for full barrels needed for bottling day. An empty wooden barrel weighs 80 pounds, but is awkward to move because of its shape. (Right)

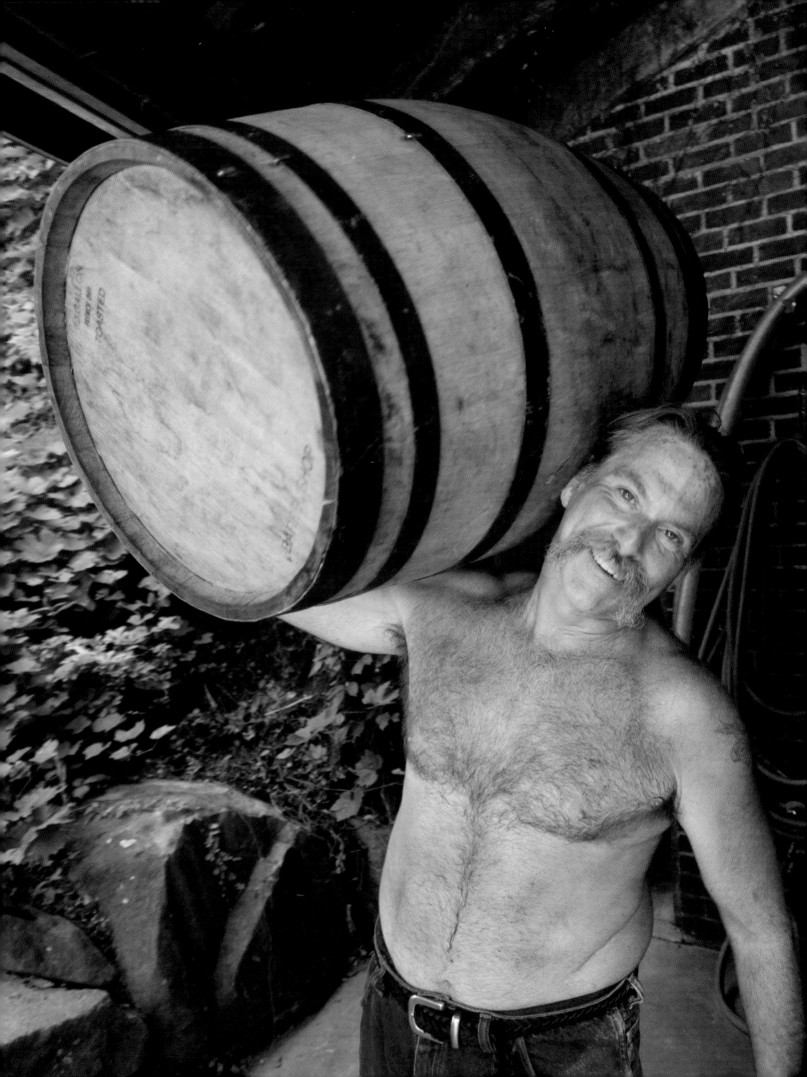

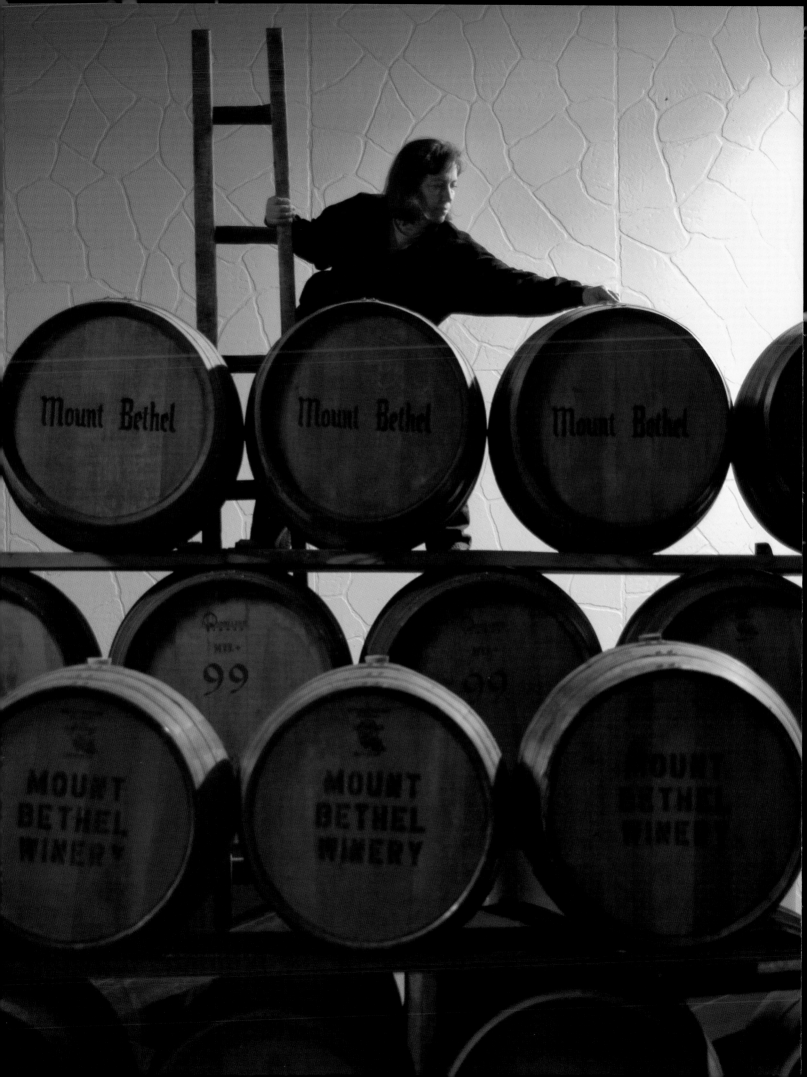

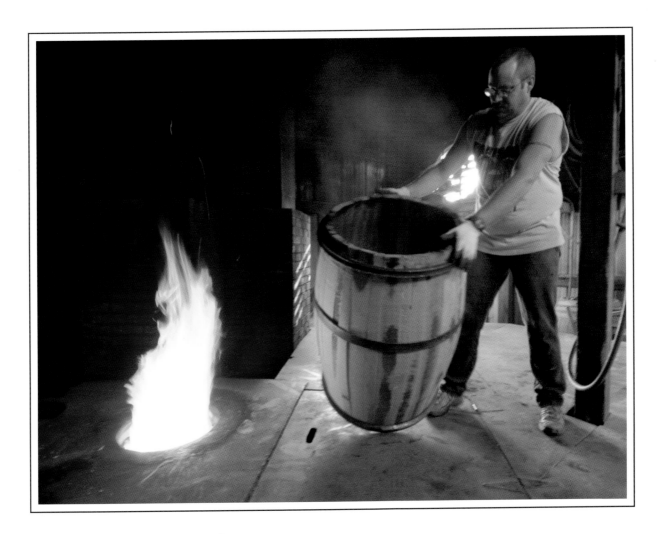

The most dramatic impact on a wine's

aroma and flavor comes from toasting the staves.

—CHRIS FLEMING, *WINES & VINES* MAGAZINE

ARKANSAS: Mary Jane Cains is the fourth generation of her family to work for Mount Bethel Winery in Altus. The winery is among five located in the state's only winemaking region. In the early 1880s, Altus was a prosperous coal mining town on a major railroad line where settlers from Europe put down wine roots. (Left)

MISSOURI: Barrel maker Jack Dike twirls a new barrel to an open fire to "toast" the wood for added flavors in the wine. A&K Cooperage of Higbee harvests American oak from their nearby forests for wine barrels used by many wineries. Barrels made from French oak are also a popular choice for wineries, but the wood must be imported. (Above)

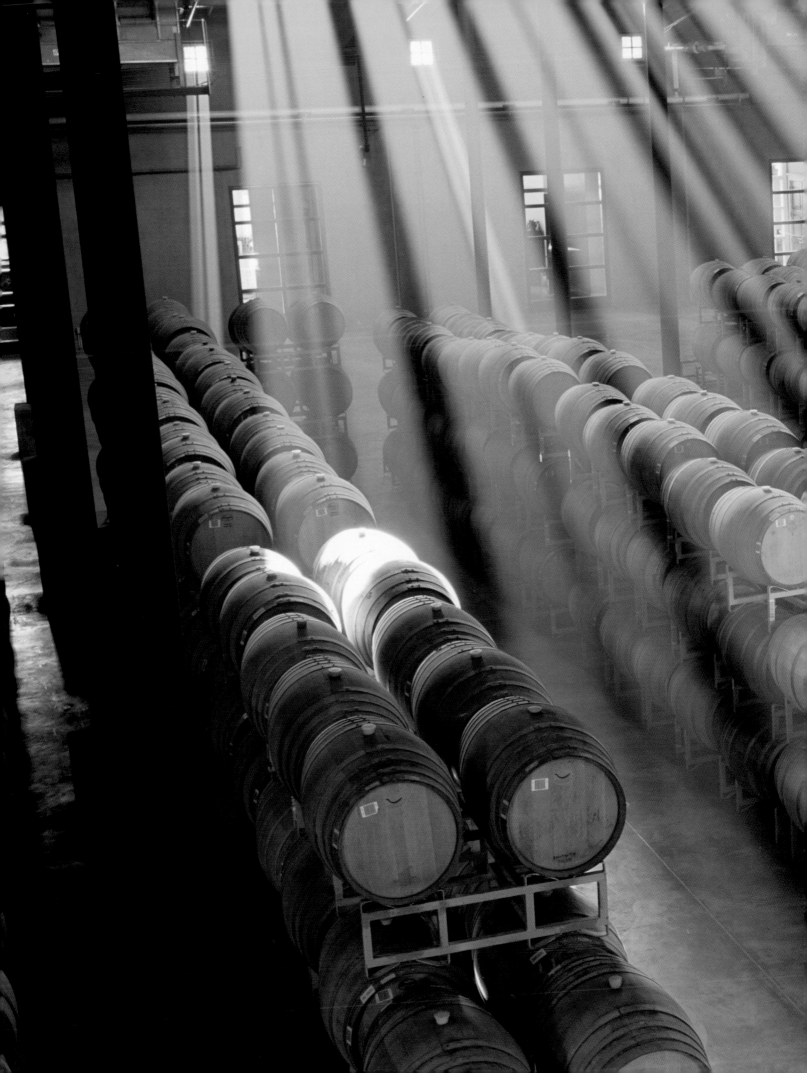

CALIFORNIA: Rays of sun illuminate the barrel room of Montevina Winery in the Sierra Foothills of Amador County, an area long known for its red wine. Winemakers often use misting devices to keep barrels damp and to prevent leaking. The moisture from the mist saturates the air which magnifies the sun rays.

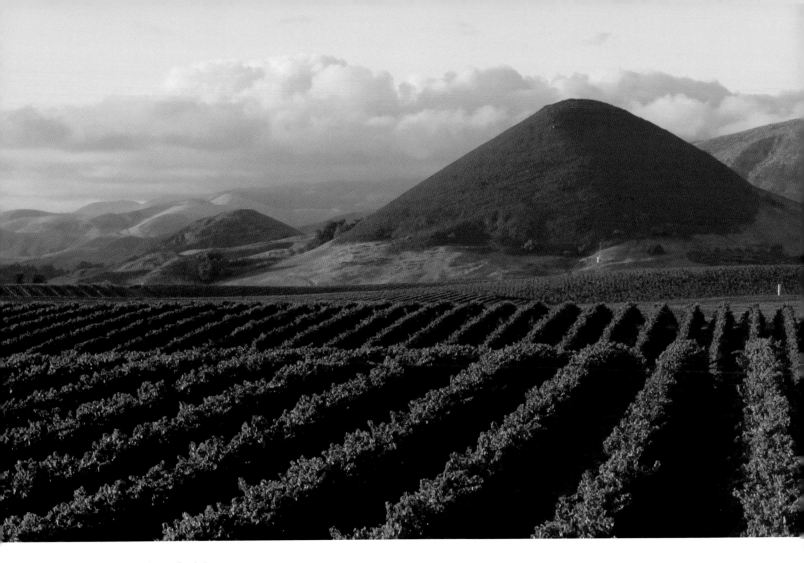

CENTRAL COAST: Vineyards near San Luis Obispo reach toward Islay Hill, a topographical icon of this winemaking region. Wine growing here reaches back to the missionary days of California viticulture, when the first grapevines were planted by Franciscan priests more than two centuries ago. Today nearly 300 wineries take advantage of the Pacific Ocean's cool marine air in the region, which stretches 200 miles between Santa Barbara and Monterey. (Above)

NAPA VALLEY: Built in Oakville in 1966, the Robert Mondavi Winery was the first established in Napa Valley since Prohibition ended in 1933. The architecture reflects the style of early Spanish missions built throughout the state more than two centuries ago. (Right)

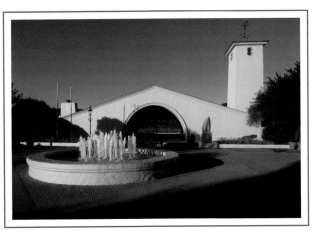

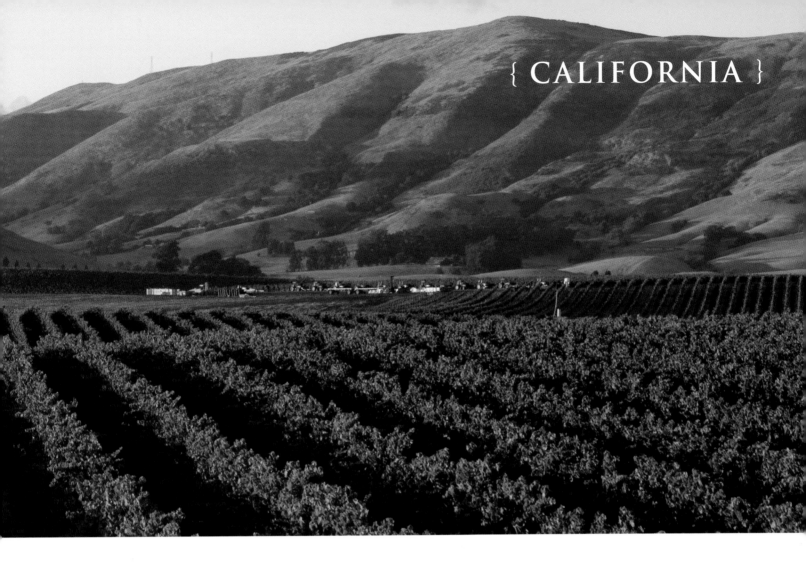

California is the premier wine growing state in the country. Because of the state's diverse soils, geography and Mediterranean climate tempered by close proximity to the Pacific Ocean, the state is well suited for growing classic European grapes such as Cabernet Sauvignon, Chardonnay, Pinot Noir, and Sauvignon Blanc. In truth, California can grow just about any grape variety it chooses and, in fact, the list of grape varieties grown here is long.

Grapevines were brought to California more than two centuries ago by Spanish explorers from Mexico who needed sacramental wine for the missions they established throughout the state. Fast forward a few hundred years to the 1960s, when Robert Mondavi opened his Napa Valley winery, launching America's modern-day love affair with wine.

Today, there are over 2,000 wineries in the state—almost half of the U.S. total—and more than 90 different viticultural regions where vineyards are found from Mendocino in the north, to the Sonoma and Napa Valleys, the Sierra Foothills, the Central Coast, and the South Coast. The most expensive agricultural land in the United States is in Napa Valley where "cult wines" can sell for thousands of dollars a bottle. Perhaps it's the high prices California wine can fetch that free winemakers to experiment, which in turn contributes to their consistently creating innovative, award-winning wines.

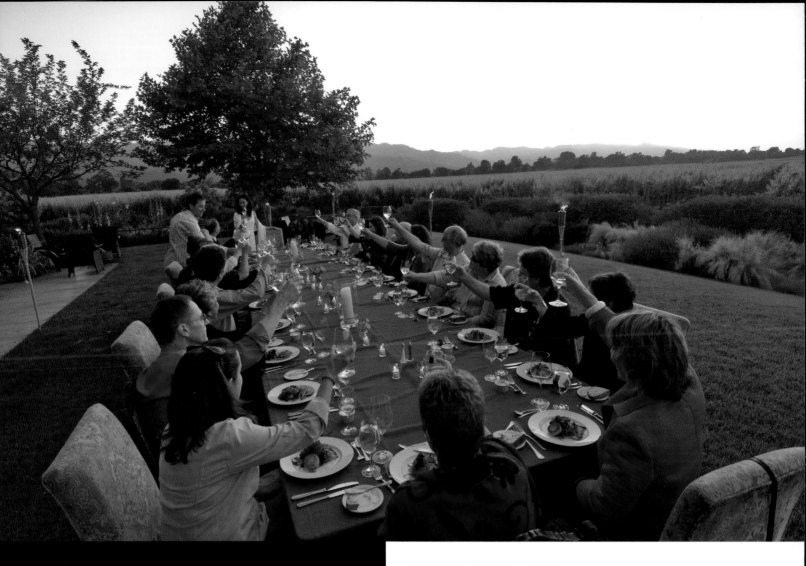

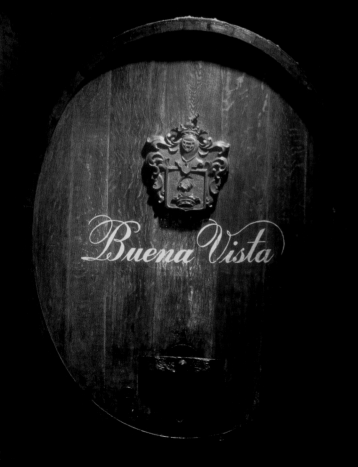

NAPA VALLEY: Guests at a lawn party in Rutherford toast owners at Honig Vineyard and Winery. (Above)

The 120-year-old Rhine House at Beringer Vineyards in St. Helena glows from the warmth of nearby autumn trees. The 17-room mansion was built as the residence of Frederick Beringer who created a villa reminiscent of the family's home near Mainz, Germany. (Right)

SONOMA VALLEY: A barrel in this historic winery in the town of Sonoma displays the name for visitors. Buena Vista was started in 1857 and is considered the oldest in the state. (Left)

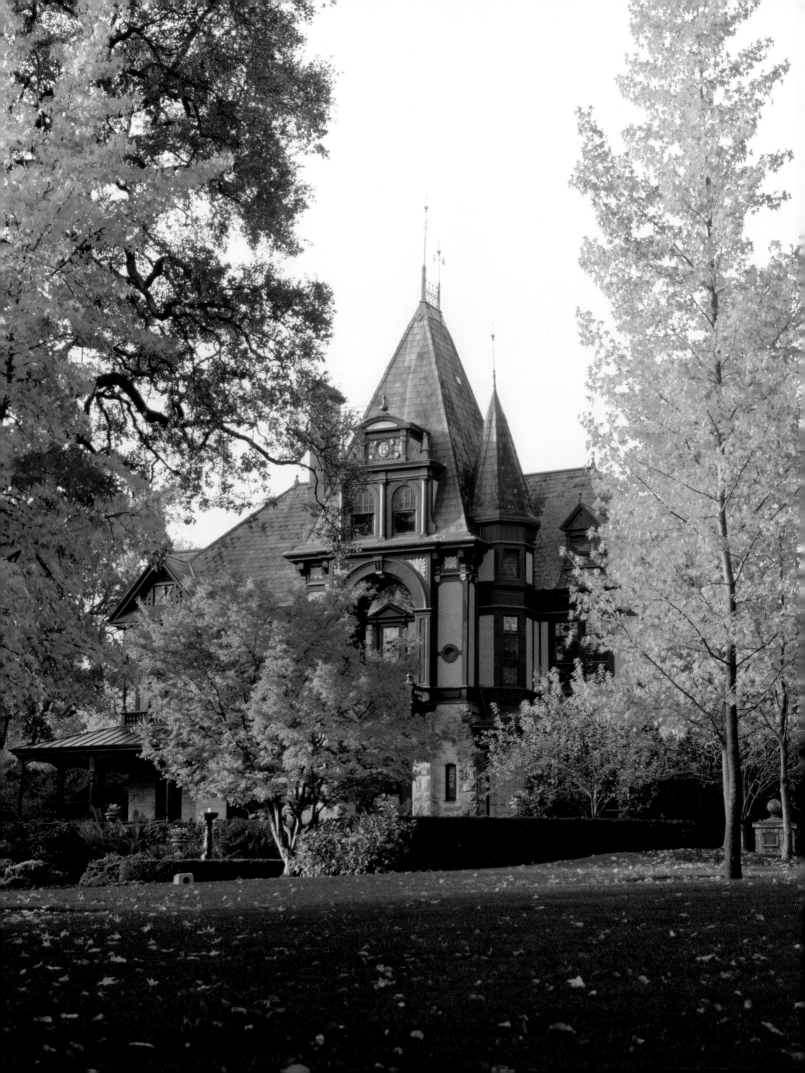

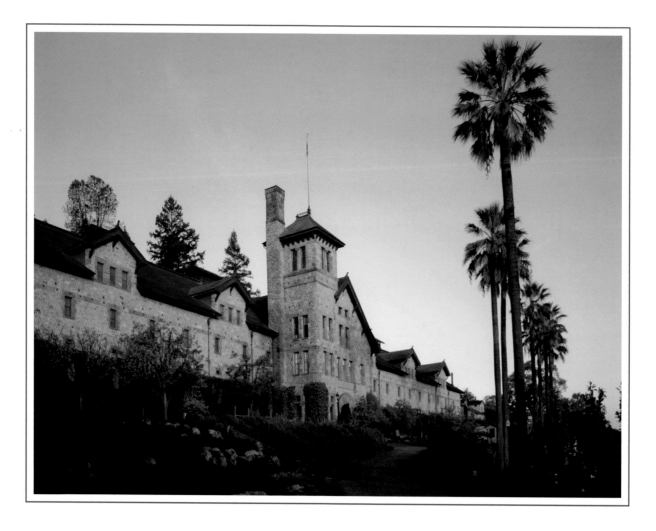

Wineries and vineyards have become icons of the landscape of California,

which has the most wineries of any state in the country.

NAPA VALLEY: The former Christian Brothers winery houses the west coast campus of the Culinary Institute of America in St. Helena. Greystone Cellars is named after Greystone Winery, originally a co-operative founded in 1889. The building is on the California Registry of Historic Places. (Above)

Fall vineyards wind through the Spring Mountain area. On the eastern slopes of the Mayacamas Mountains that separate Napa Valley from Sonoma Valley, the region encompasses 30 vineyards and wineries and 1,000 vineyard acres. (Right)

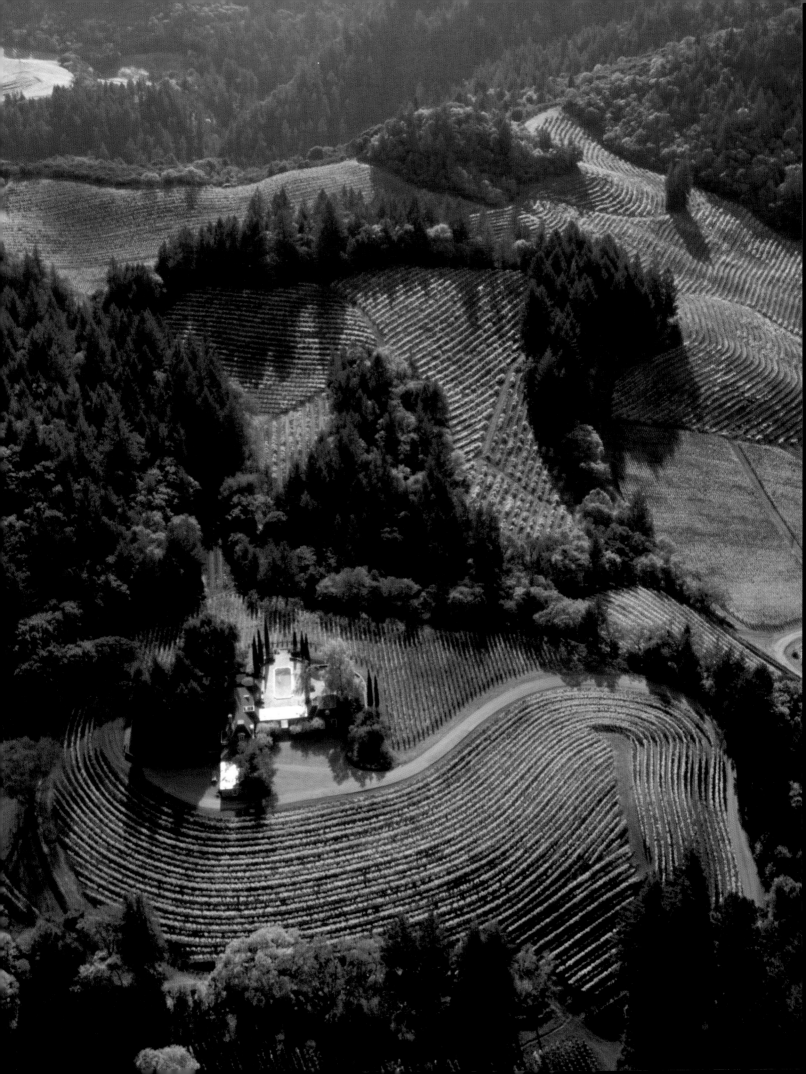

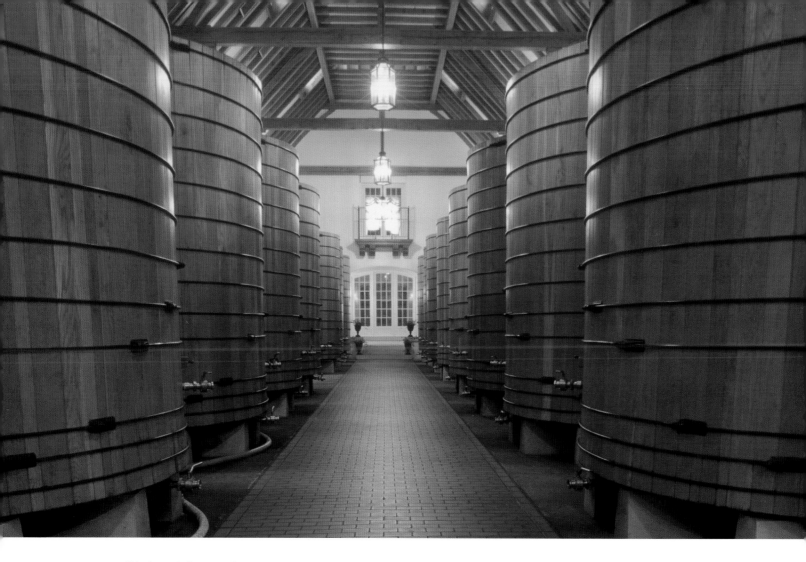

SONOMA COUNTY: Wooden tanks frame a walkway at Jordan Winery near Healdsburg. The 30-year-old winery was one of the first of the new generation of wineries built in this wine region. (Above)

NAPA VALLEY: Spring mustard blossoms between rows of dormant vines trained on the trellis style of "open V cross-arm," which opens vine leaves to sunlight and prevents shading. Spottswoode, a boutique winery in St. Helena, is seen in the distant left. (Facing page)

Many of America's premium wines come from the Napa and Sonoma Valleys north of San Francisco.

NAPA VALLEY: Once the home to Inglenook Vineyards founded by Finnish sea captain Gustave Niebaum, this imposing 1882 structure in Rutherford is now home to Rubicon Estates, owned by film director Francis Ford Coppola.

NAPA AND SONOMA VALLEYS: A golden sunset spreads across vineyards in the Carneros district of two famous wine growing valleys. Because this area borders the waters of upper San Francisco Bay it benefits from cooler summer temperatures, ideal for growing Chardonnay and Pinot Noir grapes.

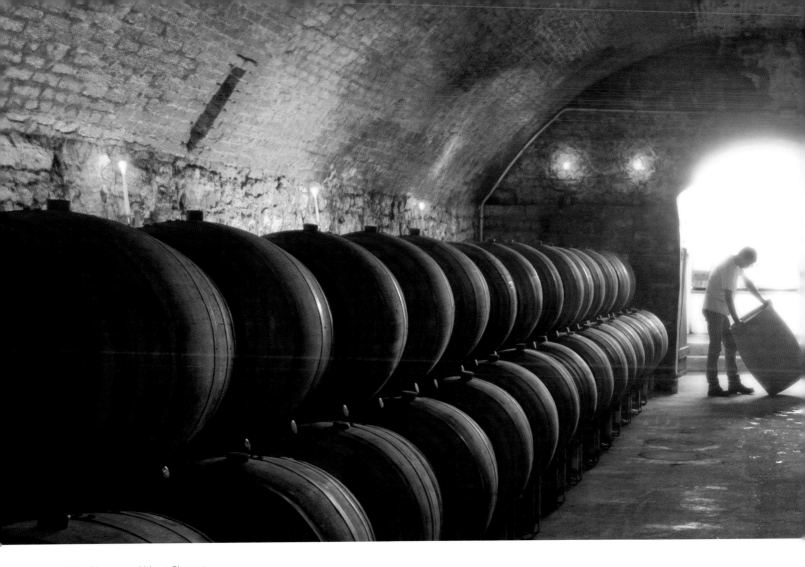

MISSOURI: The caves of Mount Pleasant Winery southwest of St. Louis in the Missouri River Valley have been aging wine since 1881. Underground caves provide moisture and even temperatures, conditions ideal for wine. The area reminded early German settlers of their homeland when they arrived in the New World. In 1980, Missouri became America's first wine region officially designated by the U.S. government with Napa Valley named the second in 1983. Here, winemaker Mark Baehmann rolls a barrel into the cellar. (Above)

OHIO: The home of Old Mill Winery in Geneva also serves as a restaurant. (Right)

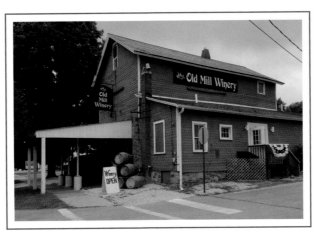

The great Midwestern states have a history of grape growing since immigrants from northern Europe settled here in the 1800s and established small vineyards on their family farms. Soon they discovered that the Missouri River Valley offered near-perfect wine growing conditions and by 1890 Missouri was a leader in the nation's grape growing, with the second largest winery in the country. All this ended with the arrival of Prohibition in 1920, when wineries and vineyards were shuttered.

Today the biggest challenge for Midwestern winegrowers is the severe winter weather. To mitigate biting cold, vineyards are found near the shores of the Great Lakes and along rivers in order to capture the water's warming effect. Many winegrowers opt for hardy grape varieties that can withstand the harsh winters, such as native grapes, American crosses, French-Hybrid grapes and newly developed varieties.

Even though it's a struggle to keep vines alive in the Midwestern states, the hearty folks who live here are forging ahead with good results. From the plains to the prairies to the great river valleys, corn, soy and wheat fields are being transformed into vineyards, and former "speakeasies," fire stations, grain mills and Victorian chapels are serving wine made from Buffalo berries, local Catawba grapes, or even Cabernet Sauvignon trucked in from California.

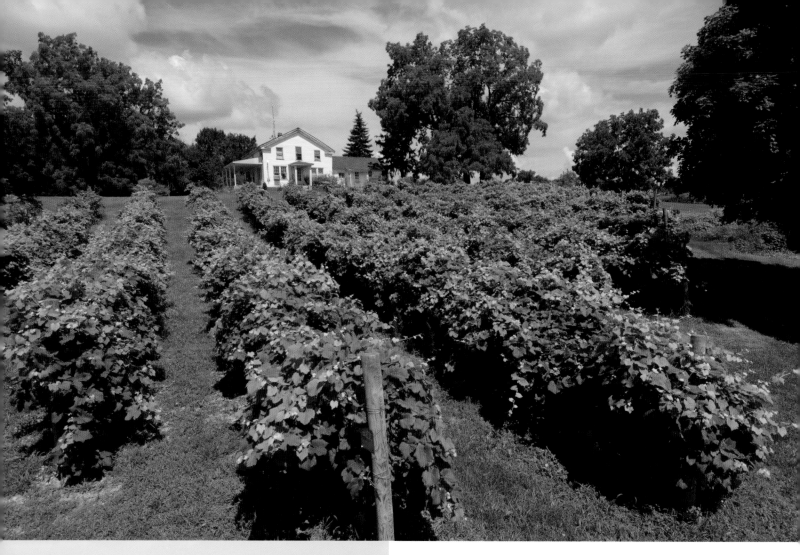

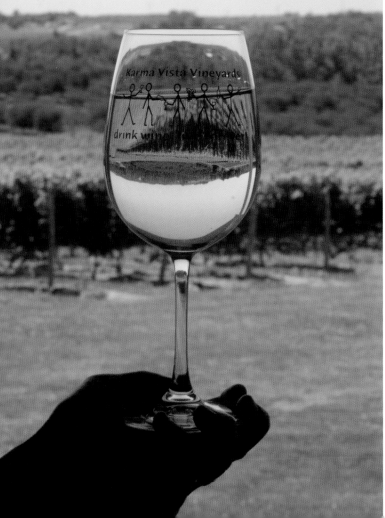

INDIANA: Steuben grapes line the front yard of a home at the entrance to Satek Winery in Fremont. (Above)

MICHIGAN: Sue Herman holds a glass which reflects the vineyard she and husband Joe have developed next to their Karma Vista Winery near Coloma. Once a cherry orchard, their hilltop vineyards benefit from Lake Michigan, which provides a tempering effect on the winter cold. (Left)

OHIO: The restaurant at Ferrante Winery in Harpersfield Township offers a tasting of six wines. (Below)

MISSOURI: The town of Hermann is seen in the distance through Norton grapevines growing in front of Stone Hill Winery. (Right)

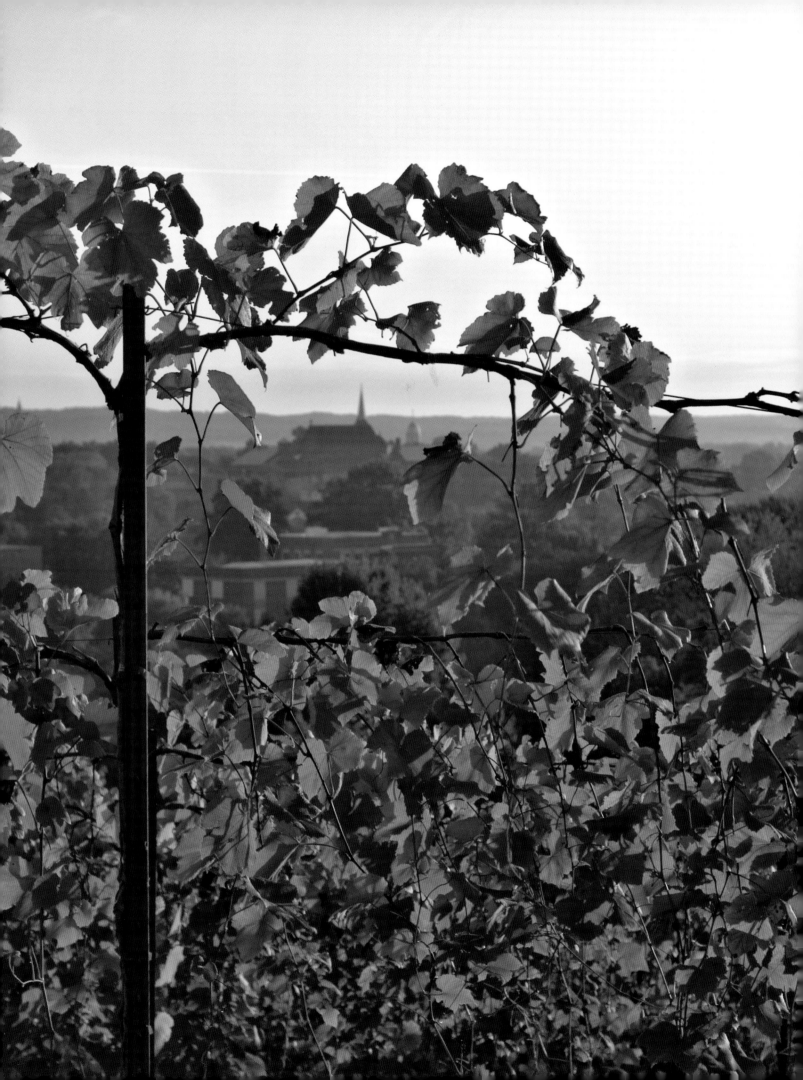

MISSOURI: The wide and muddy Missouri River flows past a hilltop vineyard above Hermann west of St. Louis. The German immigrants who settled here in the 1800s and established the first vineyards and wineries likened this picture postcard area to "Rhineland."

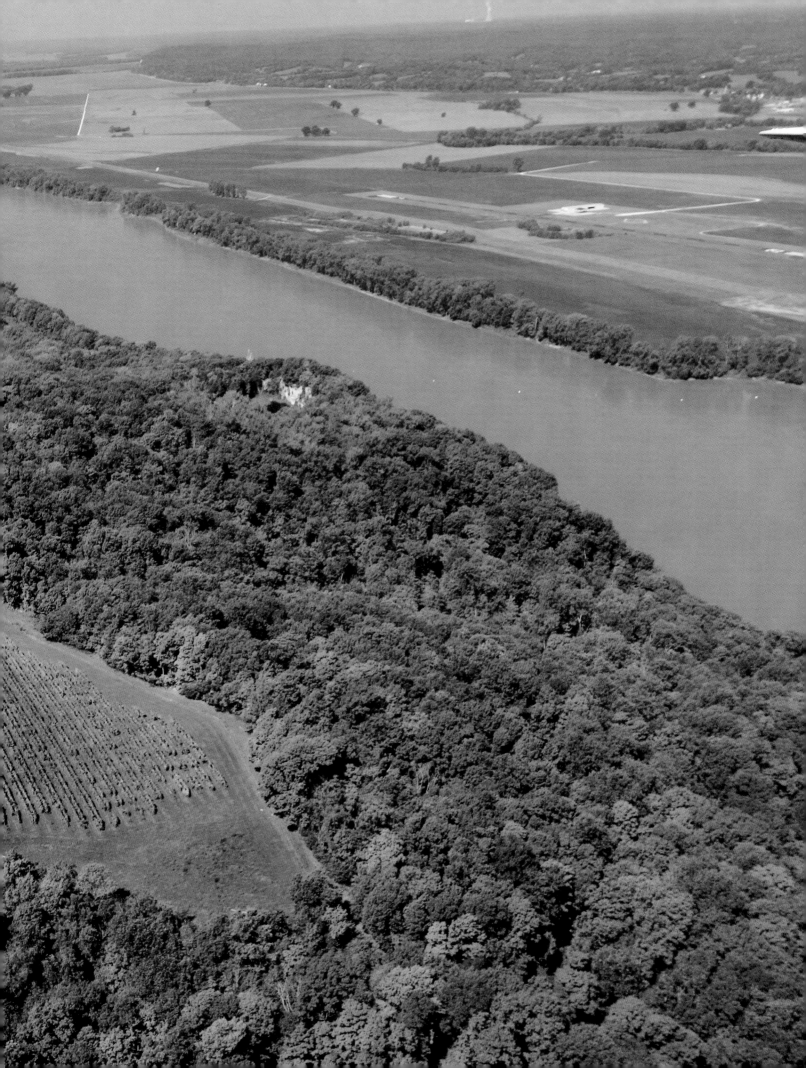

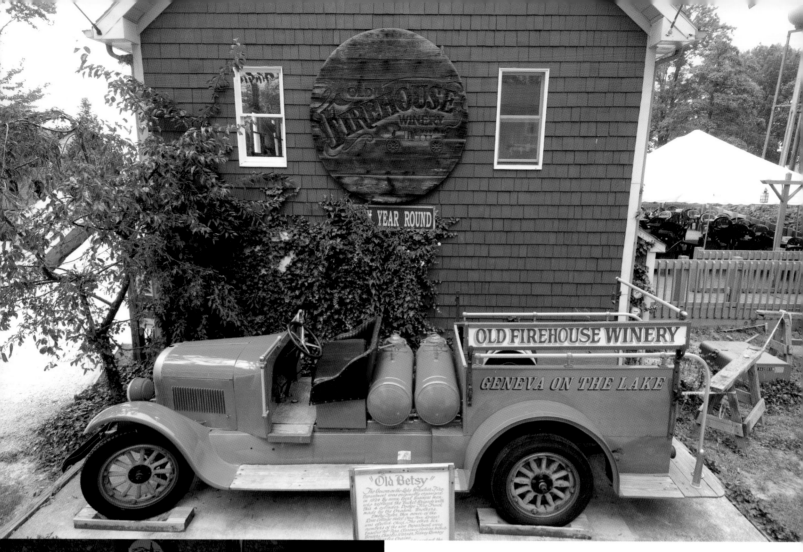

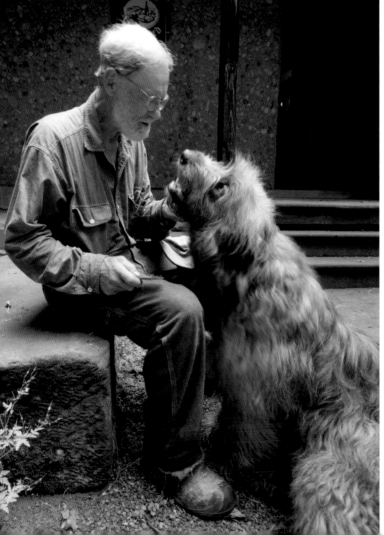

OHIO: Old Firehouse Winery in Geneva on the Lake uses a 1924 Dodge fire truck to welcome visitors. (Above)

Prominent winery owner and winemaker, Arnie Esterer, talks with Vinnie, his winery mascot. Arnie built Markko Vineyards near Conneaut in 1968. While grape growing and winemaking began in the state more than a hundred years ago, Arnie was the first to plant classic European grapes in this area a few miles from the shores of Lake Erie. (Left)

At Markko Winery, Arnie Esterer asks visitors to alert him on this radio so he can greet them. (Right)

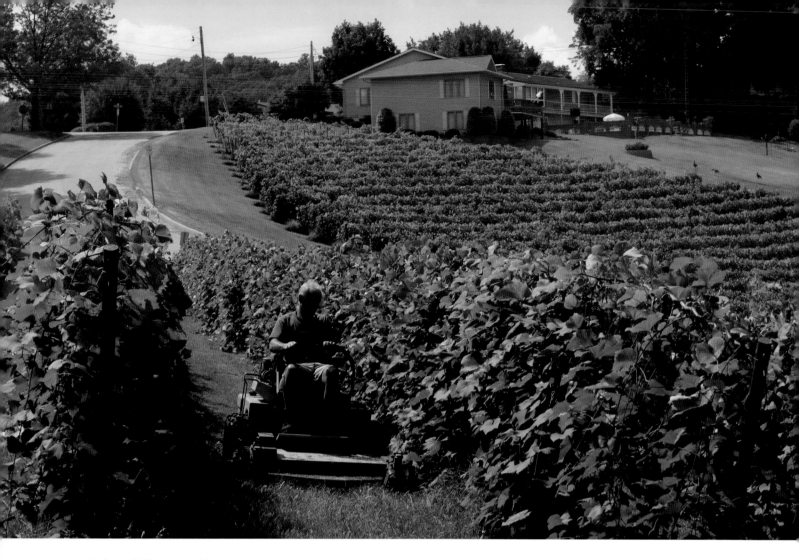

MISSOURI: A vineyard in Hermann provides a groomed backyard for residents living in this hilltop area next to Stone Hill Winery. (Above)

ILLINOIS: Italy's Tuscany region influenced the design and color of Blue Sky Vineyard's winery and tasting room in the state's southern region near Makanda. In 2000, Chicago businessman Barrett Rochman, along with his son-in-law Jim Ewers, planted their first grapes in this remote site because of its potentially good "terroir" critical to successfully growing wine grapes. (Facing page)

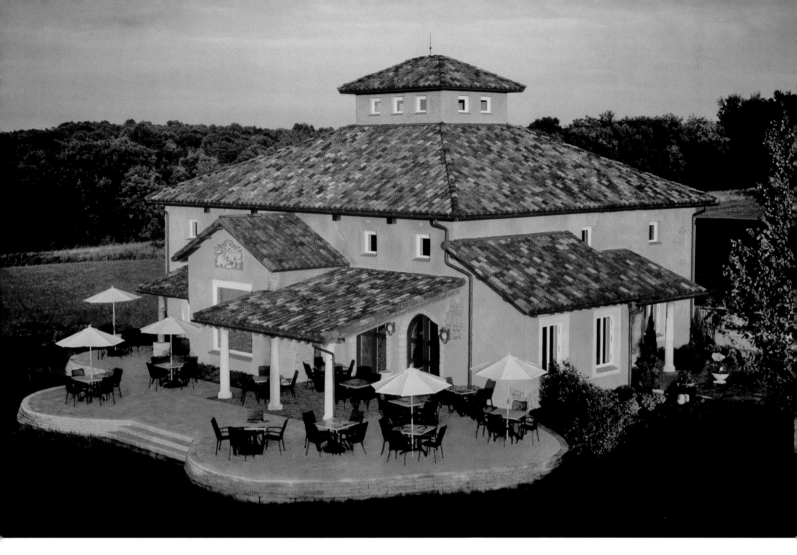

The state of Missouri had the first designated wine district or American Viticultural Area (AVA) in the United States.

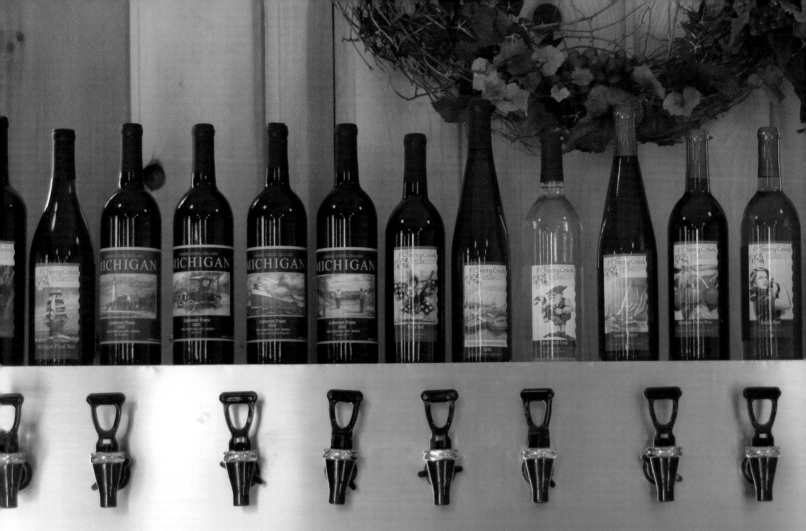

WISCONSIN: An antique hand-operated grape crusher and basket press is displayed for visitors at Wollersheim Winery outside of Prairie du Sac. (Left)

MICHIGAN: A panel of faucets appears to dispense wines from the bottles at Cherry Creek Winery south of Jackson. (Above)

OKLAHOMA: Gary Butler bottles by hand Sherry sold from his Summerside Vineyards and Winery in Venita. (Right)

MICHIGAN: A carved cask decorates an entertainment area at Tabor Hill Winery close to Buchanan. The cask, which aged wine for three decades, was carved by T.C. Cavey. (Below)

More miracles come from a cask full of wine than

a cask full of saints. —ITALIAN PROVERB

MISSOURI: Matthew Kirby inspects American oak staves, which are "air-cured" for two years before being shaped into wine barrels at his family's factory in Higbee. (Above)

MINNESOTA: The winemaker samples wine at Alexis Bailly Vineyard near Hastings. (Right)

WISCONSIN: An ornate fence frames the original 1858 building at Wollersheim Winery east of Prairie du Sac. The winery is surrounded by land established as vineyards in the 1840s by Hungarian Count Agoston Haraszthy who later founded Buena Vista, the oldest continually operating winery in California. (Following pages)

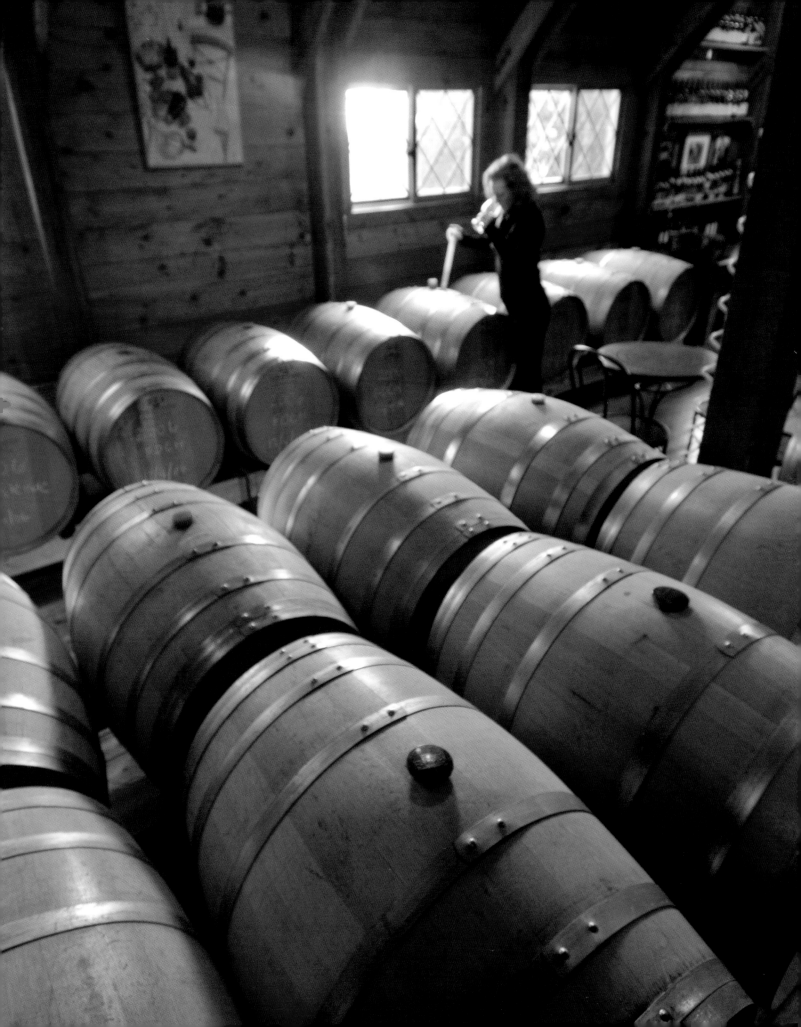

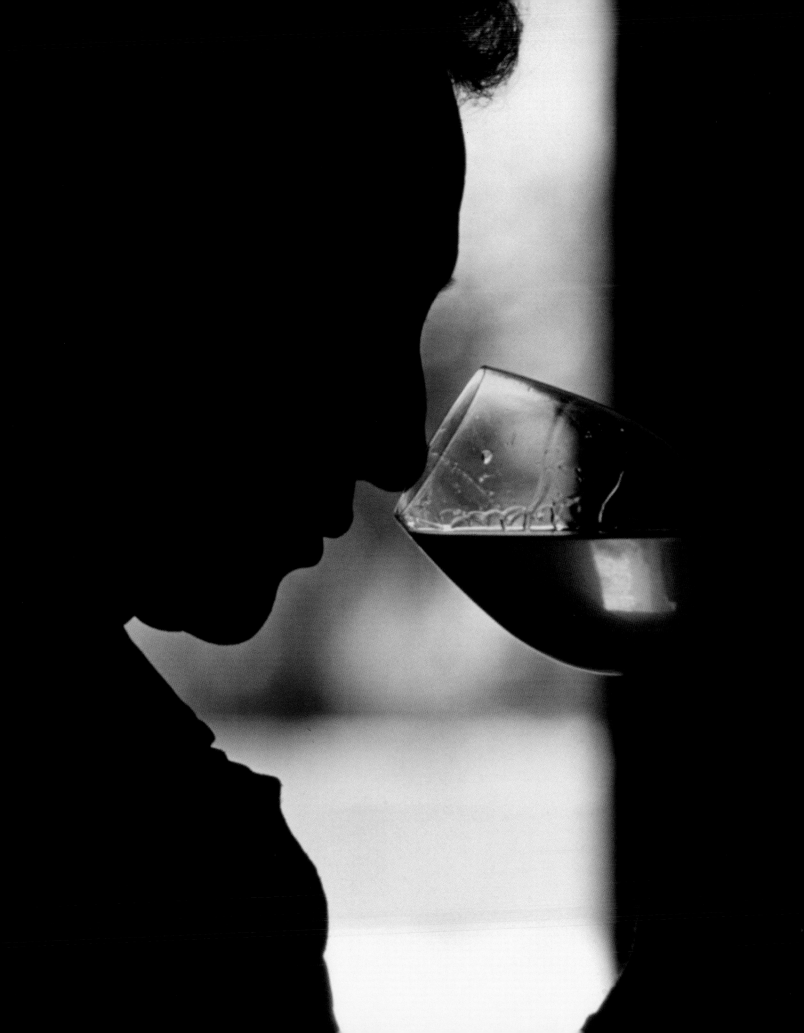

{ PASSION }

A Love Affair with Wine

Drink a glass of wine after your soup and

CALIFORNIA: Shafer Vineyards winemaker, Elias Fernandez, samples Chardonnay from the winery's cellar east of Yountville. (Preceding page 142)

ARKANSAS: In Altus, grapes are displayed for sale during the Prohibition era of the 1930s. (Preceding page 143)

CALIFORNIA: Awards and recognition from wine competitions hang on the tasting room wall of Sobon Family Wines of Plymouth in the foothills of the Sierra Mountains. This region was settled by Virginians after the Gold Rush and is best known for producing distinctive Zinfandels. (Above)

WISCONSIN: Like people and wine, vineyards can have personality. Often grape growers treat their vines like children—they watch them grow, know how they behave and enjoy what they give. Here at Wollersheim Winery outside of Prairie du Sac, a vineyard is named for assistant winemaker Vicki Orr who feels like a parent of the grapes she will transform into wine. (Facing page)

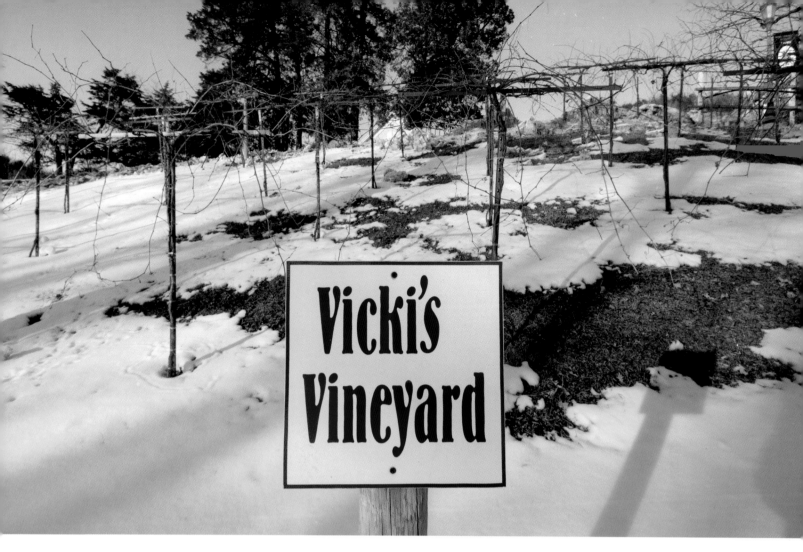

you steal a ruble from your doctor. —RUSSIAN PROVERB

{ "Terroir" is a French word for a vineyard's soil, elevation, hours of sunshine, amount of rain, and temperatures. }

Chardonnay is America's most popular wine and has been the superstar of white wines worldwide for more than two decades.

TEXAS: Chardonnay grapes form a backdrop to a glass of America's favorite white wine while 10-year-old Chardonnay Switzer helps in her family's winery in Fredericksburg. Grown worldwide, Chardonnay attained its reputation in the Burgundy region of France and is also one of the grapes used to produce Champagne. (Left and right)

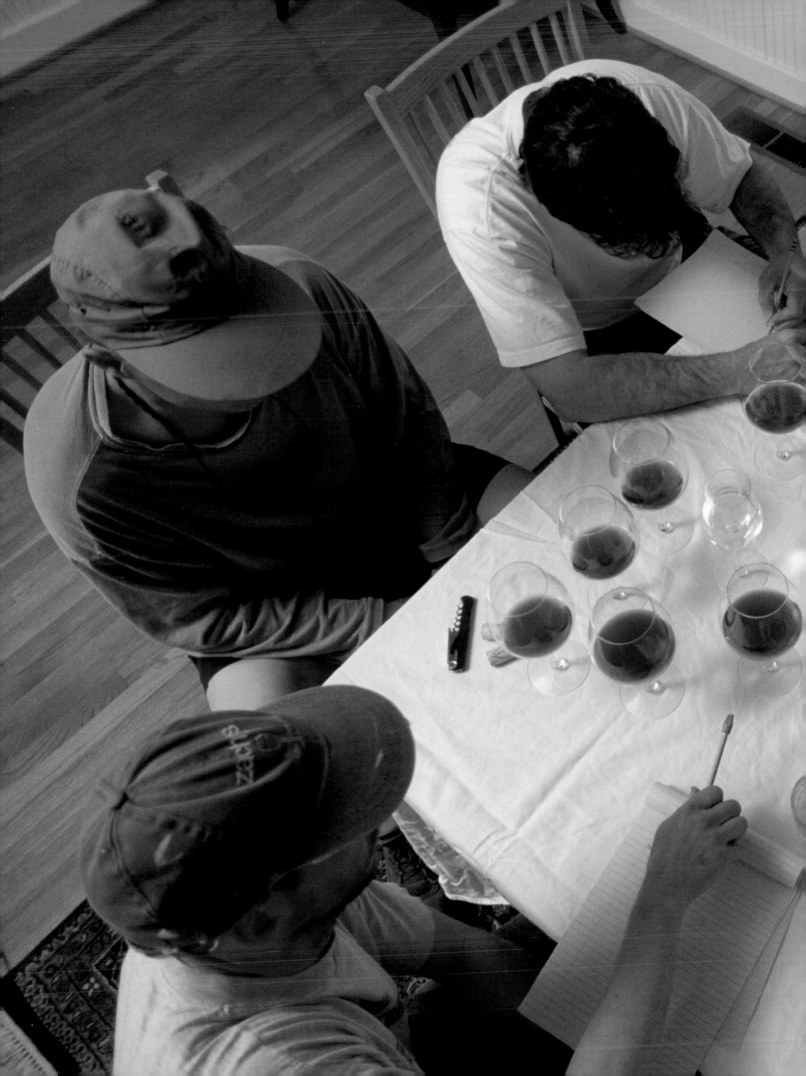

OREGON: Blending day at a winery arrives months after harvest and winemaking. This is the time when the winemakers and winery owners come together to taste wines from different barrels and vineyards to blend them for the best wine possible. Here at Argyle Winery in Dundee, winemaker Rollin Soles guides fellow employees in tasting Pinot Noir samples.

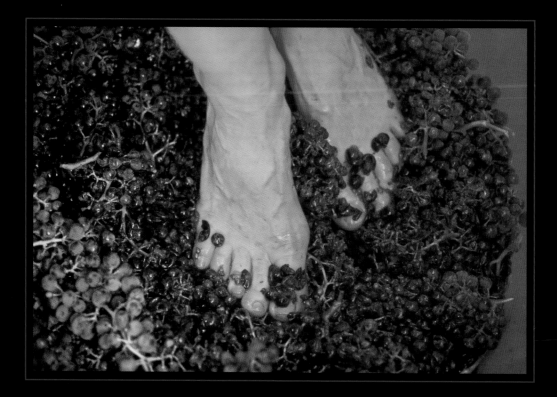

Grow some grapes, invite friends over to pick them,

crush with your feet, ferment the juice, age in wood barrels, bottle the wine,

attach your own label — and enjoy the fruit of your efforts!

CALIFORNIA: Winemaking is not limited to commercial wineries. Home winemaking has been popular since immigrants first arrived in America hundreds of years ago. Traditional methods of grape crushing with feet are limited to home winemakers who may produce only a barrel or a few cases annually. (Above)

VIRGINIA: Describing his love for wine to friends, consultant winemaker and winery owner Gabriele Rausse of Charlottesville makes his passion for winemaking clear. Gabriele's expertise remains in high demand as interest in making wine explodes in this emerging wine state. (Right)

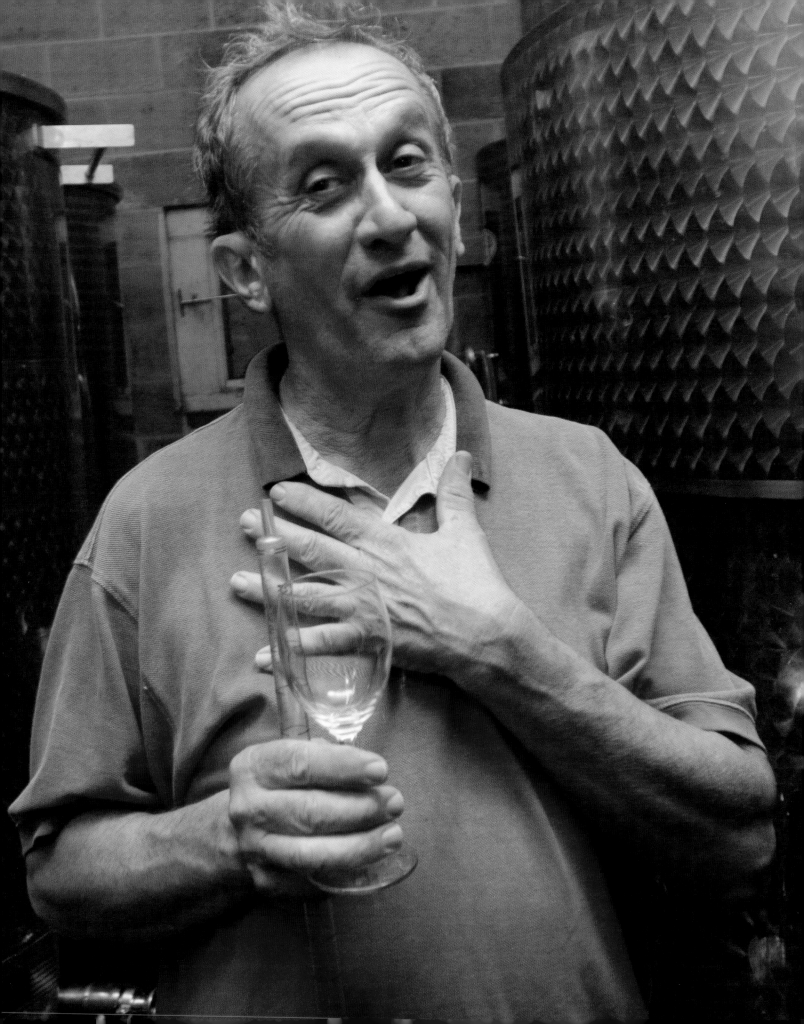

CALIFORNIA The underground Grand Chai of Opus One in Napa Valley's Oakville community houses 1,000 barrels. Inverted glass "bungs" are used here as stoppers for the first weeks of barrel aging. Bungs, which create the necessary seal for a barrel, are also made from wood and silicon.

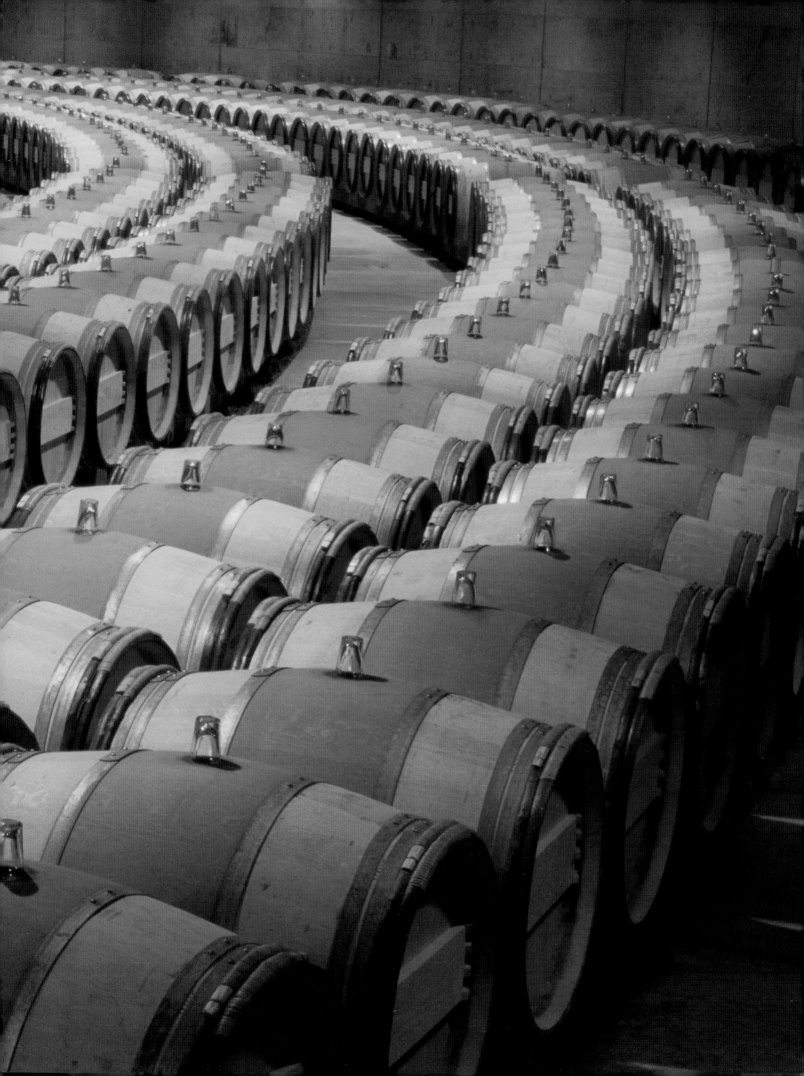

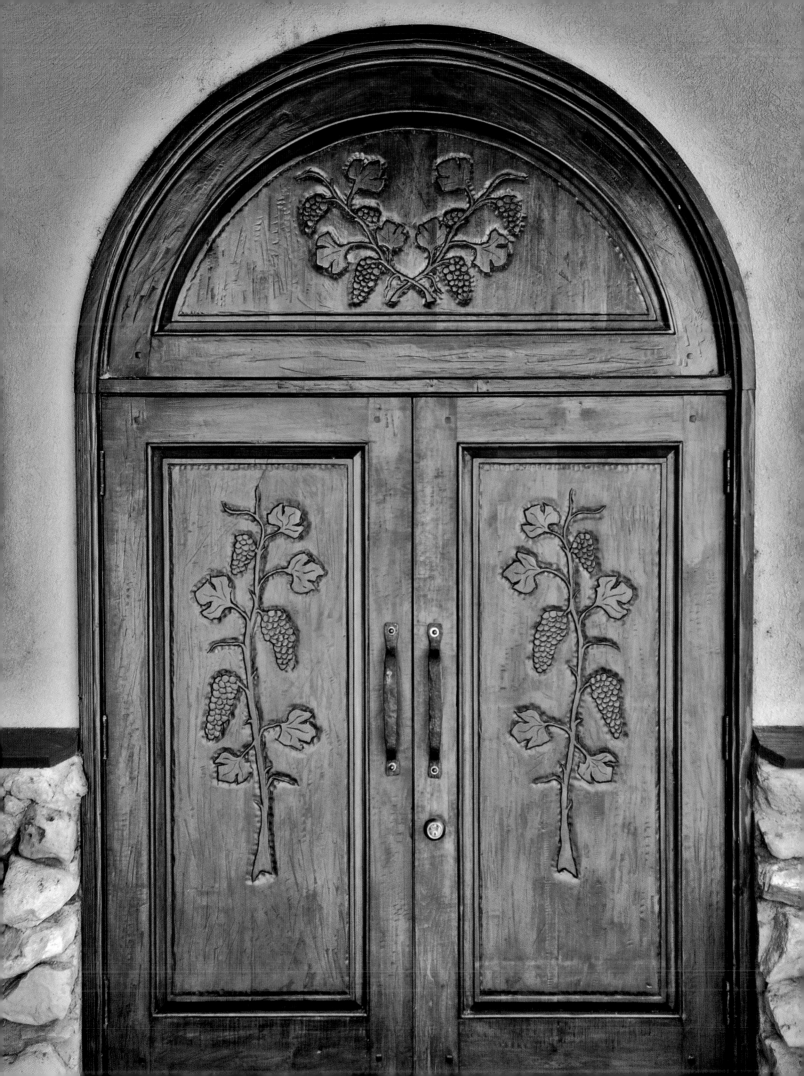

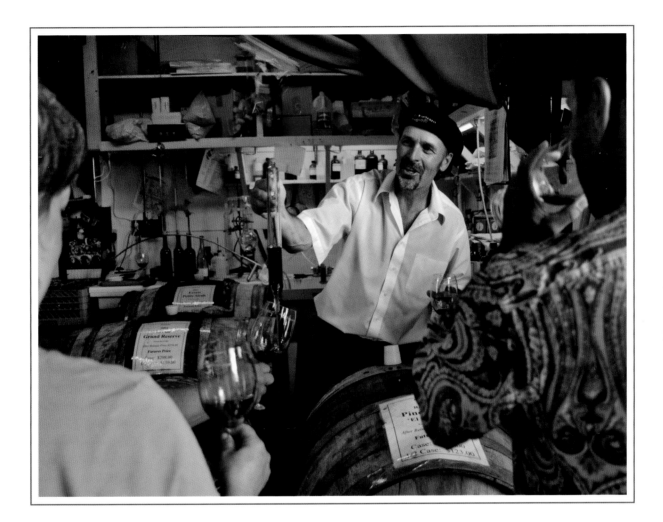

Labels were first used on wine bottles in the 1700s.

COLORADO: Arches in doors and windows have become icons for the wine industry. They can suggest entry into caves, they can recall history, and they can support a significant weight as well as span a wide area. This nine-foot entryway to Grand River Vineyards in Palisade was carved by Tom Winne in 1993. (Preceding page 154)

VIRGINIA: Winemaker Mike Heny of Horton Vineyards near Charlottesville monitors his production area located in stone cellars under the winery tasting room. (Preceding page 155)

MINNESOTA: The bathroom at Alexis Bailly Vineyard southeast of Minneapolis is decorated with labels from the wines the family has tasted since the winery opened in 1978. (Left)

CALIFORNIA: A festival atmosphere surrounds a tasting event at Charles Mitchell Vineyards in Fair Play, a town in the Sierra Mountain foothills. (Above)

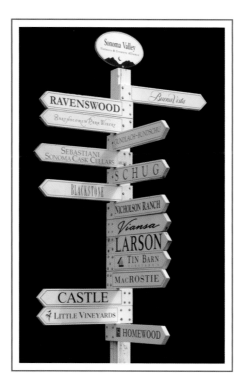

In the early 1980s, the U.S. government developed a system to define wine regions by their geography and climate. Today there are more than 170 American Viticultural Areas (AVAs).

CALIFORNIA: A road sign in Sonoma points visitors to nearby wineries. (Above)

HAWAII: Tour guide Haunani Au Yat expresses the joy she feels at telling visitors about the tasting room for Tedeschi Vineyards on Maui which was built in 1874 as a retreat for Hawaii's last king—King Kalakaua. The winery looks out over the vast Pacific Ocean from the slopes of 10,023-foot Haleakala Crater. (Top right)

ARKANSAS: Make no doubt about the passion for wine this driver feels. In the foothills of the Ozarks near Altus, Dennis Wiederkehr displays this license plate on his truck. His family settled here in the 1880s and built Wiederkehr Wine Cellars which still operates today. (Bottom right)

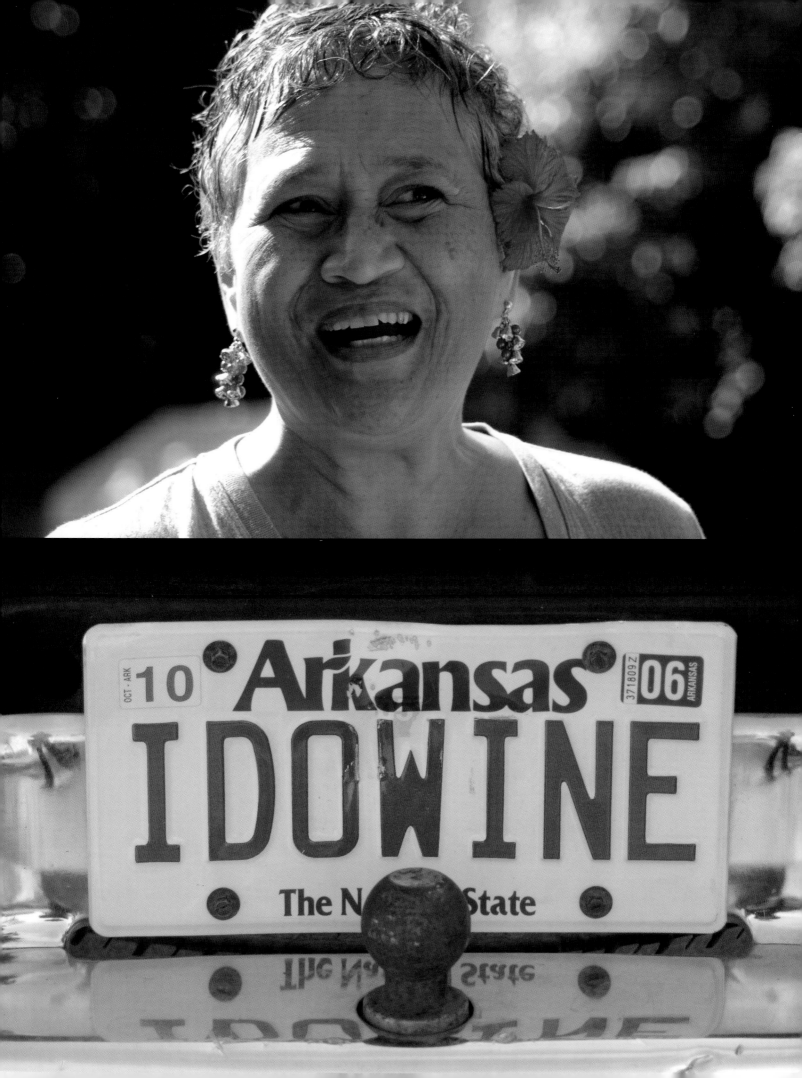

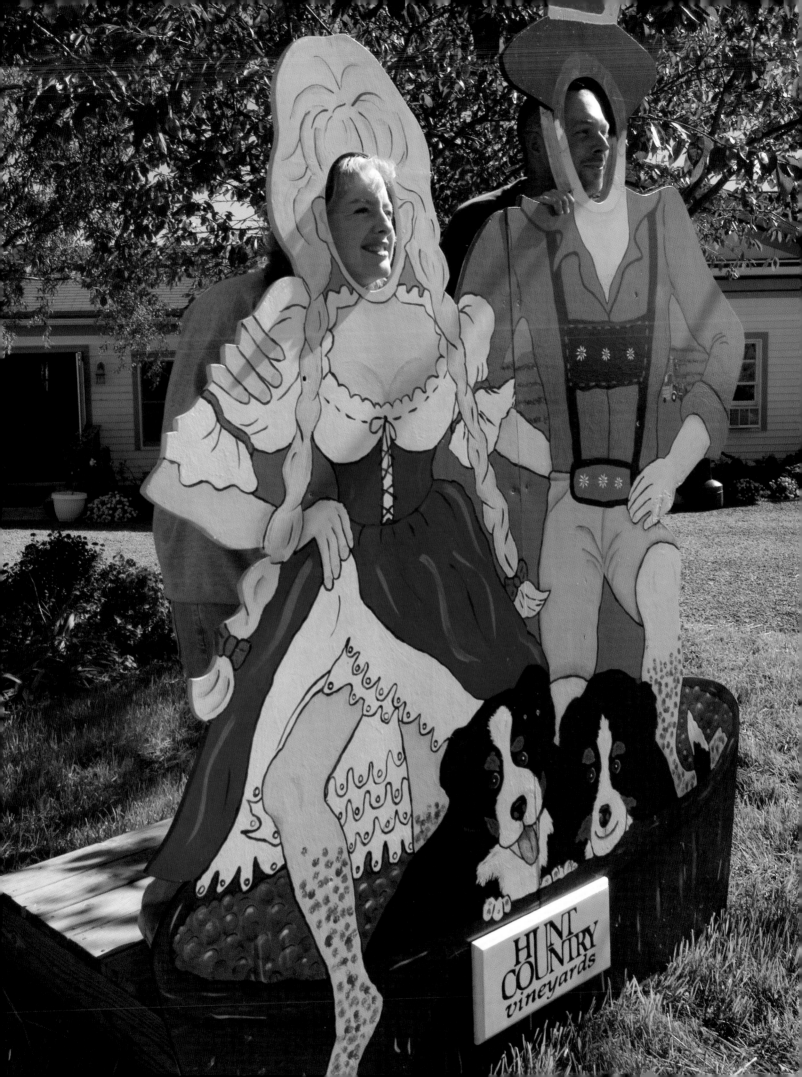

NEW YORK: Visitors are cheerful as they pose for a photo at the annual harvest festival at Hunt Country Vineyards in Branchport. (Left)

UTAH: Volunteer Ray Radley smiles at the end of a day bottling and labeling wines at Castle Creek Winery near Moab in the "Canyonlands." The growing conditions here have been described as similar to the eastern Mediterranean where wine grapes originated. (Right)

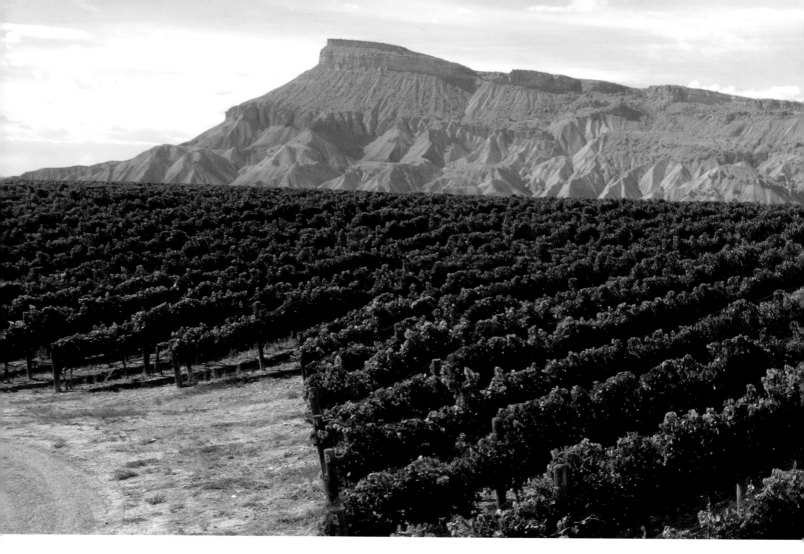

COLORADO: Mount Garfield frames the backdrop to this vineyard on Orchard Mesa above Palisade. (Above)

NEW MEXICO: A painting by Lynda Burd decorates a wall of her Black Mesa Winery on the highway between Taos and Santa Fe. The painting is based on ancient petroglyphs found in the surrounding area. (Right)

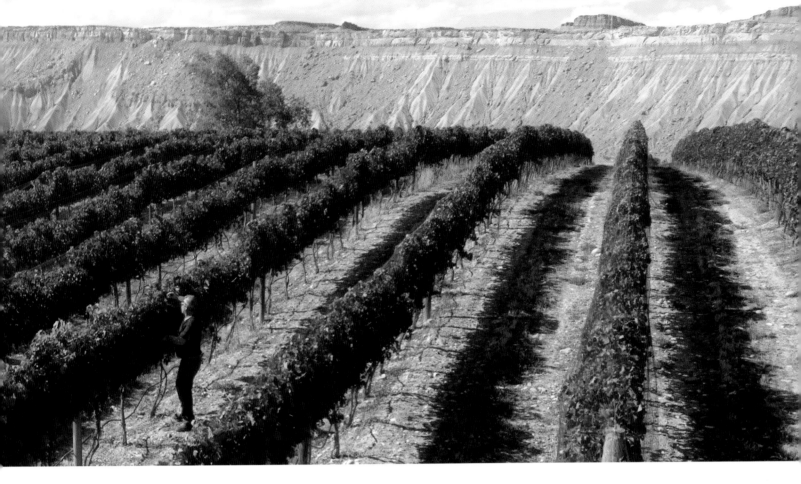

The spirit of American winemaking is reflected as fiercely in the West as in any other part of the country. Like the early pioneers, those who grow and make wine from Texas to Montana are challenged by just about everything—from difficult soils, wild terrain, high elevations, severe weather, a short growing season, and pests that range from bears to coyotes. Yet, while the grapes struggle mightily just to survive the land of cactus and tumbleweed, they are producing some wine that rivals the best in our country.

It is here in the West that we find vineyards in the red rock "Canyonlands" of Utah, the high desert plateaus of Arizona, the shadows of Idaho's Sawtooth Mountains, the hot plains of Texas, and the Colorado Rockies. In fact, the highest vineyard elevation in the country—and perhaps the world— is at 6,400 feet near Paonia, Colorado. In these parts, one is likely to find vineyards near white water rafting, rock climbing and hiking trails and wineries housed in former cotton gins, bordellos and on Indian reservations. Anything goes here in the "wild" West, where pioneering wine growers and winemakers are staking their claim in America's wine industry!

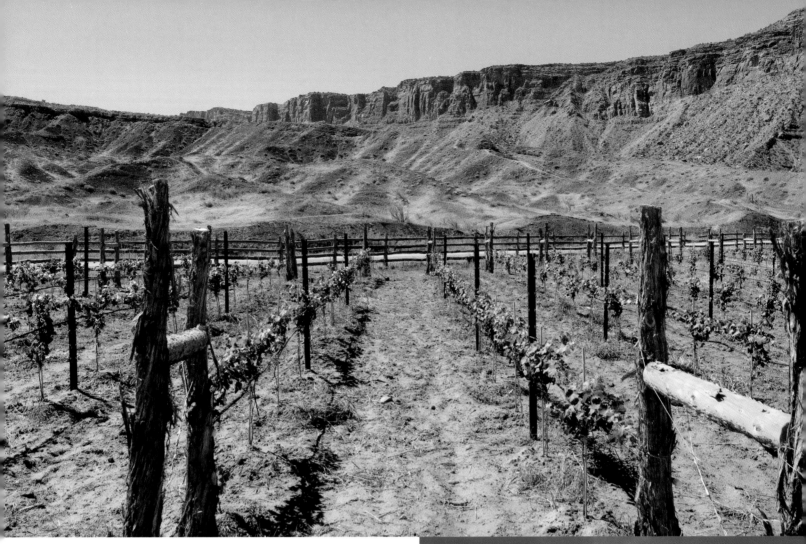

COLORADO: Nets drape a vineyard near Palisade a few weeks before harvest to protect from bird damage. The longer the grapes ripen on the vine, the higher their sugar content—which birds love as much as people. (Left)

UTAH: Newly planted Cabernet Sauvignon vines begin life at Castle Creek Winery east of Moab. This "Red Rock Country" is characterized by hot, dry summers and mild winters. (Above)

NEW MEXICO: A tile mosaic greets visitors to Casa Rondeña Winery in Albuquerque. (Below)

ARIZONA: Winery owner Kent Callaghan of Callaghan Vineyards in Elgin scrapes clay from his boots after a rainstorm. (Right)

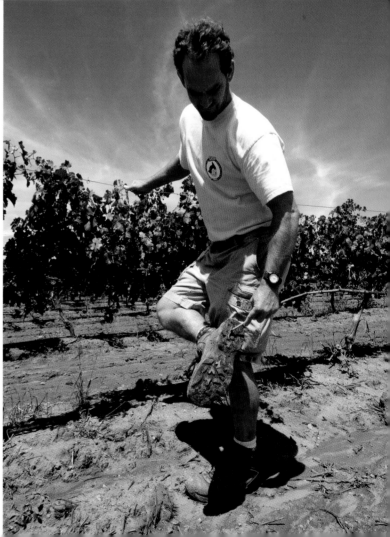

ARIZONA: A winding road leads to Sonoita Vineyards close to Eglin. Retired University of Arizona soil scientist Gordon Dutt established the vineyards and winery 25 years ago when he realized the red soils in this area near the Mexican border would produce grapes suitable for making wine.

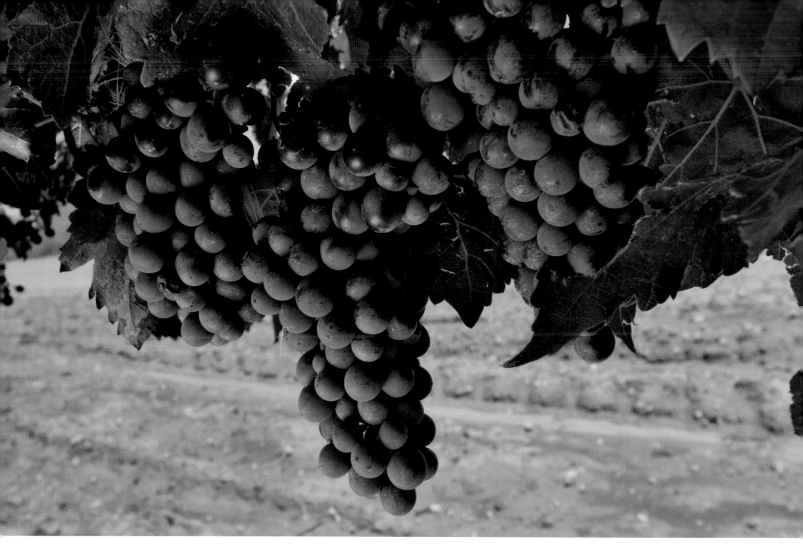

ARIZONA: Petit Verdot grapes hang from the vines of Callaghan Vineyards near the state's border with Mexico. Experts believe the grape thrives in warm, dry climates, a perfect match for this mile-high region southeast of Tucson. (Above)

NEW MEXICO: Freshly picked grapes at Swiss-owned New Mexico Vineyards near Deming are ready to be transferred to refrigerated trucks for shipment to wineries in West Texas, a distance of about 300 miles. The trucks travel overnight for morning delivery. (Facing page)

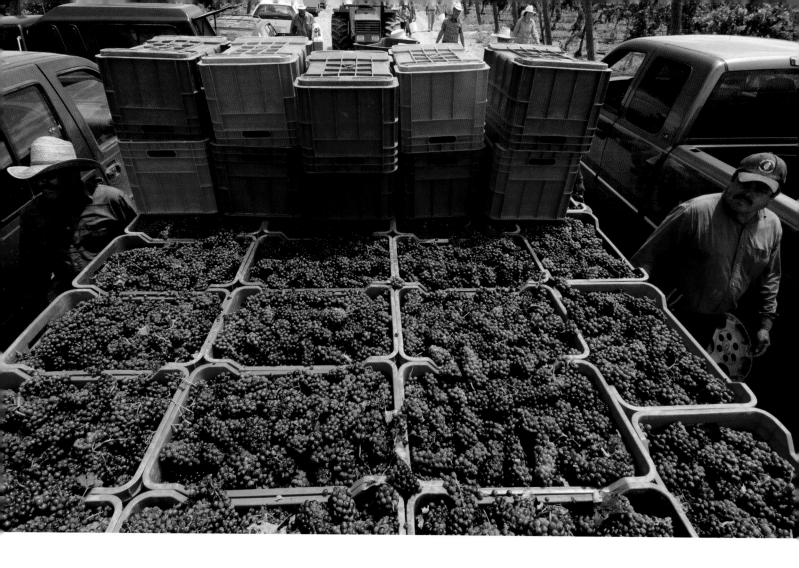

Red wine has a high amount of resveratrol, a natural compound in grapes that is reported to be linked to health benefits.

UTAH: Red spires of Castle Rock east of Moab dwarf tiny Round Mountain Vineyards located among the trees in the lower foreground. One of only five in the state, the winery grows and produces 100 cases of Chardonnay annually, making it perhaps the smallest commercial winery in America. A portion of the rock formations on the left is known as "The Priest and Two Nuns."

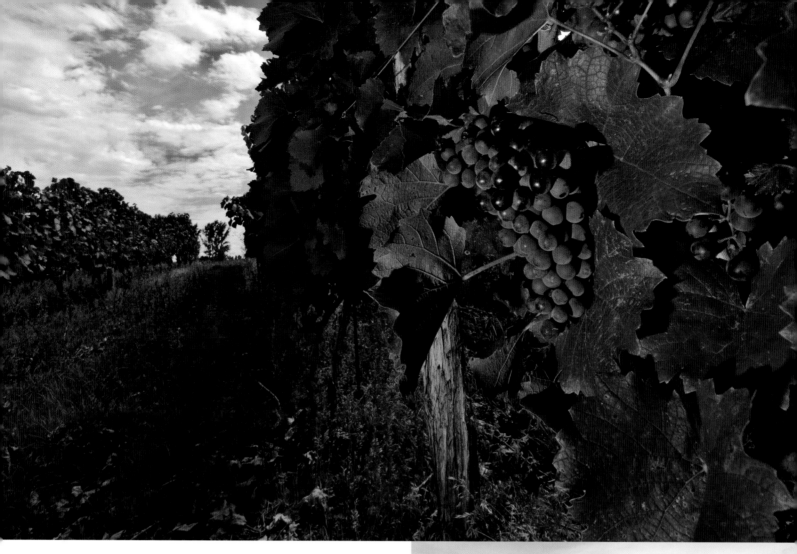

IDAHO: An early summer rain squall rolls across the fertile valley near Nampa as it approaches the vineyards of Sawtooth Winery. In the foreground, the winery's southwest facing vineyards are the warmest areas of the property and are well suited for classic European grapes, which thrive on the long hot days of Idaho summers. (Left)

COLORADO: Lemberger grapes hang ready for harvest at Carlson Vineyards in the Palisade area. (Above)

UTAH: It may not work for pests or weather, but this scarecrow at Spanish Valley Vineyards and Winery south of Moab should scare away any birds. (Right)

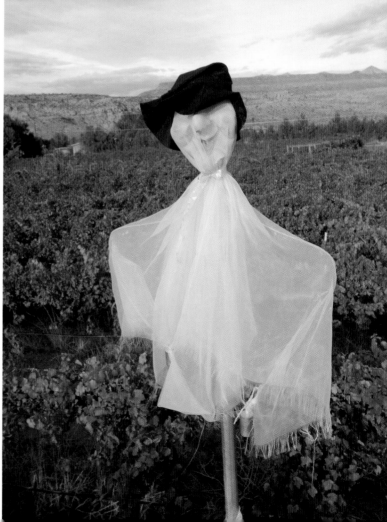

TEXAS: Visitors practice stomping grapes at a harvest festival at Becker Vineyards close to Stonewall. This Texas Hill Country winery is one of over 20 commercial wineries in the area.

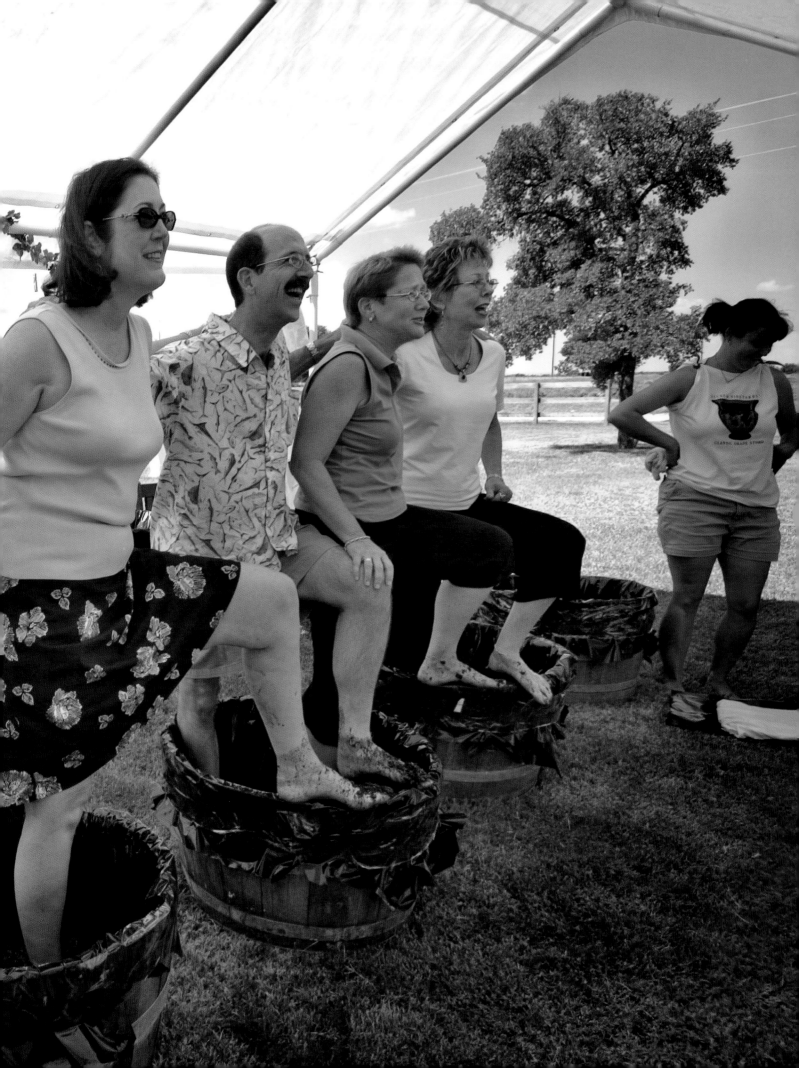

The spirit of American winemaking is reflected as fiercely in the West as in any other part of the country— from corkscrews, to wine labels, to the cowboy winemakers.

TEXAS: Footprints on T-shirts provide souvenirs for visitors who stomped grapes at Becker Vineyards during the winery's harvest festival. (Top right)

In early summer, all grapes go through a process called "véraison," a French word for the beginning of ripening. Before véraison, the berries are tiny, hard and green, but as they ripen they become soft and change color to red or gold-green depending on the grape variety. (Bottom right)

Weekend visitors crowd the Becker Vineyards tasting room in the Texas Hill Country west of Austin. (Following pages 178–179)

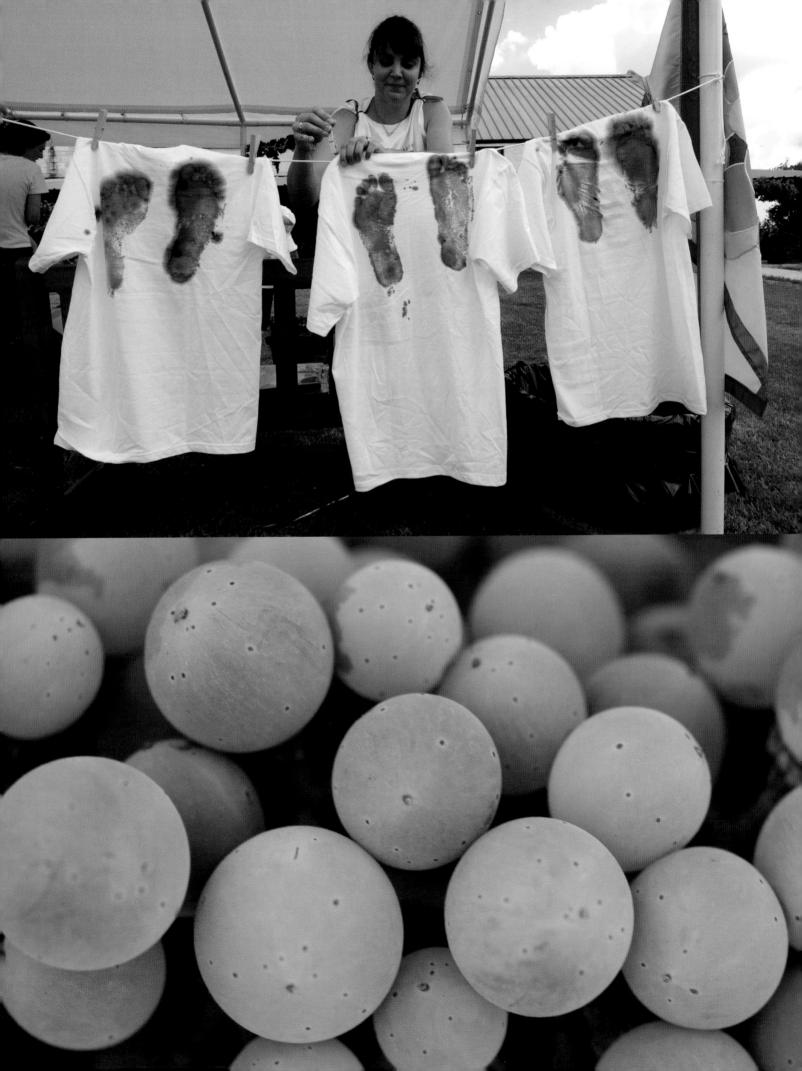

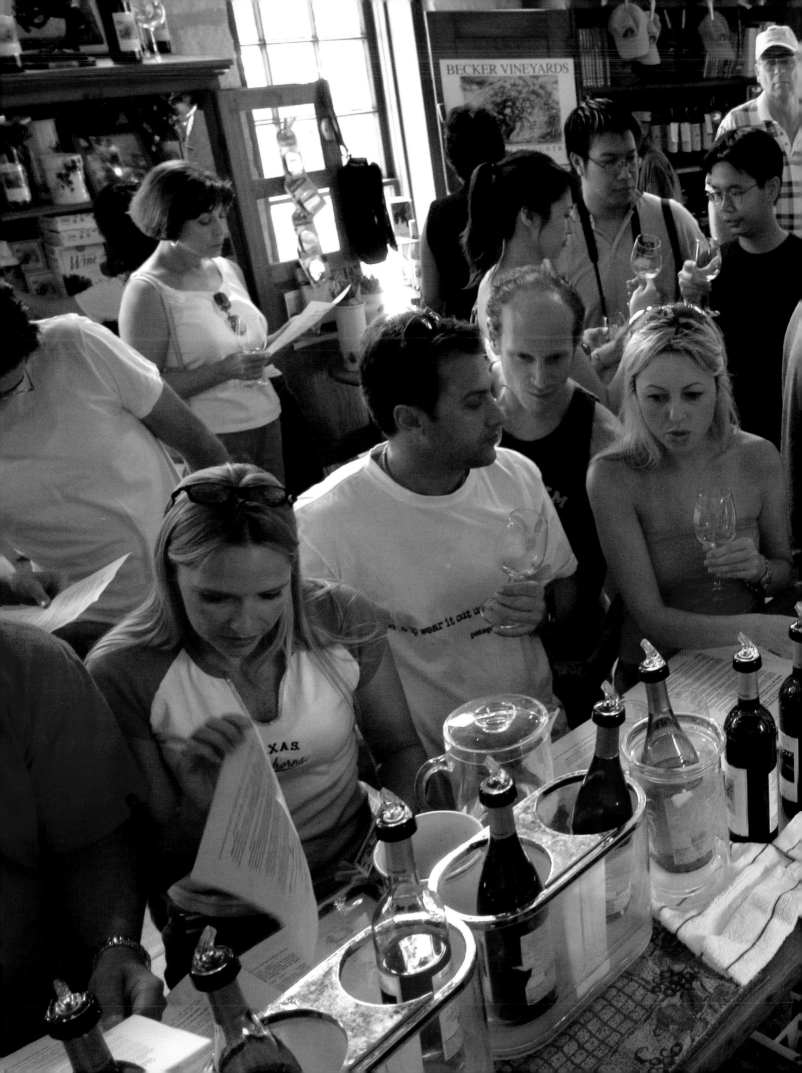

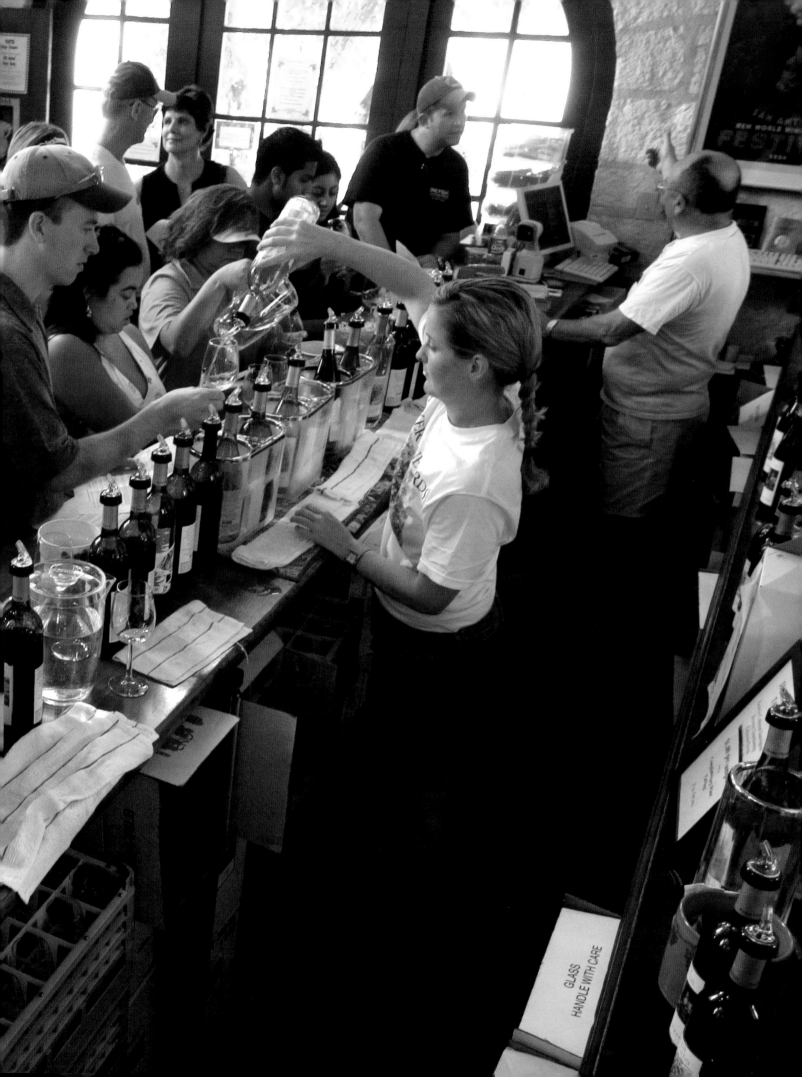

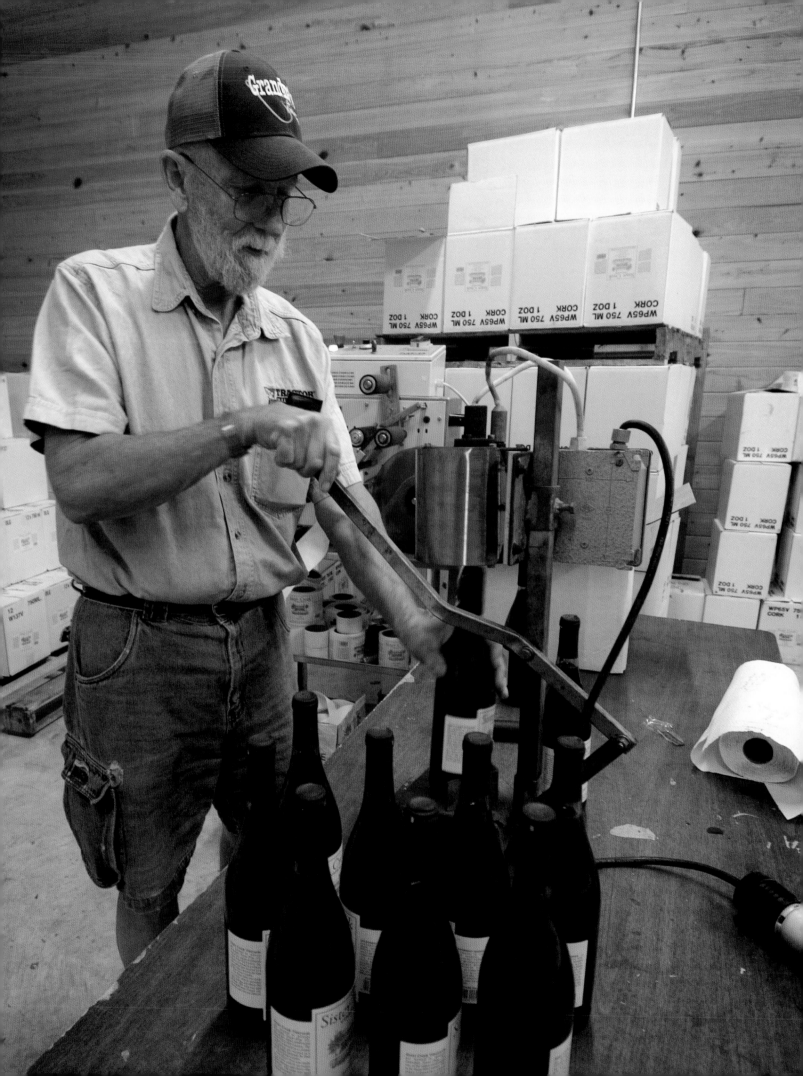

TEXAS: Fred Reissig hand corks 3,000 cases of wine annually for Sister Creek Vineyards in Sisterdale. (Left)

Lights from the guest cottage at Becker Vineyards glow during sunrise. (Above)

New wine barrels are soaked with water to expand the wood and prevent leakage so wine can be aged in them. (Below)

An iconic windmill stands above Bell Mountain Vineyards east of Fredericksburg. (Right)

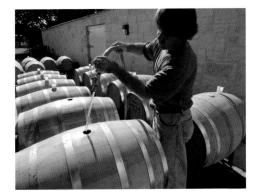

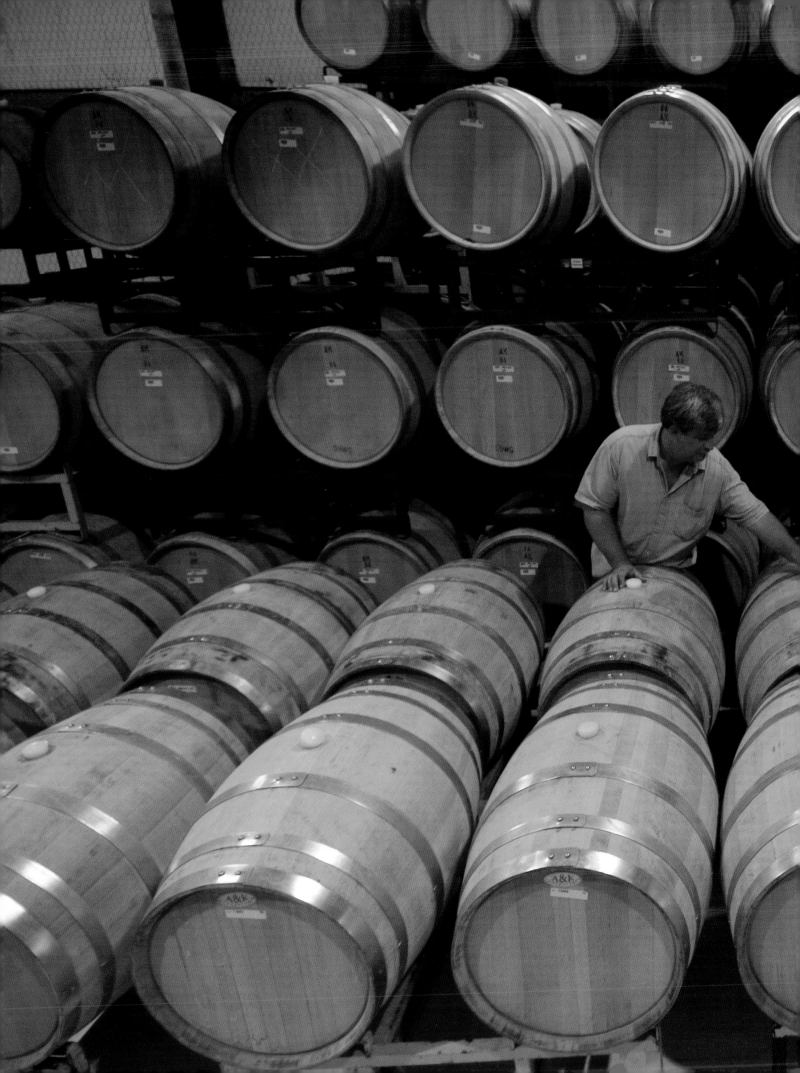

TEXAS: Winery manager Jim Brown inspects barrels at Becker Vineyards. Wine barrels traditionally hold about 60 gallons, which translates into 300 bottles of wine. Barrel makers in Missouri, Kentucky and France vie to sell to wineries across America.

COLORADO

PENNSYLVANIA

MISSOURI

VIRGINIA

MARYLAND

WINERY ARCHITECTURE U.S.A.:
(Top row, left to right) Native rock shapes a door at Stone Cottage Cellar in Paonia, Colorado. The tower of Mt. Hope Winery at Manheim, Pennsylvania. Pastel colors highlight a building at Mt. Pleasant Winery in Augusta, Missouri. Dusk surrounds a Napa Valley dinner party at the Gleason Barn of Nickel & Nickel in Oakville, California. A former church serves South River Winery near Geneva, Ohio. A giant wooden portico greets visitors at Snoqualmie Winery in Prosser, Washington.

(Bottom row, left to right) Contemporary touches highlight Boxwood Winery near Middleburg, Virginia. An historic barn at Boordy Vineyards in Hydes, Maryland. A front view of Bedell Cellars on Long Island, New York. In Georgia, at the foothills of the Appalachian Mountains, windows make a statement at Frogtown Cellars north of Dahlonega.

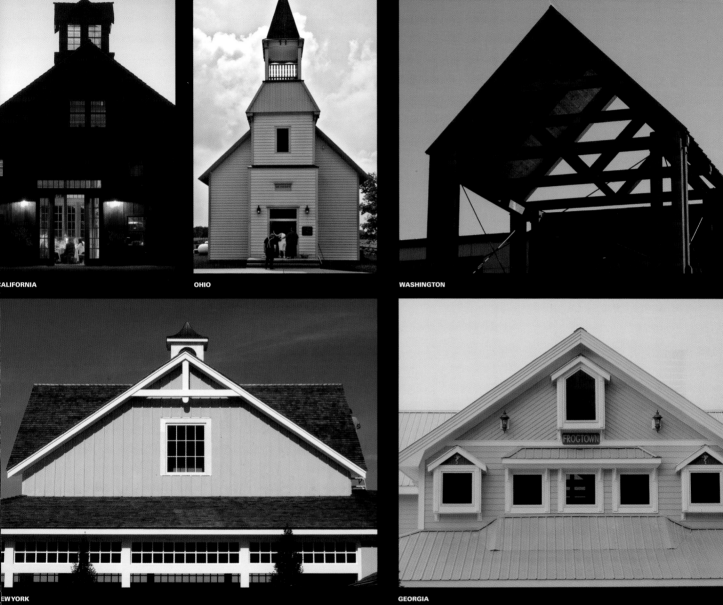

CALIFORNIA

OHIO

WASHINGTON

NEW YORK

GEORGIA

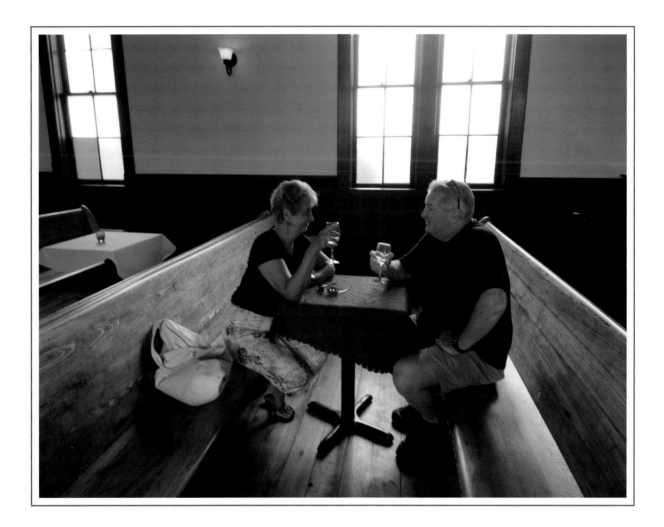

"Go eat your food with gladness,

and drink your wine with a joyful heart, for it is now that God

favors what you do." —ECCLESIASTES 9:7

OHIO: In the pews of a former Methodist Episcopal church, visitors John and Mary Hall, taste wine at South River Winery south of Geneva. Built in 1892, the church building was slated for destruction before it was bought and moved in 2002 to serve as a winery and tasting room. (Above)

CALIFORNIA: A balancing act is performed by waiter Mario Traverso as he carries 25 crystal wine glasses at the Wine Spectator Greystone Restaurant on the campus of the Culinary Institute of America in St. Helena. (Right)

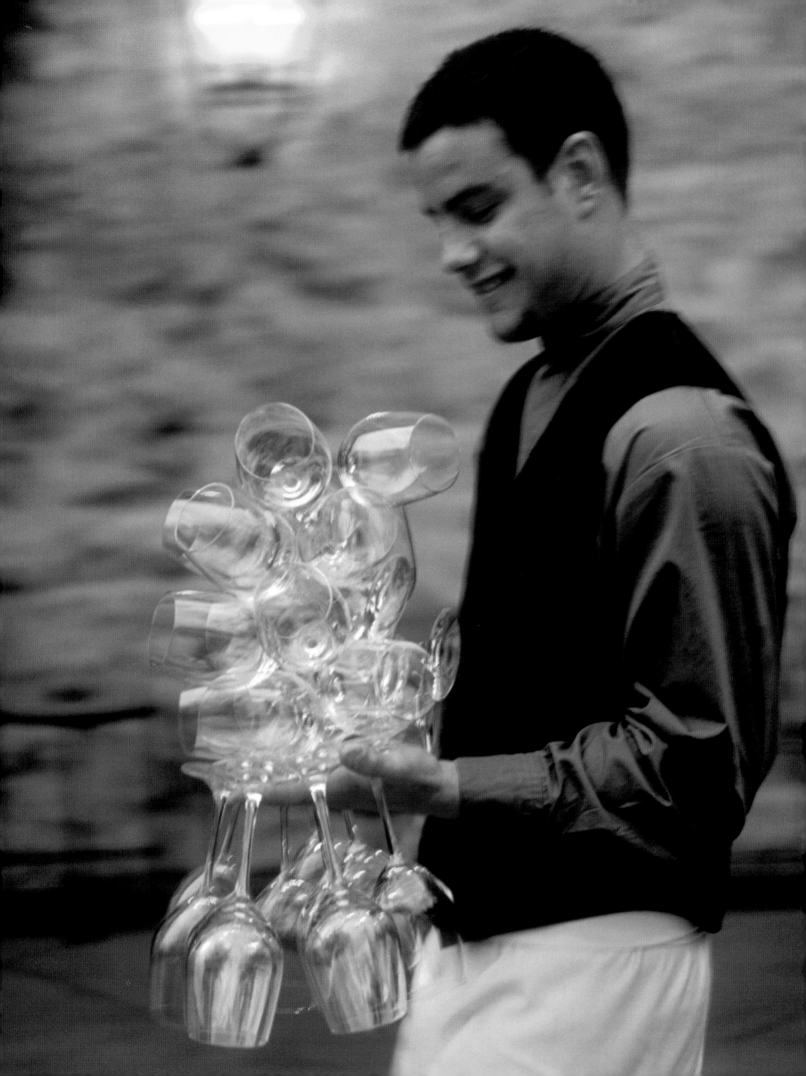

NEW YORK: A visitor enjoys views at Long Island's Old Field Vineyards, a winery which transformed a pre-Civil War tool shed into its tasting room. These vineyards in Southold descend to the edge of Peconic Bay, which is fed by the Atlantic Ocean. The "ocean effect" provides moderate summer temperatures for optimum vineyard growth.

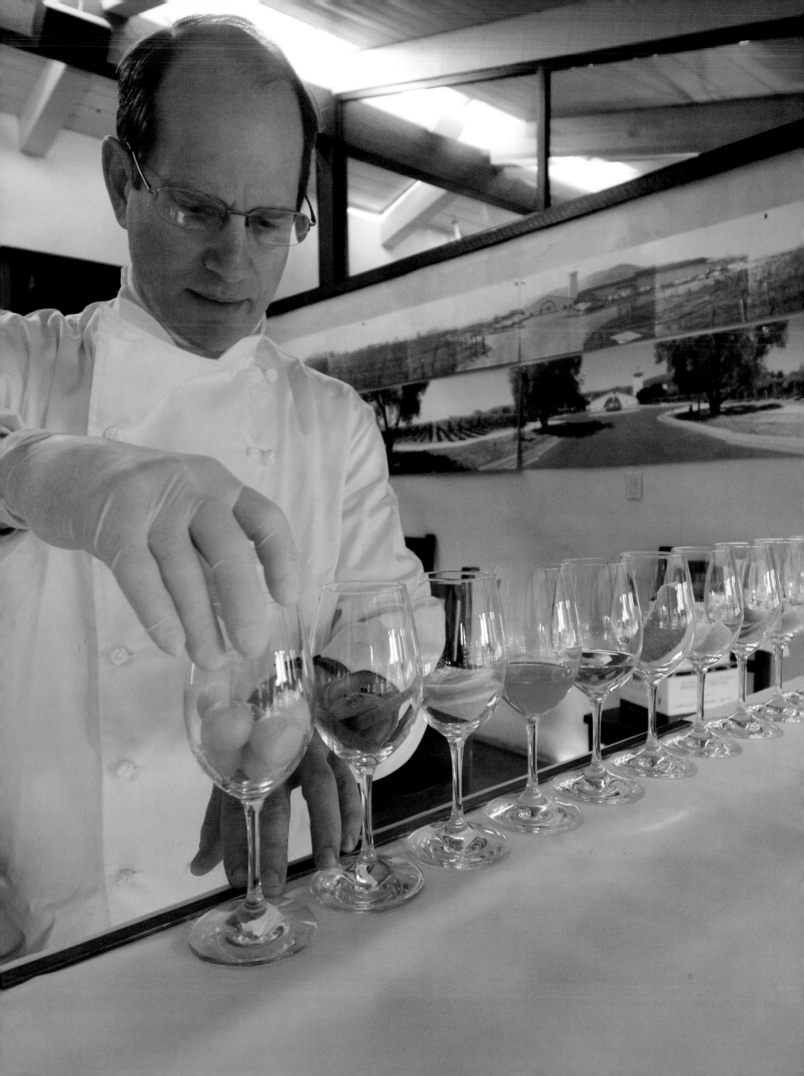

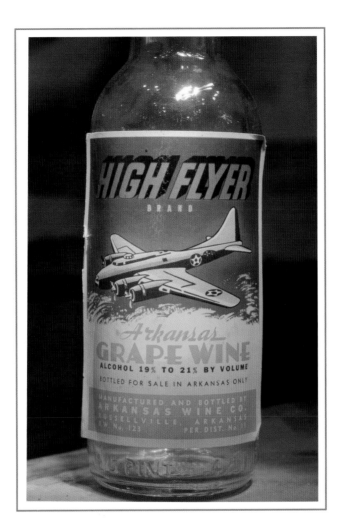

The tongue detects only five flavors (sweet, sour, salt, bitter, umami) while the nose detects 10,000 smells.

CALIFORNIA: The aromas of wine are as important as the taste. To demonstrate that, chef George Ellis prepares 84 glasses with a different ingredient as part of a weekly "Essence Tasting" at the Robert Mondavi Winery in Napa Valley. The class unveils the mysteries of aromatic essences commonly associated with red and white wines such as green apple, cherries, peach, smoke, pineapple, berries or oak. (Left)

ARKANSAS: Early days of winemaking in this region are on display at the Cowie Wine Cellars in the northwest corner of the state. This bottle of "High Flyer" was produced in the 1940s at the Arkansas Wine Company of Russellville. (Above)

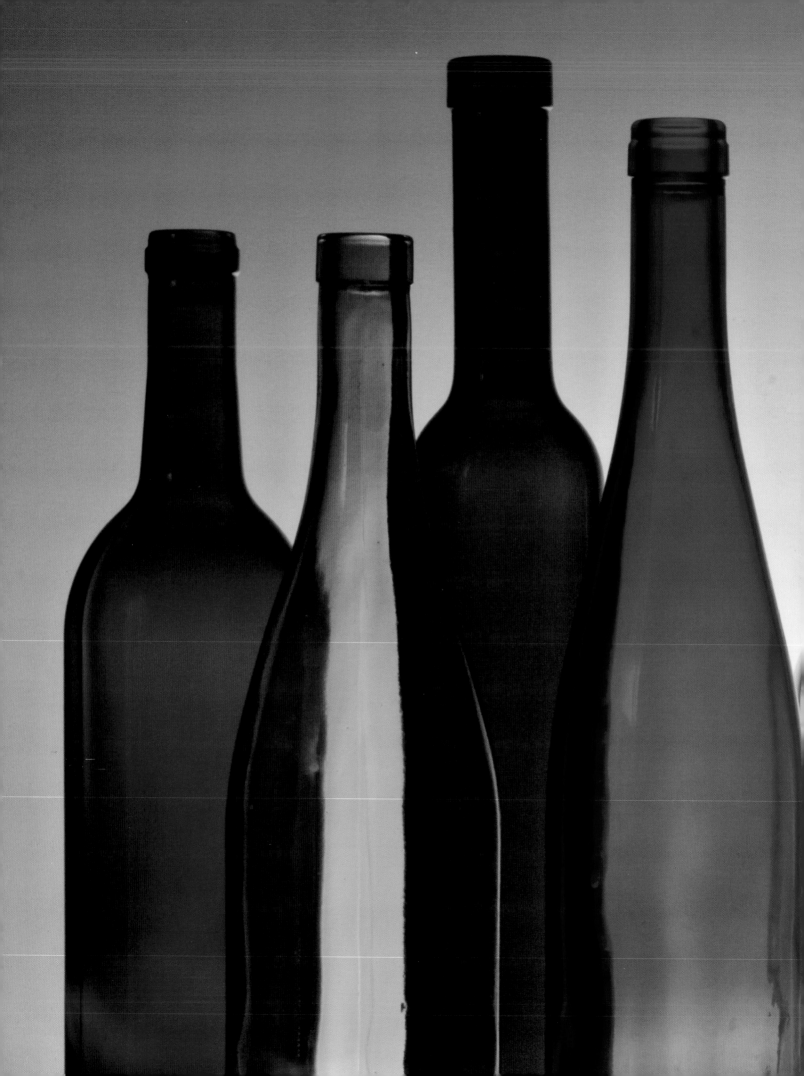

Back of this Wine is
the Vintner
And back through the years
his Skill
And back of it all are the Vines
in the Sun and the Rain
And the Master's Will.

M. Barone

1857

They have no Wine
John 2-3

Here's to those
who wish us well
All the rest
may go to Hell!

...I shall bring about
the restoration of my people Israel.
They shall rebuild
and inhabit ruined cities,
Plant vineyards and drink the wine,
set out gardens and
eat the fruit
Amos 9:11

...there
no doubt
(Bob Cowie)
to his own
Ken Forres...
Arkansas...

Original barrel from
Frank Nichols Winery
...89 Scranton

ARKANSAS: Wine barrels display paintings at the Arkansas Historic Wine Museum, part of Cowie Wine Cellars near Paris. Bette Kay Cowie began painting the barrels in 1974 and today they age the family's Port wines. A barrel with an early portrait of owner Bob Cowie receives attention from winery staff.

GEORGIA: Chateau Élan, a French-style chateau north of Atlanta, serves as a convention center and winery. The winery, which has some 75 acres of grapes, plants the vines further apart than growers do in other parts of the country to provide better ventilation because of the hot, humid climate. (Above)

A one-foot wide leaf from a Norton grapevine is held for examination. This vine, first propagated in Virginia in 1835, represents a truly American grape variety. (Right)

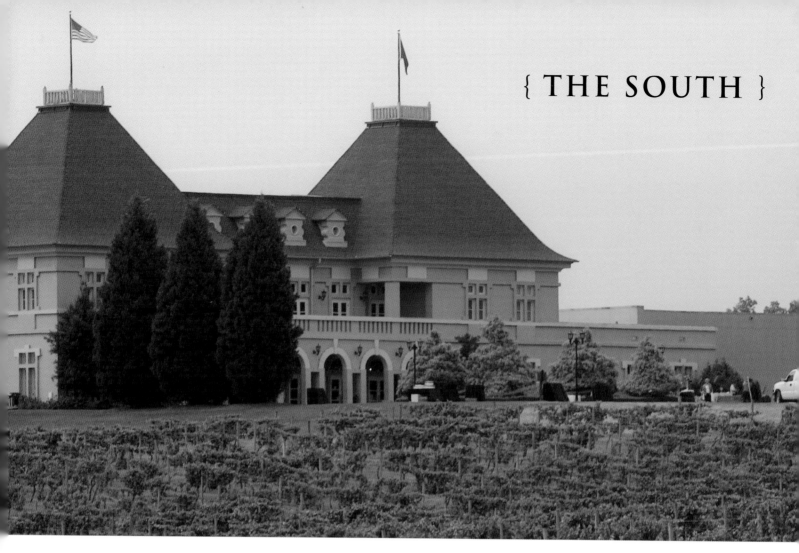

O f all the Southern States, Virginia makes the most wine, perhaps because the state has been growing wine grapes since the Jamestown settlers were required to do so in the early 1600s. Nearly 200 years later, Thomas Jefferson planted European wine grapes at Monticello, struggling with the old world grape in the new world climate. Today, Virginia is one of the largest wine producing states in America, but other Southern states are coming up strong, particularly North Carolina, where the winery at the Biltmore Estate in Ashville has become the most visited in the country.

Wineries are sprouting up all over the South, from the plantation country of Louisiana and Mississippi to the tobacco and horse racing regions of Kentucky, the cotton fields of Alabama and South Carolina, the cornfields of Maryland, and alligator territory of Florida lake country. Folks in the Ozarks of Arkansas, the foothills of the Appalachian Mountains in Georgia, the Great Smoky Mountains of Tennessee, and in the shadow of the Blue Ridge Mountains of Maryland are all making wine, some of it from the "Grape of the South"—the native Muscadine grape—which tolerates the region's high humidity. Today, Jefferson's dream that everyone have a little vineyard in their backyard seems to have come true in the South.

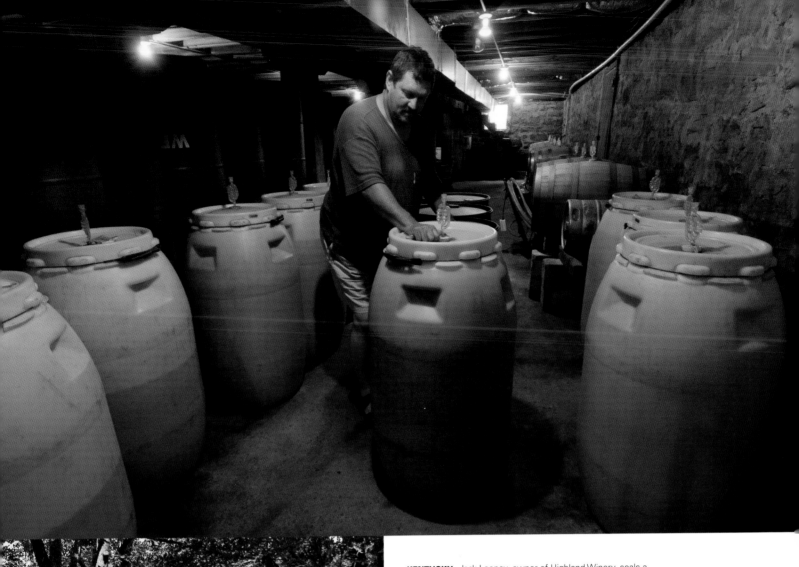

KENTUCKY: Jack Looney, owner of Highland Winery, seals a plastic barrel of wine in his basement, a former coal company headquarters in Seco. The wine will be moved into the surrounding hills where it will age in an abandoned coal mine. (Above)

VIRGINIA: In contrast to large commercial wineries, Great Falls resident Bill Garrett prepares his Italian grape press to make wines by hand. (Below)

TENNESSEE: The state's largest vineyard near Madisonville is monitored by owner Mike Frizzell. He supplies five varieties of Muscadine grapes to several state wineries. A barn formerly used to age tobacco once grown on the property rises in the distance. (Facing page)

ARKANSAS: Frank's Grape Wine made by Nichols Winery in Scranton is displayed at the Cowie Wine Cellars in Paris. The Nichols Winery operated between 1940 and 1953. In the early 1950s, 130 wineries existed in the state and Bob Cowie created a museum to preserve that history. (Following page 200)

GEORGIA: A portion of a 50-foot mural hangs behind the tasting bar at Chateau Élan northeast of Atlanta. Artist Art Rosenbaum, an art professor at University of Georgia, traced the history of wine from ancient beginnings to the present. (Following page 201)

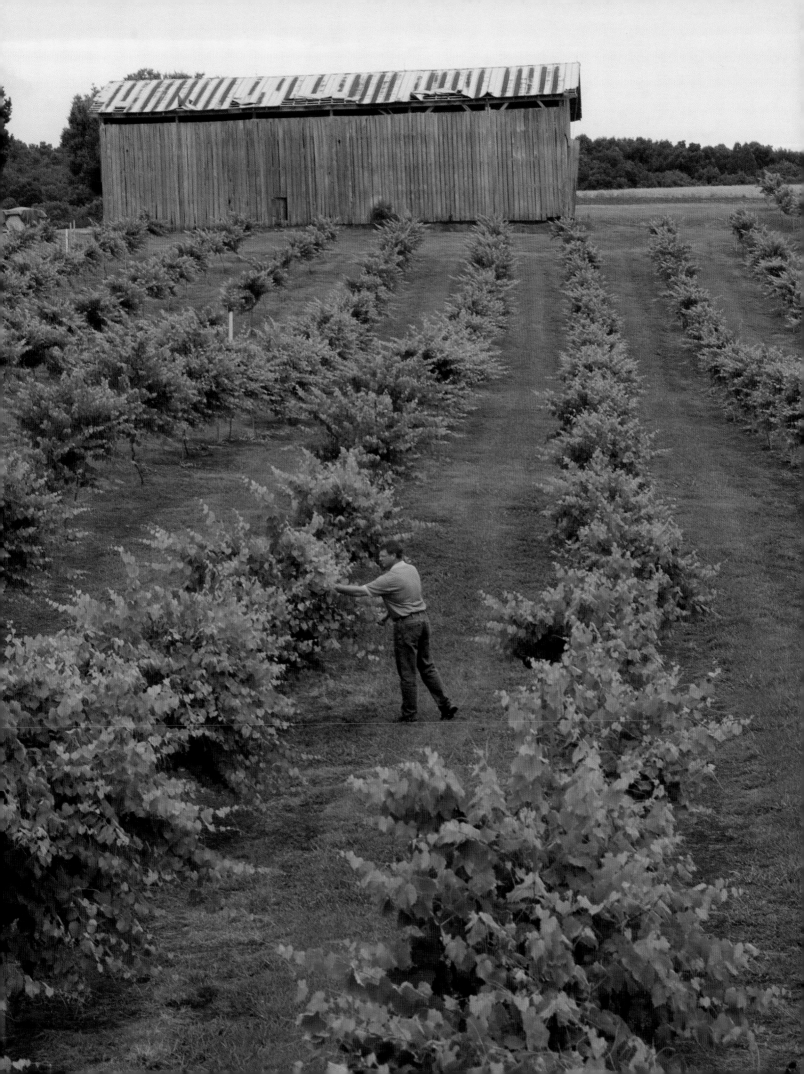

STATE OF ARKANSAS

FRANK'S
ARKANSAS
GRAPE WINE
Alcohol Contents
19 to 21 Per Cent by Volume
Manufactured and Bottled by
Nichols Winery
SCRANTON, ARKANSAS

Ark. Permit No. M77 No. W1631
Bonded Winery No. 89

© 1934

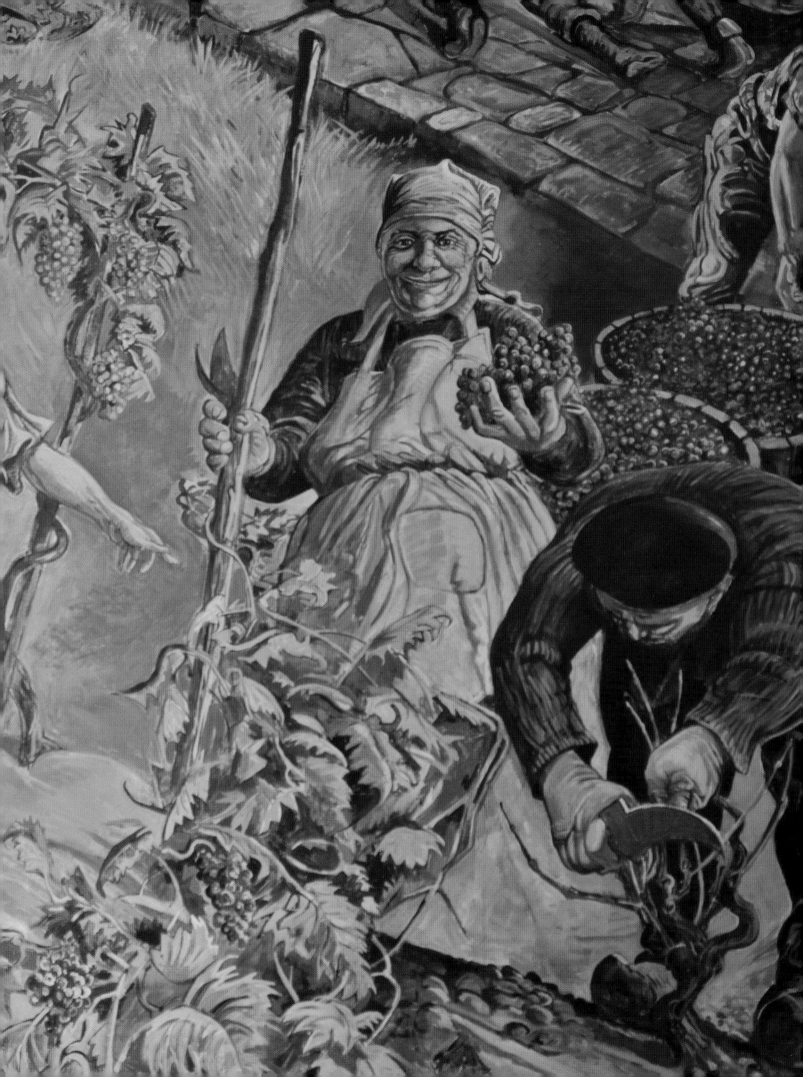

KENTUCKY: A barn formerly used to cure tobacco now serves as the winery production area for Equus Run Vineyards near Lexington. Joe Bohn, brother of owner Cynthia Bohn, pushes a filter into the winery before bottling.

No one knows how long the corkscrew has been around, but what is known is that the first patent was granted in the late 1700s to an English priest. Corkscrews come in many variations, from purely functional to wild and crazy.

KENTUCKY: At Equus Run Vineyards east of Lexington, summer crowds gather for food, wine and musical concerts. Many wineries across the country provide entertainment to draw visitors. (Top right)

When existing buildings aren't available for new wineries, the next best thing is to build your own. Here, Neil and Rachel Vasilakes drink wine on the porch of their newly constructed Wildside Vines winery south of the historic town of Versailles. They built the one-room winery to resemble area Bluegrass horse barns, complete with cupola. (Bottom right)

ALABAMA: Hands of winery owner Kelly Bryant tell the story of the work necessary to operate a small winery. Kelly retired as a Birmingham fireman and now operates Bryant Vineyards winery from the basement of the family home near Talladega. Grapes for the wine are grown on a former cotton field owned by his family since the late 1800s.

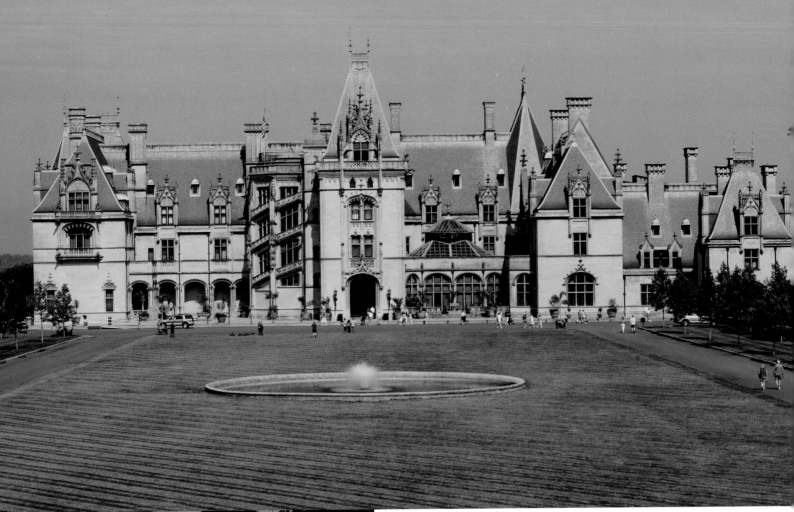

NORTH CAROLINA: The heart of the Biltmore Estate in Ashville is this 250-room mansion built in the 1890s by railroad industrialist George Vanderbilt. In 1985, a former dairy barn on the property was converted into a winery that attracts 600,000 visitors annually, making it the most visited winery in the United States. (Above)

VIRGINIA: A tower of the Barboursville Vineyard winery rises above the countryside northeast of Charlottesville. The vineyards, located at the foothills of the Blue Ridge Mountains, were established in 1976 on a former plantation owned by James Barbour who served as governor and senator almost 200 years ago. The winery produces more than a dozen wines from its 125 vineyard acres. (Left and facing page)

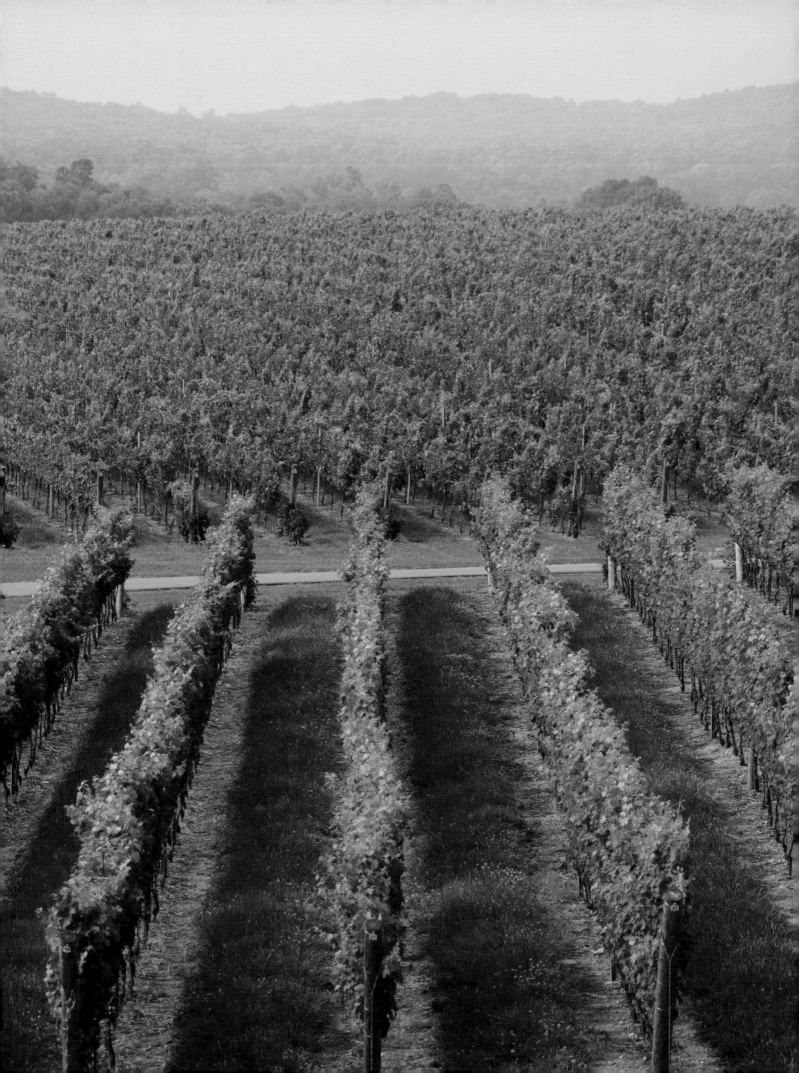

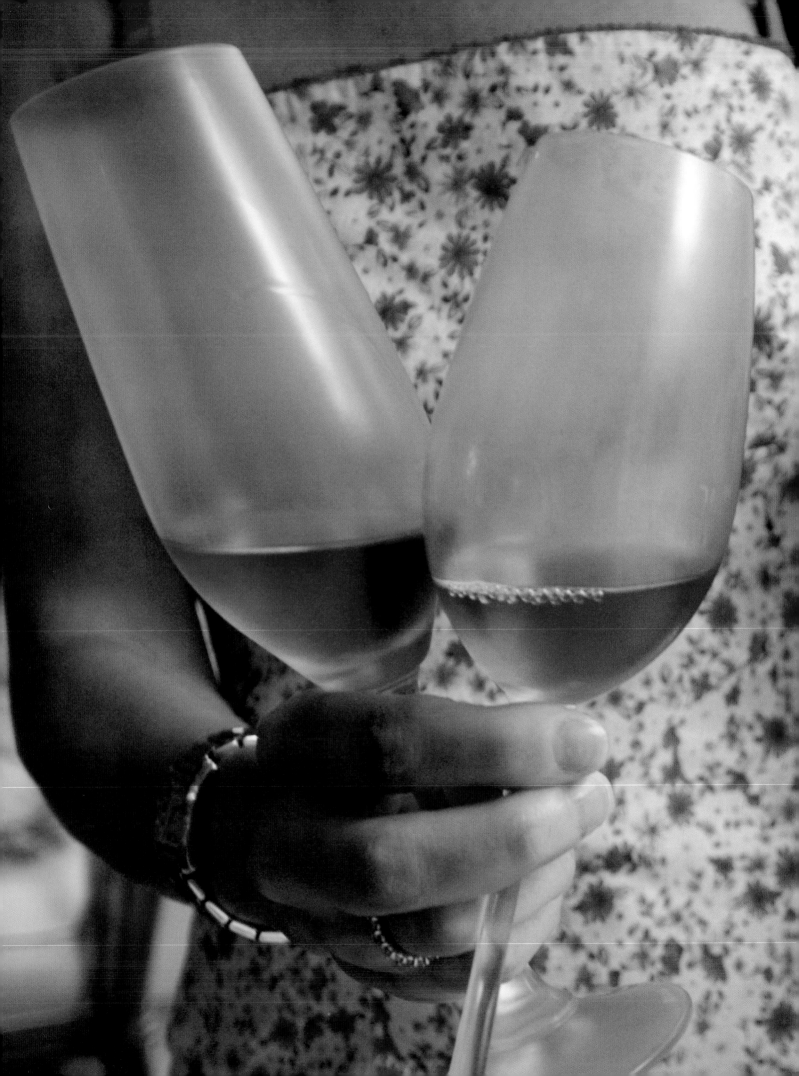

VIRGINIA: A rosé wine and sparkling white wine are served to visitors on a humid summer day at Kluge Estate Wines near Charlottesville. The wines were brought to a porch from the air-conditioned Farm Shop, which created condensation on the glasses, adding to the colors.

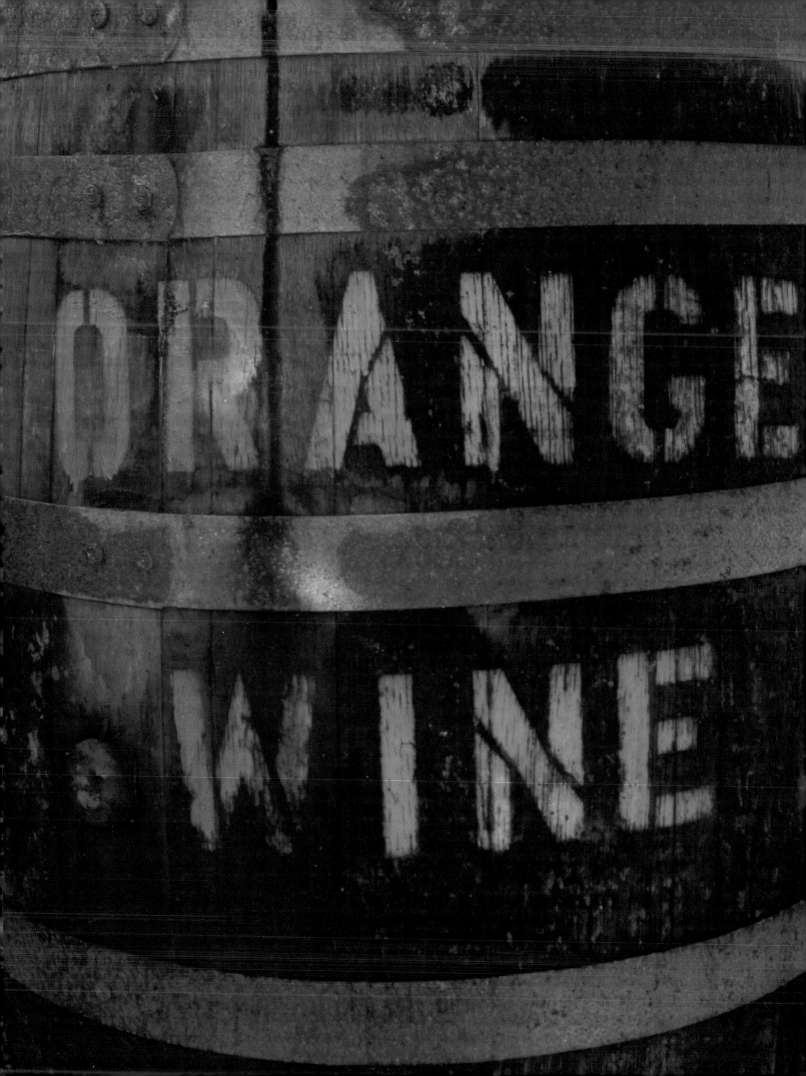

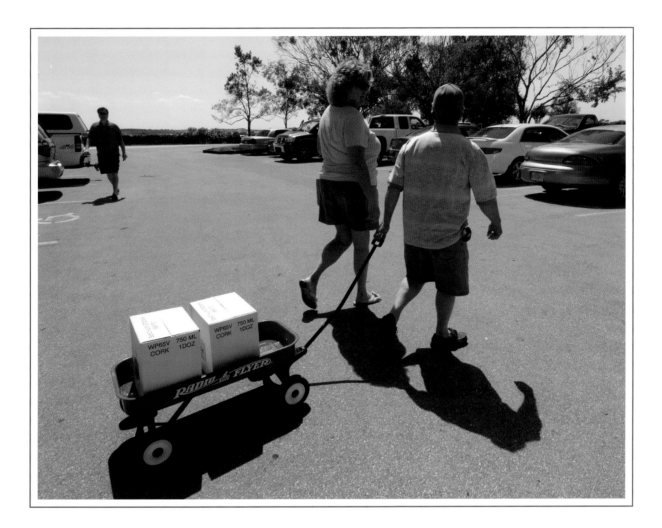

*Wine was made in Florida by the
early Spanish settlers more than 300 years before
California became a state.*

FLORIDA: In this hot and humid region, grapes work hard to survive so wineries like St. Petersburg's Florida Orange Grove and Winery produce wine from citrus fruits and specialize in labels such as "Mango Mamma" and "Category 5," a white sangria of five tropical fruits. At this former citrus stand, a barrel tells visitors to the winery what to expect inside. (Left)

Wines by the wagonload leave the largest winery in the state, Lakeridge Winery in Clermont, which provides a welcome destination for wine lovers. (Above)

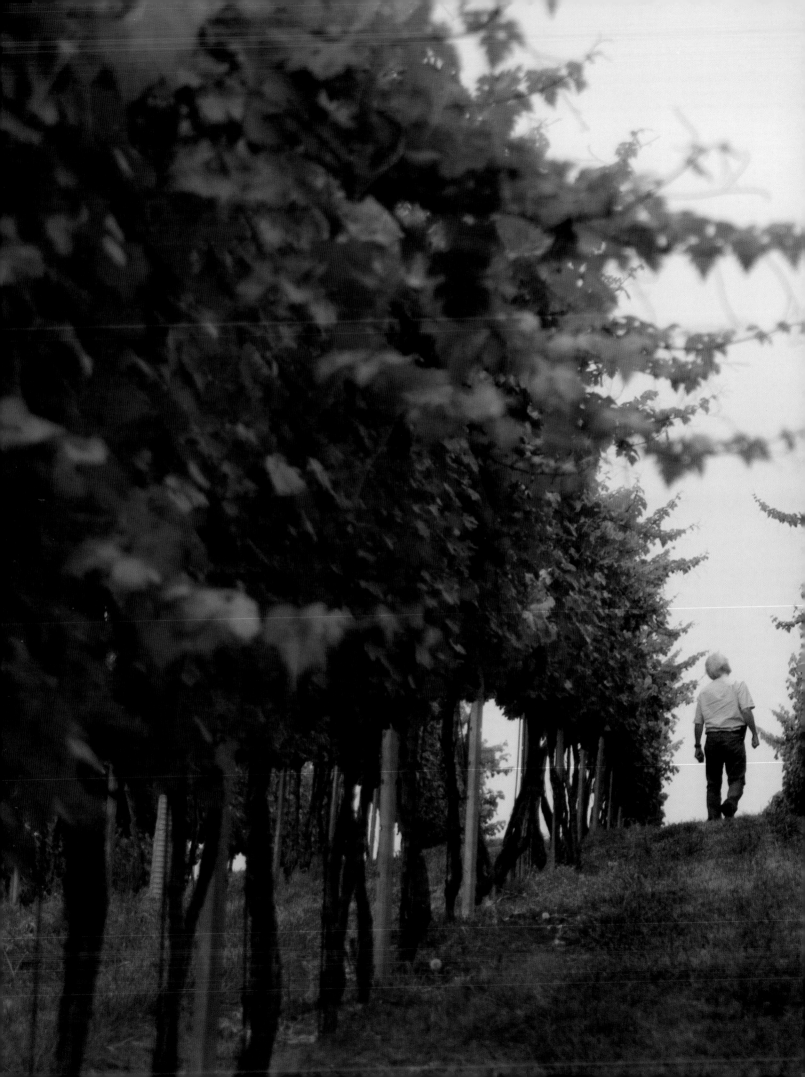

GEORGIA: A visitor walks among the summer vines of Wolf Mountain Vineyards north of Dahlonega. At 1,800 feet above sea level, where the days are hot and the nights cool, this region of the South can grow classic European grapes.

NORTH CAROLINA: Grape vines frame a rising sun at the Biltmore Estate's vineyards along the French Broad River in Ashville.

After rising on America's eastern shores,
the sun will set seven time zones later in Hawaii, ripening
grapes for yet another harvest.
Wine across America will have experienced another day.

{ WINE BOTTLES U.S.A. }

In a rare collection for public view, Fredericksburg Winery in the Texas Hill Country displays wine from all 50 states. Most of the bottles came from visitors to the winery who, after returning to their home state, shipped a bottle of their local wine to add to the collection.

ALABAMA

ALASKA

ARIZONA

ARKANSAS

CALIFORNIA

COLORADO

CONNECTICUT

DELAWARE

FLORIDA

GEORGIA

HAWAII

IDAHO

ILLINOIS

INDIANA

IOWA

KANSAS

KENTUCKY

LOUISIANA

MAINE

MARYLAND

MASSACHUSETTS **MICHIGAN** **MINNESOTA** **MISSISSIPPI** **MISSOURI** **MONTANA**

NEBRASKA **NEVADA** **NEW HAMPSHIRE** **NEW JERSEY** **NEW MEXICO** **NEW YORK**

NORTH CAROLINA **NORTH DAKOTA** **OHIO** **OKLAHOMA** **OREGON** **PENNSYLVANIA**

RHODE ISLAND **SOUTH CAROLINA** **SOUTH DAKOTA** **TENNESSEE** **TEXAS** **UTAH**

VERMONT **VIRGINIA** **WASHINGTON** **WEST VIRGINIA** **WISCONSIN** **WYOMING**

{ WINE FACTS U.S.A. }

ALABAMA
First Winery: Perdido Vineyards, 1979*
Top Grapes: Muscadine, Scuppernong*
Website: alabamawines.org

ALASKA
First Winery: Denali winery, 1997*
Website: chiff.com

ARIZONA
First Winery: Sonoita Vineyards, 1983*
Top Grapes: Cabernet Sauvignon, Pinot Noir, Viognier, Sauvignon Blanc*
Website: arizonawine.org

ARKANSAS
First Winery: Post Familie Vineyards, Wiederkehr Wine Cellars, both in 1880*
Top Grapes: Cynthiana, Chardonnay, Zinfandel, Muscadine, Cabernet Sauvignon*
Website: arkansas.com

CALIFORNIA
First Winery: Buena Vista, 1857*
Top Grapes: Cabernet Sauvignon, Chardonnay, Merlot, Syrah, Sauvignon Blanc, Pinot Noir*
Website: wineinstitute.org

COLORADO
First Winery: Ivancie Winery (now closed), 1968*
Top Grapes: Merlot, Chardonnay, Syrah/Shiraz, Cabernet Sauvignon*
Website: coloradowine.com

CONNECTICUT
First Winery: Hopkins Vineyard, 1979*
Top Grapes: Chardonnay, Vidal Blanc, Seyval Blanc, Pinot Noir, Cabernet Franc, Cabernet Sauvignon*
Website: ctwine.com

DELAWARE
First Winery: Nassau Valley Vineyards, 1993*
Top Grapes: Seyval Blanc, Cabernet Sauvignon, Merlot, Chardonnay*
Website: chiff.com

FLORIDA
First Winery: Lakeridge Winery and Vineyards, 1989*
Top Grapes: Muscadine*
Website: fgga.org

GEORGIA
First Winery: Georgia Winery, 1983*
Top Grapes: Muscadine, Cabernet Franc, Merlot, Cabernet Sauvignon, Chardonnay*
Website: georgiawine.com

HAWAII
First Winery: Tedeschi Vineyards, 1974*
Top Grapes: Carnelian, Chenin Blanc*
Website: weekendwinery.com

IDAHO
First Winery: Ste. Chapelle Winery, 1976*
Top Grapes: Riesling, Cabernet Sauvignon, Merlot, Chardonnay*
Website: idahowine.org

ILLINOIS
First Winery: Lynfred Winery, 1979*
Top Grapes: Traminette, Foch, Chambourcin, Norton*
Website: illinoiswine.org

INDIANA
First Winery: Oliver Winery, 1972*
Top Grapes: Chardonel, Traminette, Chambourcin, Foch*
Website: indianawines.org

IOWA
First Winery: Ehrle Brothers Winery, 1934*
Top Grapes: Niagara, Frontenac, St. Croix, Maréchal Foch*
Website: chiff.com

KANSAS
First Winery: Smokey Hill Vineyards and Winery, 1991*
Top Grapes: Cabernet Franc, Syrah*
Website: winesofkansas.com

KENTUCKY
First Winery: Lover's Leap Vineyard and Winery, 2000*
Top Grapes: Cabernet Sauvignon, Merlot, Riesling, Vidal Blanc*
Website: chiff.com

LOUISIANA
First Winery: Casa De Sue Winery, 1992*
Top Grapes: Muscadine, Niagara, Blanc du Bois*
Website: weekendwinery.com

MAINE
First Winery: Bartlett Maine Estate Winery, 1982*
Top Grapes: Niagara, Chardonnay, Cabernet Sauvignon*
Website: mainewineries.com

MARYLAND
First Winery: Boordy Vineyards, 1945*
Top Grapes: Cabernet Sauvignon, Merlot, Chardonnay, Chambourcin, Seyval, Vidal Blanc*
Website: marylandwine.com

MASSACHUSETTS
First Winery: Chicama Vineyards, 1971*
Top Grapes: Riesling, Chardonnay, Pinot Noir, Voignier, Cabernet Sauvignon*
Website: chiff.com

MICHIGAN
First Winery: St. Julien, 1921*
Top Grapes: Pinot Noir, Chardonnay, Riesling, Gewürztraminer, Chancellor*
Website: michiganwines.com

MINNESOTA
First Winery: Alexis Bailly Vineyard, 1978*
Top Grapes: Frontenac, Foch, St. Croix, Prairie Star*
Website: chiff.com

MISSISSIPPI
First Winery: Old South Winery, 1979*
Top Grapes: Muscadine*
Website: chiff.com

MISSOURI
First Winery: Stone Hill Winery, 1847*
Top Grapes: Cynthiana, Vignoles, Seyval Blanc, Norton, Chambourcin*
Website: missouriwine.org

MONTANA
First Winery: Lolo Peak Winery, 1998*
Top Grapes: Maréchal Foch, Frontenac, Leon Millot, St. Croix*
Website: chiff.com

NEBRASKA
First Winery: Cuthills Vineyards, 1994*
Top Grapes: Edelweiss, St. Croix, Maréchal Foch*
Website: www.nebraskawines.com

NEVADA
First Winery: Pahrump Valley Winery, 1990*
Top Grapes: Cabernet Sauvignon, Merlot, Chardonnay*
Website: chiff.com

NEW HAMPSHIRE
First Winery: Jewell Towne Vineyards, 1990*
Top Grapes: Maréchal Foch, Seyval Blanc, Vignoles, Chardonnay*
Website: chiff.com

NEW JERSEY
First Winery: Renault Winery, 1864*
Top Grapes: Riesling, Chambourcin, Cabernet Franc, Vidal Blanc, Seyval Blanc, Pinot Noir, Chardonnay*
Website: newjerseywines.com

NEW MEXICO
First Winery: La Vina Winery, 1977*
Top Grapes: Cabernet Sauvignon, Chardonnay, Johannisberg Riesling, Merlot, Pinot Noir, Sauvignon Blanc, Zinfandel*
Website: nmwine.com

NEW YORK
First Winery: Brotherhood Winery, 1839*
Top Grapes: Merlot, Cabernet Franc, Riesling, Chardonnay, Cabernet Sauvignon, Pinot Noir*
Website: newyorkwines.org

NORTH CAROLINA
First Winery: Medoc Vineyards, 1835*
Top Grapes: Scuppernong, Chardonnay, Cabernet Sauvignon, Merlot, Viognier, Cabernet Franc*
Website: ncwine.org

NORTH DAKOTA
First Winery: Pointe of View Winery, 2002*
Top Grapes: Frontenac, Prairie Star*
Website: chiff.com

OHIO
First Winery: Meiers Winery, 1856*
Top Grapes: Riesling, Chardonnay, Pinot Gris, Cabernet Franc, Cabernet Sauvignon, Pinot Noir*
Website: ohiowines.org

OKLAHOMA
First Winery: Cimarron Cellars, 1983*
Top Grapes: Cynthiana, Vignoles, Chardonnay, Shiraz, Zinfandel, Riesling*
Website: oklahomawines.org

OREGON
First Winery: Hillcrest Vineyards, 1961*
Top Grapes: Chardonnay, Pinot Gris, Pinot Noir*
Website: oregonwine.org

PENNSYLVANIA
First Winery: Franklin Hill Vineyard, 1982*
Top Grapes: Cabernet Sauvignon, Chardonnay, Gewürztraminer, Pinot Gris, Pinot Noir, Riesling*
Website: pennsylvaniawine.com

RHODE ISLAND
First Winery: Sakonnet Vineyards, 1975*
Top Grapes: Chardonnay, Gewürztraminer, Pinot Noir*
Website: chiff.com

SOUTH CAROLINA
First Winery: Carolina Vineyards (formerly known as Cruse Vineyards), 1985*
Top Grapes: Scuppernong, Chambourcin, Vidal Blanc*
Website: chiff.com

SOUTH DAKOTA
First Winery: Valiant Vineyards Winery, 1996*
Top Grapes: Baltica, Seyval Blanc, Maréchal Foch, Frontenac*
Website: chiff.com

TENNESSEE
First Winery: Highland Manor Winery, 1980*
Top Grapes: Muscadine, Seyval Blanc, Chambourcin, Chardonnay*
Website: tennesseewines.com

TEXAS
First Winery: Val Verde Winery, 1883*
Top Grapes: Chenin Blanc, Chardonnay, Cabernet Sauvignon, Merlot*
Website: texaswinetrail.com

UTAH
First Winery: Castle Creek Winery, 1989*
Top Grapes: Pinot Noir, Merlot, Cabernet Sauvignon, Chenin Blanc, Chardonnay, Gewürztraminer*
Website: chiff.com

VERMONT
First Winery: Snow Farm Vineyard and Winery, 1985*
Top Grapes: Seyval Blanc, Chardonnay, Baco Noir*
Website: chiff.com

VIRGINIA
First Winery: Farfelu Vineyards, 1967*
Top Grapes: Chardonnay, Sauvignon Blanc, Cabernet Sauvignon, Merlot, Norton*
Website: virginiawines.org

WASHINGTON
First Winery: Columbia Winery, 1962*
Top Grapes: Merlot, Cabernet Sauvignon, Chardonnay, Syrah, Riesling, Semillon*
Website: washingtonwine.org

WEST VIRGINIA
First Winery: Fisher Ridge Winery, 1977*
Top Grapes: Niagara, Baco Noir, St. Vincent*
Website: chiff.com

WISCONSIN
First Winery: Wollersheim Winery, 1972*
Top Grapes: Seyval Blanc, Riesling, Chardonnay, Pinot Noir*
Website: wiswine.com

WYOMING
First Winery: Wyoming Craft and Wine Cellars, 1999*
Top Grapes: Merlot, Zinfandel*
Website: chiff.com

{ INDEX }

A

A&K Cooperage, 111
Alabama, 21, 197, 218, 220
 Bryant Vineyards, 207
 Perdido Vineyards, 220
 Wills Creek Winery, 67
Alaska, 22, 218, 220
 Denali Winery, 104, 220
Alba Vineyard, 32, 67
Alexis Bailly Vineyard, 50, 138, 157, 220
Archery Summit, 224
Argyle Winery, 82, 149
Arizona, 20, 22, 163, 218, 220
 Callaghan Vineyards, 165, 168
 Glomski, Eric, 10
 Page Spring Vineyard, 224
 Sonoita Vineyards, 167, 220
 Village of Elgin Winery, 70
Arkansas, 23, 144, 197, 218, 220
 Arkansas Historic Wine Museum, 195
 Arkansas Wine Company, 191
 Cowie Wine Cellars, 191, 195, 198
 Mount Bethel Winery, 111
 Nichols Winery, 198
 Post Familie Vineyards, 220
 Wiederkehr Wine Cellars, 158, 220
Auler, Susan and Ed, 18
AVAs (American Viticultural Areas), 158

B

Baehmann, Mark, 126
Baileyana Winery, 4
Bailly, Nan, 50
Balagna, John, 32
Balagna Winery, 32
Barbour, James, 208
Barboursville Vineyard, 208
Baron, Christophe, 76
Barrels, 108, 111, 138, 181, 183, 195
Bartlett Maine Estate Winery, 220
Basignani Winery, 108
Beauchemin-Hall, Judy, 104
Beaulieu Vineyards, 69
Becker Vineyards, 70, 174, 176, 181, 183
Bedell Cellars, 184
Bell Mountain Vineyards, 181
Beringer, Frederick, 116
Beringer Vineyards, 116
Bernau, Jim, 79
Biltmore Estate, 67, 197, 208, 216
Black Ankle Vineyard, 224
Black Mesa Winery, 162
Blackstock Vineyards, 70
Blue Sky Vineyard, 68, 134
Bohn, Cynthia, 46, 203
Bohn, Joe, 203
Boordy Vineyards, 69, 184, 220
Bottles, 193, 218–19
Boxwood Winery, 184
Boyce, Ed, 224
Brick House Vineyards, 76, 82
Brotherhood Winery, 221
Brown, Jim, 183
Bryant, Kelly, 207
Bryant Vineyards, 207
Buena Vista, 116, 138, 220
Bungs, 152
Burd, Lynda, 162
Butler, Gary, 137

C

Cabernet Sauvignon, 26, 77, 165
Cains, Mary Jane, 111
California, 21, 22, 23, 115, 218, 220
 Baileyana Winery, 4
 Beaulieu Vineyards, 69
 Beringer Vineyards, 116
 Buena Vista, 116, 138, 220
 Central Coast, 26, 114
 Charles Mitchell Vineyards, 157
 Chateau St. Jean, 70
 Culinary Institute of America, 118, 186
 Franciscan Oakville Estate, 72
 Groth Vineyards, 37
 Hernandez, Felipe, 10
 Honig Vineyard and Winery, 116
 Hop Kiln Winery, 72
 Jordan Winery, 120
 Kunde Estate Winery, 69
 Los Angeles area, 26, 90
 Merryvale Vineyards, 14
 Montevina Winery, 113
 Napa Valley, 14, 26, 30, 37, 43, 45, 54, 72, 101, 114–16, 118, 120, 123, 124, 152, 184, 191
 Nickel & Nickel, 184
 Opus One, 152
 Ravenswood Winery, 69
 Robert Mondavi Winery, 70, 114, 191
 Rubicon Estates, 70, 123
 San Antonio Winery, 90
 Sebastiani Vineyards, 66
 Shafer Vineyards, 144
 Sierra Foothills, 113, 157
 Silver Oak Cellars, 69
 Sobon Family Wines, 144
 Sonoma Valley, 72, 116, 120, 124
 Spottswoode Winery, 101, 120
 Sterling Vineyards, 43
 Trefethen Vineyards, 70
 Viansa Winery, 17
 Wolff Vineyards, 26
Callaghan, Kent, 165
Callaghan Vineyards, 165, 168
Campbell, Tom, 46
Cape Cod Winery, 54, 64, 70
Carlson Vineyards, 173
Carolina Vineyards, 221
Casa De Sue Winery, 220
Casa Rondeña Winery, 165
Castle Creek Winery, 68, 161, 165, 221
Catawba, 20, 127
Cavey, T. C., 137
Cayuse Winery and Vineyards, 76
Chardonnay, 50, 56, 76, 90, 124, 147, 171
Charles Mitchell Vineyards, 157
Chateau Élan, 196, 198
Chateau St. Jean, 70
Chateau St. Michelle, 82
Cherry Creek Winery, 137
Chicama Vineyards, 64, 220
Chrisman Mill Vineyards, 90
Christian Brothers Winery, 118
Cimarron Cellars, 221
Clarke, Stan, 224
Colorado, 21, 23, 162, 163, 165, 218, 220
 Carlson Vineyards, 173
 Grand River Vineyards, 41, 157
 Ivancie Winery, 220
 Mathewson, Joan, 10
 Stone Cottage Cellar, 184

 Terror Creek Winery, 75, 224
 Two Rivers Winery, 70
Columbia Winery, 221
Concord, 12
Connecticut, 22, 218, 220
 Gouveia Vineyards, 64
 Hopkins Vineyard, 220
 Jonathan Edwards Winery, 54, 70
 Mellary, Michaele, 10
Coppola, Francis Ford, 123
Cork, 85
Corkscrews, 204
Cowie, Bette Kay, 195
Cowie, Bob, 195, 198
Cowie Wine Cellars, 191, 195, 198
Culinary Institute of America, 118, 186
Cuthills Vineyards, 220

D

Delaware, 218, 220
Denali Winery, 104, 220
Desert Wind Vineyard, 43
Dike, Jack, 111
Domaine Drouhin, 67, 82, 94
Dutt, Gordon, 167

E

Ehrle Brothers Winery, 220
Ellis, George, 191
Equus Run Vineyards, 46, 70, 203, 204
Esterer, Arnie, 132
Ewers, Jim, 134

F

Fall Creek Vineyards, 18
Farfelu Vineyards, 221
Feliciana Cellars, 38
Fernandez, Elias, 144
Ferrante Winery, 128
Fisher Ridge Winery, 221
Florida, 20, 22, 27, 197, 213, 218, 220
 Florida Estates Winery, 26
 Florida Orange Grove and Winery, 213
 Lakeridge Winery, 213, 220
Franciscan Oakville Estate, 72
Franklin Hill Vineyard, 221
Fredericksburg Winery, 218
Frizzell, Mike, 198
Frogtown Cellars, 49, 184
Fry, Eric, 9

G

Garrett, Bill, 198
Georgia, 22, 197, 218, 220
 Blackstock Vineyards, 70
 Chateau Élan, 196, 198
 Frogtown Cellars, 49, 184
 Georgia Winery, 220
 Tiger Mountain Vineyards, 4
 Wolf Mountain Vineyards, 215
Gewürztraminer, 56
Glomski, Eric, 224
Gouveia Vineyards, 64
Grand River Vineyards, 41, 157
Greystone Winery, 118
Groth Vineyards, 37

H

Hall, Cutter, 12
Hall, John and Mary, 186

Hall, Tom, 104
Haraszthy, Count Agoston, 138
Hawaii, 23, 218, 220
 Santiago, Ioana, 10
 Tedeschi Vineyards, 50, 67, 158, 220
Hayne, Alston "Otty," 45
Hedman, Anders, 224
Hedman Winery, 224
Held, Jim, 224
Heny, Mike, 157
Herman, Sue and Joe, 128
Hernandez, Felipe, 224
Highland Manor Winery, 221
Highland Winery, 198
Hillcrest Vineyards, 221
Honig Vineyard and Winery, 116
Hop Kiln Winery, 72
Hopkins Vineyard, 220
Horton Vineyards, 157
Houge Cellars, 99
Hunt Country Vineyards, 63, 67, 161

I

Ice wine, 60
Idaho, 163, 218, 220
 Ste. Chapelle Winery, 220
 Sawtooth Winery, 173
Illinois, 22, 218, 220
 Blue Sky Vineyard, 68, 134
 Hedman, Anders, 10
 Hedman Winery, 224
 Lynfred Winery, 220
Indiana, 21, 218, 220
 Oliver Winery, 220
 Satek Winery, 128
Inglenook Vineyards, 123
Iowa, 23, 218, 220
Ivancie Winery, 220

J

Jefferson, Thomas, 20, 35, 197
Jefferson Vineyards, 20, 35
Jewell Towne Vineyards, 221
Jonathan Edwards Winery, 54, 70
Jordan Winery, 120

K

Kansas, 218, 220
Karma Vista Winery, 128
Kentucky, 21, 91, 197, 218, 220
 Chrisman Mill Vineyards, 90
 Equus Run Vineyards, 46, 70, 203, 204
 Highland Winery, 198
 Lover's Leap Vineyard and Winery, 220
 Wildside Vines, 204
King Estates Winery, 85
Kirby, Matthew, 138
Klaffke, Forrest, 79
Kluge Estate Winery, 90, 211
Kunde Estate Winery, 69

L

Labels, 9, 18, 20–23, 157
La Chiripada Winery, 68
Lakeridge Winery, 213, 220
"Late harvest" wine, 60
La Vina Winery, 221
L'Ecole No 41, 82
Lemberger, 173
Lenz Winery, 9, 56

Leon Millot, 50
Lolo Peak Winery, 220
Looney, Jack, 198
Louisiana, 23, 102, 197, 219, 220
 Casa De Sue Winery, 220
 Feliciana Cellars, 38
 Pontchartrain Vineyards, 68
Lover's Leap Vineyard and Winery, 220
Lynfred Winery, 220

M

Maine, 21, 55, 218, 220
Manuel, Juan, 224
Markko Vineyards, 132
Maryland, 23, 197, 218, 220
 Basignani Winery, 108
 Black Ankle Vineyard, 224
 Boordy Vineyards, 69, 184, 220
 Boyce, Ed, 10
 O'Herron, Sarah, 10
Massachusetts, 219, 220
 Cape Cod Winery, 54, 64, 70
 Chicama Vineyards, 64, 220
 Westport Rivers Winery, 11
Matheson, Mark, 102
Mathewson, Joan, 224
Matzinger, Anne, 224
Medoc Vineyards, 221
Meiers Winery, 221
Mellary, Michaele, 224
Merlot, 77, 82
Merryvale Vineyards, 14
Michigan, 22, 219, 220
 Cherry Creek Winery, 137
 Karma Vista Winery, 128
 Round Barn Winery, 38
 St. Julien, 220
 Tabor Hill Winery, 137
Miller, Shannon, 108
Mills, Melissa, 82
Minnesota, 21, 219, 220
 Alexis Bailly Vineyard, 50, 138, 157, 220
Mission Mountain, 46
Mississippi, 22, 197, 219, 220
 Old South Winery, 67, 220
Missouri, 22, 126, 127, 130, 135, 138, 219, 220
 A&K Cooperage, 111
 Held, Jim, 10
 Mt. Pleasant Winery, 126, 184
 Stone Hill Winery, 67, 128, 134, 220, 224
Mon Ami Winery, 70
Mondavi, Robert, 20, 115
Montana, 23, 219, 220
 Lolo Peak Winery, 220
 Mission Mountain, 46
Montevina Winery, 113
Morton, Lucie, 96, 97
Mount Bethel Winery, 111
Mt. Hope Winery, 184
Mt. Pleasant Winery, 126, 184
Muscadine, 20, 27, 38, 197, 198

N

Nassau Valley Vineyards, 220
Nebraska, 219, 220
Nelson, Chris, 90
Nevada, 219, 221
New Hampshire, 21, 55, 219, 221
New Jersey, 219, 221
 Alba Vineyard, 32, 67

Renault Winery, 221
New Mexico, 23, 101, 219, 221
 Balagna, John, 10
 Balagna Winery, 32
 Black Mesa Winery, 162
 Casa Rondeña Winery, 165
 Castle Creek Winery, 165
 La Chiripada Winery, 68
 La Vina Winery, 221
 New Mexico Vineyards, 90, 168
 Santa Fe Vineyards, 102
 Toast of Taos wine judging, 35
New York, 21, 23, 55, 219, 221
 Bedell Cellars, 184
 Brotherhood Winery, 221
 Finger Lakes region, 60
 Hunt Country Vineyards, 63, 67, 161
 Lenz Winery, 9, 56
 Long Island, 9, 56, 59, 184, 188
 Old Field Vineyards, 188
 Peconic Bay Winery, 68
 Pellegrini Winery, 59
 Tilton, Madeline, 10
Nichols Winery, 198
Nickel & Nickel, 184
Niebaum, Gustave, 123
North Carolina, 21, 197, 219, 221
 Biltmore Estate, 67, 197, 208, 216
 Medoc Vineyards, 221
North Dakota, 21, 104, 219, 221
Norton, 4, 20, 128, 196

O

Oakencroft Winery, 70
O'Herron, Sarah, 224
Ohio, 22, 219, 221
 Ferrante Winery, 128
 Lake Erie region, 28
 Markko Vineyards, 132
 Meiers Winery, 221
 Mon Ami Winery, 70
 Old Firehouse Winery, 132
 Old Mill Winery, 126
 South River Winery, 184, 186
Oklahoma, 219, 221
 Cimarron Cellars, 221
 Summerside Vineyards and Winery, 18, 137
Old Field Vineyards, 188
Old Firehouse Winery, 132
Old Mill Winery, 126
Old South Winery, 67, 220
Oliver Winery, 220
Opus One, 152
Oregon, 12, 23, 219, 221
 Archery Summit, 224
 Argyle Winery, 82, 149
 Brick House Vineyards, 76, 82
 Cayuse Vineyard, 76
 Domaine Drouhin, 67, 82, 94
 Dundee Hills, 80, 82, 85, 149
 Hillcrest Vineyards, 221
 King Estates Winery, 85
 Matzinger, Anne and Otto, 10
 Sokol Blosser, 80
 Tyrus Evan, 79
 Willamette Valley, 76, 77, 82, 97
 Willamette Valley Vineyards, 79
Orr, Vicki, 144

P

Page Spring Vineyard, 224
Pahrump Valley Winery, 221
Peconic Bay Winery, 68
Pellegrini Winery, 59
Pellet, Jean-François, 80
Pennsylvania, 12, 22, 219, 221
 Franklin Hill Vineyard, 221
 Mt. Hope Winery, 184
 Pennsylvania Wine Co., 55
Pepper Bridge Winery, 80
Perdido Vineyards, 220
Petite Sirah, 45
Petit Verdot, 168
Pinot Noir, 75, 76, 77, 82, 124
Pointe of View Winery, 221
Pontchartrain Vineyards, 68
Post Familie Vineyards, 220

R

Radley, Ray, 161
Rausse, Gabriele, 150
Ravenswood Winery, 69
Raver, John, 108
Reininger Winery, 79
Reissig, Fred, 181
Renault Winery, 221
Resveratrol, 169
Rhode Island, 23, 219, 221
 Sakonnet Vineyards, 9, 221
Riesling, 60, 75
Robert Mondavi Winery, 70, 114, 115, 191
Rochman, Barrett, 134
Rodland, Tucker and Hunter, 12
Roguenant, Christian, 4
Rosenbaum, Art, 198
Round Barn Winery, 38
Round Mountain Vineyards, 171
Rubicon Estates, 70, 123
Russell, Rob and Bill, 11

S

Ste. Chapelle Winery, 220
St. Julien, 220
Sakonnet Vineyards, 9, 221
San Antonio Winery, 90
Sanchez, Rafael, 90
Santa Fe Vineyards, 102
Santiago, Ioana, 224
Satek Winery, 128
Sauvignon Blanc, 101
Sawtooth Winery, 173
Sebastiani Vineyards, 66
Seven Hills Vineyard, 82, 92
Shafer Vineyards, 144
Silver Oak Cellars, 69
Sister Creek Vineyards, 17, 181
Smokey Hill Vineyards and Winery, 220
Snoqualmie Winery, 68, 184
Snow Farm Vineyard and Winery, 221
Sobon Family Wines, 144
Sokol Blosser, 80
Soles, Rollin, 149
Sonoita Vineyards, 167, 220
South Carolina, 21, 197, 219, 221
South Dakota, 21, 22, 218, 221
South River Winery, 184, 186
Spanish Valley Vineyards and Winery, 173
Spottswoode Winery, 101, 120
Sterling Vineyards, 43

Steuben, 128
Stone Cottage Cellar, 184
Stone Hill Winery, 67, 128, 134, 220, 224
Strikers Premium Winery, 108
Summerside Vineyards and Winery, 18, 137
Switzer, Chardonnay, 147
Switzer, Cord, Bert, and Jene, 224
Switzer, Oma, 107

T

Tabor Hill Winery, 137
Tedeschi Vineyards, 50, 67, 158, 220
Tennessee, 21, 197, 198, 219, 221
 Highland Manor Winery, 221
 Strikers Premium Winery, 108
Terroir, 145
Terror Creek Winery, 75, 224
Texas, 23, 107, 147, 163, 219, 221
 Becker Vineyards, 70, 174, 176, 181, 183
 Bell Mountain Vineyards, 181
 Fall Creek Vineyards, 18
 Fredericksburg Winery, 218
 Manuel, Juan, 10
 Sister Creek Vineyards, 17, 181
 Switzer, Cord, Bert, Jene, 10
 Val Verde Winery, 221
Tiger Mountain Vineyards, 4
Tilton, Madeline, 224
Toast of Taos wine judging, 35
Traverso, Mario, 186
Trefethen Vineyards, 70
Tunnell, Doug, 82
Two Rivers Winery, 70
Tyrus Evan, 79

U

Utah, 23, 163, 219, 221
 Castle Creek Winery, 68, 161, 221
 Round Mountain Vineyards, 171
 Spanish Valley Vineyards and Winery, 173

V

Valiant Vineyards Winery, 221
Val Verde Winery, 221
Vanderbilt, George, 208
Vasilakes, Neil and Rachel, 204
Véraison, 176
Vermont, 21, 55, 219, 221
Viansa Winery, 17
Village of Elgin Winery, 70
Virginia, 21, 23, 97, 150, 197, 198, 219, 221
 Barboursville Vineyard, 208
 Boxwood Winery, 184
 Farfelu Vineyards, 221
 Horton Vineyards, 157
 Jefferson Vineyards, 20, 35
 Kluge Estate Winery, 90, 211
 Oakencroft Winery, 70

W

Walla Walla Vintners, 67
Washington, 4, 23, 77, 79, 219, 221
 Cayuse Winery and Vineyards, 76
 Chateau St. Michelle, 82
 Clarke, Stan, 10
 Columbia River Valley, 87
 Columbia Winery, 221
 Desert Wind Vineyard, 43
 Houge Cellars, 99
 L'Ecole No 41, 82

 Pepper Bridge Winery, 80
 Reininger Winery, 79
 Seven Hills Vineyard, 82, 92
 Snoqualmie Winery, 68, 184
 Walla Walla Vintners, 67
Westport Rivers Winery, 11
West Virginia, 219, 221
Wheeler, Mike, 4
Wiederkehr, Dennis, 158
Wiederkehr Wine Cellars, 158, 220
Wildside Vines, 204
Willamette Valley Vineyards, 79
Wills Creek Winery, 67
Wine
 annual consumption of, 108
 aromas of, 191
 color of, 46
 harvesting grapes for, 92, 94, 101
 history of, 4, 20
 making, at home, 150
Wineries. *See also individual wineries*
 annual visits to, 38
 architecture of, 37, 38, 43, 64, 68–69, 72, 114, 157, 184
 distribution of, by state, 18, 104
 first, by state, 220–21
 growth in, 17–18, 20, 103
Winne, Tom, 157
Wisconsin, 21, 219, 221
 Wollersheim Winery, 69, 137, 138, 144, 221
Wolff Vineyards, 26
Wolf Mountain Vineyards, 215
Wollersheim Winery, 69, 137, 138, 144, 221
Wyoming, 219, 221

Y

Yat, Haunani Au, 158

Z

Zinfandel, 144

PORTRAITS: (Page 10, top row, left to right) Stan Clarke, Director, Center for Enology and Viticulture, Walla Walla Community College, Walla Walla, Washington; Anders Hedman, owner, Hedman Winery, Alto Pass, Illinois; Ioana Santiago, vineyard worker, Maui, Hawaii; Anna Matzinger and Otto, winemaker, Archery Summit, Dayton, Oregon.

(Second row from top, left to right) Felipe Hernandez, vineyard manager, Santa Ynez, California; John Balagna, owner, Balagna Winery, Los Alamos, New Mexico; Juan Manuel, winery worker, Stonewall, Texas.

(Third row from top, left to right) Michaele Mellary, winery worker, Clinton, Connecticut; Sarah O'Herron and Ed Boyce, owners, Black Ankle Vineyard, Mt. Airy, Maryland; Madeline Tilton, 72-year-old vineyard worker, Hammondsport, New York; Jim Held, owner, Stone Hill Winery, Hermann, Missouri.

(Bottom row) Eric Glomski, winery owner, Page Spring Vineyard, Cornville, Arizona; Cord, Bert and Jene Switzer, winery owners, Fredericksburg, Texas; Joan Mathewson, winery owner, Terror Creek Winery, Paonia, Colorado.